To Gemma
with love
Jackie

August 2002

Paul Heathcote's Rhubarb and Black Pudding

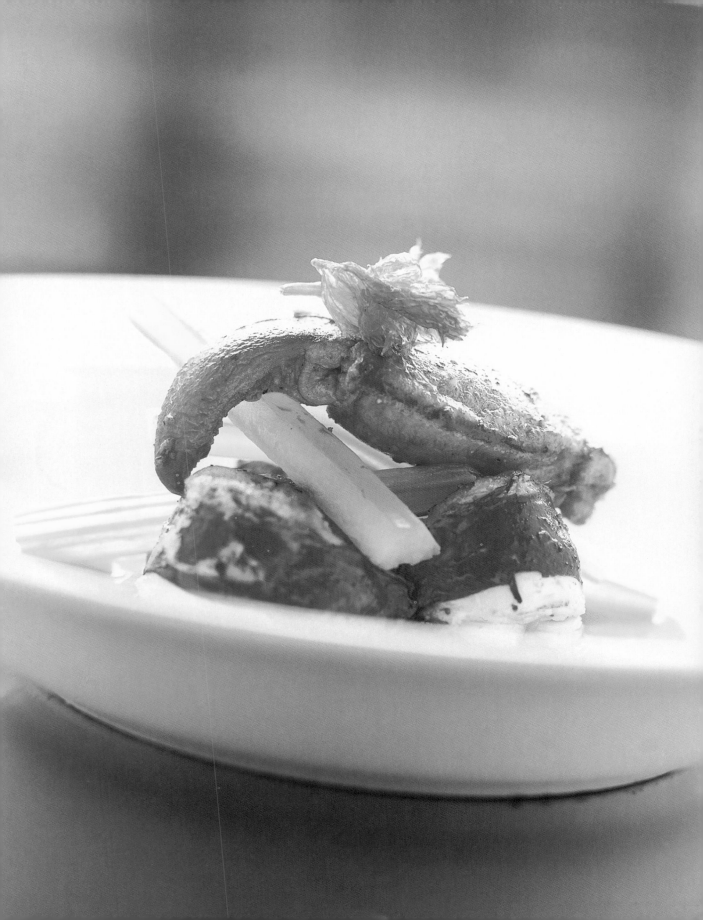

Paul Heathcote's
Rhubarb and
Black Pudding

Matthew Fort

Colour photography by Tim Morris

Black-and-white-photography by Peter Williams

Fourth Estate · *London*

For my parents. MF
For Mum, Dad, Gabbi and Georgia. Thank you.
My thanks also to Andy Barnes for all his invaluable help, both at
Heathcote's and on this book. PH

Throughout the book all recipes serve four people,
unless otherwise specified.

Both metric and imperial quantities are given.
Use either all metric or all imperial, as the two are
not necessarily interchangeable.

The lines of verse from 'Show Saturday' by Philip Larkin
are taken from Collected Poems by Philip Larkin, reproduced here
by kind permission of Faber and Faber Limited and the author.

First published in Great Britain in 1998 by
Fourth Estate Limited
6 Salem Road
London W2 4BU

A catalogue record for this book is available from the British Library.

ISBN 1-85702-500-8

Editor & project manager: Lewis Esson
Art direction: Paul Welti
Colour photography: Tim Morris
Black-and-white photography: Peter Williams

Colour separations by Articolor, Verona
Printed and bound in Italy by L.E.G.O., Vicenza
Typesetting by Peter Howard

Contents

Preface

I first came to the Ribble valley in 1955, when I was seven years old. My father, Richard Fort, had been elected as Conservative Member of Parliament for Clitheroe in 1950. He was not the first Fort to have represented the constituency. Forts had been appearing on the benches at Westminster off and on since 1832.

Like other families in the area, my forebears had made a good deal of money from cotton, and like other families too, as soon as they had made their pile, distanced themselves from the trade that had made them rich and took up the less lucrative business of being country gentlefolk, living in some style at Read Hall, a handsome nineteenth-century house between Whalley and Padiham.

My memories of those early travels in Ribblesdale are patchy but vivid. I remember sweeping the streets of Whalley with my father and my brother James, to launch a 'Clean-up Whalley' campaign. I remember getting lost at Great Harwood Agricultural Show, and phlegmatically waiting to be found. I remember the dusty tedium of sitting in silence through the surgeries my father held in Clitheroe, Whalley, and Padiham. Most of all I remember the extraordinary combination of warmth and a kind of self-sufficient, granitic pragmatism that seemed to me to characterize everyone I met.

When my father died, the regular visits to Clitheroe stopped, and the beauties and people of the Ribble valley disappeared from my life until I was eighteen and I spent three years at the University of Lancaster, on the other side of the Trough of Bowland. Then I rediscovered, in part, this idiosyncratic corner of the world.

That period, too, drew to a close, and my reasons for visiting Clitheroe and the other parts of the Ribble valley drifted away. I stopped going there, except for the very occasional excursion, for over twenty years, until, one summer Friday in 1991, I stopped at Longridge in search of lunch on my way north to do some fishing in Cumbria. I had read about Paul Heathcote's restaurant in one of the guides, and at that time it seemed to represent the only worthwhile watering hole between Oxford and Grasmere.

I was immediately transfixed by the style and quality of the food. I was served poached salmon with a courgette flower stuffed with courgette mousse; smoked chicken and broccoli soup; slow-roasted shoulder of lamb braised with an aubergine mousse; and chocolate parfait with honey and oatmeal ice-cream, all for – and here's a sign of the times – £12.75. Although the influence of French cooking and finesse were uppermost, nevertheless there was English sensibility running through the flavours, the textures, the combinations of ingredients. Each course was made and presented with the technique I had come to associate with French cooking. I wrote accordingly in the *Guardian*.

Since then, of course, Heathcote's has developed its style of English cooking, and been celebrated for it. It has gained Michelin stars and all manner of encomiums and accolades from guides and reviewers. Heathcote's begat Heathcote's Brasserie in Preston and Simply Heathcote's in Manchester. And I came to know Paul Heathcote.

We bumped into each other at various industry functions, and we would talk about his approach to food, and life at large. Little by little, the notion of writing a book was batted about. There was a time when any chef worth his gossip column entries was producing a book. Clearly a book of their food became not just a status symbol for chefs, but a landmark in their career path. And very dull, not to say impractical, most of them were, too. I was not interested in ghosting a cheffy, state-of-my-art, recipe book. Recipes *per se*, food shorn of its human context, is pretty tedious stuff. Cooking and eating only become interesting when they intersect with human experience.

So I proposed a different kind of chef's book, a portrait of a restaurant in the round. Naturally recipes have a critical part in this, but a restaurant is not the sum of the food it serves, any more than a chef is. A restaurant is the sum of the people who work in it, in the front of the house as well as the kitchen, the people who supply it with raw materials and the people who eat in it. More particularly, a restaurant like Heathcote's has a particular relationship with the area in which it is situated. In a way it is a paradigm of that area. It reflects the areas outstanding characteristics, and they, in turn, help give shape and force to the dishes.

So the book would have to try and place Heathcote's in some kind of social and cultural context. It would provide the opportunity to examine the nature of English cooking, of what makes English food English and to try to redefine it for a contemporary audience in the same way that Paul has managed to achieve in a practical form in his kitchen. I am not sure that this was the kind of book that Paul had in mind when he first suggested the idea to me, but, with characteristic generosity and perception, he agreed to it.

So I spent a year or so interviewing many people who helped make Heathcote's what it is. It has been an exhilarating experience. Without fail I have met openness, kindness, generosity and enthusiasm. Everyone to whom I have spoken has shared their own knowledge and experience with invigorating enthusiasm. If what I have written reflects a tithe of their vivacity, enthusiasm and individuality, I will have accomplished what I set out to do.

Earth, sweet Earth, sweet landscape, with leaves throng
And louched low grass, heaven that dost appeal
To, with no tongue to plead, no heart to feel;
That canst but only be, but dost that long –
Thou canst but be, but that thou well dost; strong
Thy plea with him who dealt, nay does now deal,
Thy lovely dale down thus and thus bids reel
Thy river, and o'er gives all to rack or wrong.

And what is Earth's eye, tongue, or heart else, where
Else, but in dear and dogged man? – Ah, the heir
To his own selfbent so bound, so tied to his turn,
To thriftless reve both our rich round world bare
And none reck of world after, this bids wear
Earth brows of such care, care and dear concern.

RIBBLESDALE, Gerard Manley Hopkins

Introduction
Cow-heel and Quakerism

Stand beside the road that leads over the crest of Jeffrey Hill at the south-eastern end of Longridge Fell, with your back to the Longridge Golf Club and Cycling Association course, and look out over the valley of the River Loud towards Chipping. The land rolls away from your feet, over the dark density of Turnleys Wood, to a smooth curve of fields, stitched with hedgerows and upholstered with spinneys and copses. It has a neat, close-cropped weave, trim, orderly, quiet but for the plaintive, idiot sound of sheep and the occasional stuttering roar of a tractor.

Just beyond Chipping rises the wilder, forbidding escarpment of the Trough of Bowland. The Trough is specked with tiny clusters of doughty grey-stone houses – Newton, Slaidburn, Whitewell and Dunsop Bridge, the nearest point to the centre of the British Isles, according to the Ordinance Survey. It is an area more inhabited by sheep, crows, sparrow-hawks and kestrels than it is by humans, except in summer, when walkers and picnickers spread like a rash up from the towns that lie beyond the ring of villages around its edge.

Make a half turn to your right, and the line of the hill will carry your eye farther up the line of the Long Ridge, to where the hump of Longridge Fell cuts off the view to the Hodder valley. Walk to the other side of the road, however, and peer over the dry stone wall, and you can see quite clearly, if the mist and

rain aren't marching in across from the north-east, down to where Hurst Green and Stoneyhurst College shelter beneath the brow of Longridge Fell, to where the Hodder flows into the larger Ribble, just below Great Mitton and just above where the River Calder adds its weight.

From here you can trace the line of the A59 that sweeps along the curiously anonymous floor of the valley between Preston and Skipton, passing Osbalston, Copster Green, and Whalley. It races between the oppressive mass of Pendle Hill and the ancient market town of Clitheroe, crossing the old Roman Road at Chatburn, before skipping north and east through Gisburn and Broughton to Skipton and beyond.

This is a very curious landscape: part sear fell; part steep-banked rich grass field and woodland; part park, where the cotton magnates plotted their rural retreats from the reeking mills; and part the untidy, transient, plastic and plate-glass successors to the mills. Each element is coiled round the other, so that the transition from one to the other comes with disorienting rapidity. This is the middle Ribble. If, from your vantage point on Jeffrey Hill you turn a little farther, you will see where the river broadens through the runs and glides around Ribchester, winding its way through the water-meadows to Preston.

'Proud Preston, poor people/Low church, no steeple,' goes the traditional couplet. You still couldn't call Preston a beautiful town. It's a bit too utilitarian for that. Modern development has left its undistinguished mark on the centre, but there are still plenty of handsome eighteenth- and nineteenth-century buildings to bear witness to its substantial past as the administrative centre of the county.

Preston stands at the edge of The Fylde, the flat, alluvial plain that stretches away – cut by motorway, canal and railway, and pockmarked with villages, dotted with random patterns of black-and-white Friesian cattle, divided tidily by hedgerow and brook – to the dun brown sands of Lytham, Blackpool, and the old fishing port of Fleetwood. This is where you leave the Ribble valley and enter the valley of the Wyre, and from the Wyre to the valley of the Brock. It is quite possible to see Fleetwood from Jeffrey Hill on a clear day, as you swing round, running your eye over Garstang, Claughton, Goosnargh to – it would be nice to say Longridge, to come full circle, 360 degrees. It would be tidy and pleasing, but it wouldn't be true.

Longridge is tucked away under your feet, under the lea of Jeffrey Hill, a nondescript, nonesuch town, spreading down the lower slopes of the hill, and on to the plain, a kind of customs post between the wild, open-skied peace of the fells, and the productive, purposeful order of the Fylde.

The gloss of calm and order is slightly misleading. This is a part of England that armies have trudged and fought over since the Romans colonized the area after AD70, making their headquarters at Ribchester.

All the subsequent comings and goings of Angles, Danes and Norsemen can be traced through the place names: in the 'ing's, as in Melling; 'cet's, as in Cheetwood; 'pen's, as in Pendle; 'kirk's, as in Kirkham and Ormskirk; 'wick's, as in Winwick; and 'ecles', as in Eccleshill and Eccleston. The history of any part of England can be read in its place names.

It was, however, the eighteenth and nineteenth centuries that left the most visible marks of Lancashire's history. Then the county began to prosper, through its ports – Liverpool pre-eminent among them – through its domination of the textile industry, coal mining and smelting, salt refining and chemicals, through it turnpikes, canals and early railways. The abundance of water lay at the heart of the industrial prosperity; water for transport, but more importantly – along the valleys of the Ribble, Calder, Hodder and Loud – water for power.

Now most of the chimneys like church spires have gone, William Blake's 'dark Satanic mills', the vast thundering engines of the industrial revolution, the hanging pennants of smoke, the mazes of back-to-back terraces, all those details made familiar by *Love on the Dole* by Walter Greenwood, *Hobson's Choice* by Harold Brighouse, the mythopoeic *Road to Wigan Pier* by George Orwell, and the

energetically romantic novels of Howard Spring have largely been demolished.

True, the grand houses with their muscular parks, like Read, Capernwray, Hey House, Astley, Gawthorpe – built, enlarged and improved by successive generations over three or more centuries, to bear social witness to commercial success – still mark the landscape, and the ghost of that dominant past haunts the valleys and their surrounding fells. In the towns, however, you catch the authentic whiff of that extraordinary history only here and there.

Like the remains of a lost civilization, the great monuments of municipal pride – Decimus Burton's North Euston Hotel in Fleetwood, the Blackpool Tower, the Harris Public Library, Museum and Art Gallery in Preston, Manchester's Cathedral and Albert Square – are preserved within the shale of modern urban building.

However, it would be a profound mistake to assume the spirit and energy that sculpted the Leeds and Liverpool Canal, the Great Northern Railway, the docks at Wigan and Liverpool, that turned the waters of this fluid part of the world into steam and power, and set the mark of Lancashire upon the world, is gone.

One of the qualities that has invigorated this part of the country consistently since Roman times, and perhaps before, is the spirit of nonconformity, a spirit that found its natural expression in pragmatic action. Wander through the streets of any mid-Lancashire town and you will find the signs of successive expressions of nonconformist thought. In their time, Quakerism, Methodism, Congregationalism, Unionism, Socialism, the Co-operative Movement, all thrived here. Even the vigorous championing of Roman Catholicism in the seventeenth and eighteenth centuries, and with it the lost cause of the Jacobite kings, was a form of nonconformity with the prevailing conventions. Bloody-mindedness and independence seem the hall mark of Lancastrians in general, and of the Ribble valley in particular. All this you can see as you walk the streets of Longridge.

On Chapel Brow at the top of the town is the short, square tower of the Anglican church of St Lawrence. At the bottom of the town, on Derby Street is the soaring spire of St Wilfrid's, which serves the Catholic community. The Methodist/United Reformed chapel is in Berry Lane. Perhaps most remarkable of all, and the strongest evidence of the independence of mind and spirit that invigorated people of the area, is the short terrace known as Club Row. These cottages were built between 1794 and 1804, financed by twenty men who banded themselves together to form a proto-building society. Each man contributed a guinea a month towards materials and construction costs. The men acted as their own labour force, and then, as each house was finished, held a ballot to decide who should move in.

Just as the nonconformist vigour of Lancashire at large has left its mark on Longridge, so Longridge has left its mark on other parts of Lancashire. Longridge gritstone had long been used for house and farm buildings in the area, but the rapid expansion of industry in the nineteenth century prompted a parallel growth in municipal building. Quarrying became a major local industry as gritstone from Jeffrey Hill was carved into monuments to civic pride all over Lancashire.

At the same time, cotton mills flourished, and with them other industries, tile-making, brass and iron foundries, were set up. In spite of all this commercial activity, Longridge never became as significant as, say, Bolton or Bury or Clitheroe. Longridge, in a sense, was a benchmark of ordinariness. There was,

there is, nothing remarkable about Longridge. There are thousands of Longridges in Britain, decent, orderly, girdled by their moats of light industry – a timber yard, a fork-lift truck depot, warehouses. Within this outer ring there are substantial new estates, with well-kept gardens and modern playgrounds. They are places that get on with life, uncelebrated by all except those who live in them.

There are five roads into the town, and each represents a different strand of the region's identity. The B6243 comes in from the south-south-west, from Preston and Grimsargh. Take your place in the convoy of juddering 40-tonne juggernauts, and it will take you past the industrial shanty towns called 'business parks' and 'enterprise estates'. In fact, it skirts the lower edge of the town, sending a spur road into the centre, before it carries on to Hurst Green and Clitheroe. Then there's the B5269 from the south-west, which runs from Broughton, through the pleasant farmland around Grimsargh. Coming round the compass, there's the lane that links into the maze of small roads that criss-cross the less prosperous farmland of the Loud valley, between Whitechapel and Chipping. And finally there's Higher Road, which runs out of the town up Jeffrey Hill and away to the austere splendour of the high fells.

Follow Higher Road to where it bends to the left, and at the corner, set back on the right, is another nineteenth-century stone house, solid and serious, white-faced and with 'AFTJ 1808' incised into a stone on the front wall. Once this was the Quarryman's Arms. Now it is Paul Heathcote's restaurant.

Heathcote's would be remarkable enough for its success. It is more remarkable, however, for the manner in which it has achieved that success. Paul and his team draw on local products and local producers to create a style of cooking which, whatever it may owe to European culinary development for its techniques and its sophistication, quite clearly has its roots in the traditions, flavours, textures, patterns of English cooking.

In truth, Paul is doing no more than what French chefs have been doing for several generations. He is renewing the cooking of his region – *la cuisine du terroir*, as the French would say. He is not alone in this. There are a number of younger chefs who are turning back to their own culinary culture, learning from it, finding new ways to express it. At times, it seems we have largely lost touch with our own culinary culture. The people who do prepare food tend to use the word 'cuisine' rather more frequently than they do the word 'cook'. There is a greater knowledge about the qualities of different extra-virgin olive oils than there is of the qualities of potatoes. Supermarket-bred gourmets can tell the difference between a mangosteen and a rambutan, but not between a mulberry and a medlar. People stir-fry more readily than they stew, bake cheesecakes with gusto, but blanch at the thought of Eccles cakes.

That is not to say we have abandoned English cooking altogether. We fall upon it as we would an old friend when we do stumble across fish and chips, steak and kidney pudding, pies, sausages and sweet puddings. It is when we move away from the province of puddings and other familiar dishes that we begin to lose our bearings. Somehow we have lost confidence in what we once ate and the way we once cooked. Consequently, our own cooking has not progressed in the same way as it has in other countries. It has remained inert, set in aspic. Indeed, few people could actually define the qualities that distinguish

British cooking – not that spurious invention, 'Modern British Cooking', which has little to do with Britain or modernity – let lone English cooking.

For a start there is something distinctive about the shape of an English meal or even a dish. Italian, Indian and Chinese – even French and Spanish – meals are rectangular. They consist of a series of courses, none of which is of greater importance or has greater weight than another. A traditional British meal is pyramidical. We have a starter, a main course and a pudding. The main course is well named. It is the apex of a meal in every sense. Frequently it itself comes in the form of a pyramid, with many elements heaped on the plate. Think of the roast beef with Yorkshire pudding and roast potatoes and carrots and parsnips and Brussels sprouts or cabbage and gravy and horseradish sauce and mustard.

Such an assembly of elements all on the same plate is unthinkable in Italy, for example, where if you ask for a grilled veal chop it will come alone and unadorned, except, perhaps, for a slice of lemon. Vegetables will be served separately as well as separate from each other.

Of course, the nature of English cooking begins with the ingredients that are typical of our country and our climate. If asked to name classic English vegetables, most people would probably say cabbage, potatoes, parsnips and carrots. Asparagus has its season, and, in some places, new season's peas and broad beans are a treat; but, on the whole, not for us the artichoke to serve with a vinaigrette, or cardoon, or French bean, or brilliant red tomato. You can't just take a sublime ingredient and plonk it on a plate. We do not have the weather to produce the intensity of flavour required. Our stock vegetables need cooking.

To transform a cabbage into a higher gastronomic experience takes imagination. To make a carrot a cornerstone of culinary culture demands patience and discernment. The same is true of our fruit. Rhubarb is a fine natural product, but you just can't eat rhubarb in the same way you can peaches or melons or grapes. Nor are we disposed to wrap up our meats and fishes in elaborate sauces. We wish them to stand proud when they are good enough to be roasted. The cheaper cuts need longer and more considered treatment. So the single most important defining characteristic of English, even British, cooking is that the sum is greater than the parts. On the whole, the elements of any particular dish come together in the cooking process, reconcile rather than surrender their individuality within carefully controlled circumstances, participate in what a friend of mine once notably described as the polite exchange of flavours.

The consequence of this is the creation of a link between the elements of a dish, flavours shared by the potatoes cooked in the fat from the beef, the gravy from the chicken moistening the vegetables, dripping being rubbed into the flour to make the paste for steak and kidney pudding, the alliance between onions, potatoes and lamb cooked together for Lancashire hot-pot. Clearly, too, season, location and experience have established certain combinations – bacon and cabbage, tripe and onions, pork and apple for example – as marriages made in some culinary heaven. And that is where we have allowed them to rest. But culinary marriages, like human ones, need to be worked at if they are not to stagnate and cease to satisfy.

The satisfaction of the food at Heathcote's lies in the fact that it is not fossilized, it is not a monument to culinary archaeology. Because Paul and his

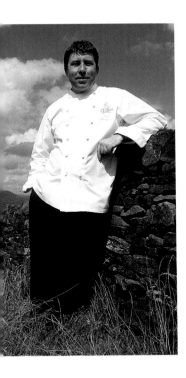

brigade can bring the whole battery and science of modern *haute cuisine* – as well as their own culinary imagination – to bear on indigenous ingredients and dishes, what they create is as sophisticated as anything produced in this country. Yet it is English. It could not have been produced by a Frenchman, an Italian, a Spaniard, or a chef of any other culinary culture.

It helps, of course, that virtually all of Paul Heathcote's primary ingredients come from within an area defined by what you can see from Jeffrey Hill. In many cases he has been instrumental in their development. His ducks and geese come from Goosnargh, lamb and beef from Clayton-le-Moors, vegetables from Preston, fish from Fleetwood. The Lancashire cheese on the cheeseboard is made by Mrs Kirkham, just outside Goosnargh. Game is brought down from the fells in the Trough of Bowland, deer from the woods around the golf course on Jeffrey Hill. Their own particularity imparts individuality to the dishes in which they appear.

You can trace traditional combinations and the flavours that reconcile one ingredient with another, albeit with a refreshing touch of imagination and technique: roast suckling pig with baked apple, braised cabbage with smoked bacon and herb juices; pressed ham terrine with parsley potatoes and mustard dressing; or partridge with walnut mashed potato, chicory, candied onions and its own juices.

This last dish is a classic example of how taste and imagination and craft can bring the gloss of supremely sophisticated cooking to a combination of familiar ingredients. The partridge meat is carved off the carcass. The carcass is then left to steep in the game sauce that has already been prepared, together with the walnuts. The complementary flavours of these two ingredients infuse the sauce, linking it back to the other ingredients. It is a simple touch, but one that elevates the dish to a more satisfying level.

You can appreciate, too, how the alchemy of technology and taste underpins the food at Heathcote's, in the potato broth with asparagus and wild mushrooms; the pig's trotter stuffed with ham hock and served with a pea purée and onion sauce; the black pudding with crushed potatoes and baked beans; lobster with celery and cabbage; skate with a tartare of mussels and parsley; Goosnargh duckling with cider potatoes and a confit of parsnips; and wild strawberry trifle. They have all, however, been transformed into subtle and sophisticated experiences while remaining true to the area which produced them.

Lancashire, like other counties, has remained true to its own regionality. You can still quite readily find Manchester pudding, Manchester tart, Orkskirk gingerbread, Preston parkin, Morecambe Bay shrimps, Bolton brewis, Goosnargh cakes, Eccles cakes, Bury oatcakes, Bury simnel cake. Modern tastes and abundance may have dented the popularity of the traditional cooking of economy and thrift – cow heel pie, tripe and onions, weasand, black puddings, hot-pot, brawn, meat and potato pies, but not to the extent that these dishes have become as rare as the bittern or the natterjack toad. They survive because they are an expression of place and of community.

The same elements of place and community run through Heathcote's staff and customers, each contributing to the character of the whole. Heathcote's is Lancastrian both by design and by nature. It could not be anything else.

Spring

The spring is coming by a many signs;
The trays are up, the hedges broken down,
That fenced the haystack, and the remnant shines
Like some old antique fragment weathered brown.
And where suns peep, in every sheltered place,
The little early buttercups unfold
A glittering star or two – till many trace
The edges of the blackthorn clumps in gold.

YOUNG LAMBS, John Clare

Cooking a Classic
Preparing a Signature Dish

BREAST OF GOOSNARGH
DUCKLING, WITH FONDANT
POTATOES, DUMPLINGS MADE
FROM THE LEG AND MEAD-
SCENTED SAUCE, PAGES 60-61

The front of the Paul Heathcote's restaurant is bright with yellow, cream, white and bronze pansies, in beds along the base of the white-faced building and in the window boxes at eye level. Layers of cloud move smoothly overhead. The sun breaks through, casting long lines of light and shade in the kitchen before being snuffed out again.

One of Reg Johnson's ducks rests on a red plastic chopping board on the stainless-steel work surface. It is plucked, naked. It looks a bit like a parcel. It has a purposeful order about it. The breast is plump and curved. The skin of the bird has a curious quality of inertness, white with a slight trace of cream, like lard, meshed with dimples where the feathers were once set. The legs are tucked in neatly on each side.

'Breast of Goosnargh duckling with fondant potatoes, dumpling made from the leg, roasted turnips, beetroot, caramelized apple and cider sauce' reads the entry on Heathcote's spring menu. 'When we first start to develop the principles of a dish, I tend to look at the negatives, at the things that put people off and ask myself, "How can we avoid that?". With duck you'd say that it was fatty, that it can be tough.' says Paul Heathcote.

He tips the duck on end and lifts the flap of skin that once covered the neck. He runs stubby, powerful fingers over the breast, working his fingers under the skin, feeling for the breastbone. He looks less bulky than he did when he took the field for Chipping against Grimsargh in an evening cricket match yesterday, but then he was wearing two sweaters, a shirt and a vest; and needed every one of the layers. Spring has been a bit of joker this year. May weather came in April and April weather in May. Blue skies and brilliant warmth were brushed aside by rain, sleet and then snow. But it does seem to have settled in now, though, even if the season's sweet vanilla freshness is tempered by an edge of cold on the wind.

Paul presses his fingers in firmly on either side of the curved breastbone. He slips the end of a knife into the flesh along one side of the bone, and swiftly runs the blade up and down its length. He repeats the action on the other side. He puts down the knife and slips his fingers into the cuts and behind the bones. Grimacing slightly with the effort, he pulls the wishbone away from the securing sinews, and out.

Chipping lost comprehensively come 8.30. Paul was not pleased with the result or his performance. He does not like losing at cricket, at squash, at business – but he is not the man to let such things prey on his mind. Moaning is not part of his nature.

'Putting the dish together didn't seem that difficult, in truth. The only time I look to put fruit with meat is probably duck. I wouldn't rule it out with other meats. It can be nice, but it doesn't appeal to me at the moment. But duck does, and putting it with apple seems natural to me. And using cider seems relevant.

I think it came about because I thought, "What can we do with cider?" It's a British, an English thing, and a natural link with the apple.

'We introduced the apple about three years ago, but the dish is very similar to one we used to do seven years ago, when we first opened. We put a kind of layer potato cake underneath it in those days.'

Now he turns the duck on one side, and levers the leg away from the rest of the carcass, so that the skin shifts and stretches. He runs the glittering thin blade around the semicircle of the thigh. The creamy, white skin opens. A thin line of burgundy-coloured flesh appears on the edge of the cut.

He pulls the leg hard out and down. The leg flaps limply as the ball comes out of the socket. He cuts down firmly through the skin that still holds it in place. The leg is now free. He trims off some of the fat and lays it on one side. Then he turns the duck on its other side and repeats the operation. The plump parcel now looks distinctly streamlined. Without pause he hefts a massive chef's knife, cuts heavily down through what he calls 'the undercarriage', the cartilage that forms the base of the duck. The whole breast, the double crown as it is known, is still on the bone, but free.

'If you roast a magret, a breast, off the bone, like some people do, it curls up and you get something about half the size, and tough.'

Paul chops up the carcass into small pieces, the knife blade crunching its way through the bone. These will form the basis for the sauce.

'I cut the carcass up quite small because the smaller you get the bits, the more colour you can then get on them when you brown them. The more they colour up, the better the colour of the sauce at the end. And it makes it easier to extract the flavours.'

He cuts away the skin and fat from the legs, until all the burgundy-coloured flesh is exposed. With a small knife he trims all the flesh off the bone, until he has a small glistening mass of shreds and lumps of raw meat. He moves this to a blue chopping board and reduces it to fragments with a series of rapid, rhythmical snaps of the big knife. He works with the relaxed ease of long practice.

AFTER REMOVING THE LEGS FROM THE DUCK, THE PARSON'S NOSE IS CHOPPED OFF (BELOW), FOLLOWED BY THE WINGS (RIGHT)

OPPOSITE:
THE ROASTED DUCK IS
REMOVED FROM THE OVEN TO
SEE IF IT IS COOKED TO THE
RIGHT STAGE

Using a dish cloth to protect his hand, he pulls a blackened frying pan off a stack of them kept in the oven so that they are always warm. Almost all chefs work with drying cloths tucked into their aprons so that they can handle the pots and pans, the handles of which are always searing. He clatters the black frying pan on the heavy metal surface of the cookers and pours a thin stream of olive oil into it. The oil slithers off to the sides as soon as it hits the heat.

Paul tosses the whole breast into the pan, skin-side down. There is a burst of sizzles. The inverted side of the breast looks like the model of the hulk of an old sailing ship, the little needle ribs of the bird like the ribs of the hull. It will stay in the pan for couple of minutes to take on a golden amber colour, draw out some of the subcutaneous fat and begin to cook the flesh. While the duck breast crackles away cheerfully, with an easy, rippling motion of the knife he rapidly peels, quarters and dices a carrot, two celery stalks and half an onion.

'I tend not to use leeks. If they get overcooked or stewed, you can taste them right through the sauce.'

Swiftly, he uses the broad blade of the knife to scrape the chopped vegetables into a small battered colander, silver with use and repeated washing. He crushes a clove of garlic and tosses that in. Then in go a couple of bay leaves and a branch of thyme.

A second blackened frying pan clatters on the hot plate and is slicked with another cascade of olive oil. He tips in the dismembered bits of duck carcass, stirring them over and over to get them covered in oil, and then leaves them to brown with a rapid sputtering.

The browning on the surface of a piece of meat is caused by the caramelizing of sugars in the liquids held in the muscle fibres, which are drawn to the surface by the heat. This is known as the Maillard Reaction. Even the air-conditioning cannot dissipate the rich toffee smells of the Maillard Reaction.

He checks the duck breast. The skin has gone a luxurious golden brown, with a slight path of darker amber patching part of the central bone. It is two minutes since it first thumped into the hot oil. Paul moves the pan down to the oven to continue cooking more gently. There is no precise temperature gauge on the ovens, although, like the hobs, their general heat is far higher than anything to which the domestic oven can aspire. Chefs get to know their ovens through experience, and time their food accordingly.

'It'll roast skin-side down for about fifteen to eighteen minutes altogether.' He turns the browning bits of carcass over again with a wooden spoon. There is a quick flutter of blue flame like St Elmo's fire as the fat catches light. It dies down as quickly as it caught.

He comes back to the work surface and rapidly peels a potato, cutting off the ends and trimming it with a knife. With a pastry cutter, he presses out one thick puck of tuber. One fondant potato per root, that's the average. On a normal service, the kitchen may get through fifty or sixty fondant potatoes. But the unused bits aren't wasted. They go to make crushed potato, mashed potato or chips for the staff meal, depending what's on the menu.

So he has a single, short, thick, ivory-white disk of potato. He reaches for another pan, a small copper saucepan. Cooks tend to be profligate with pans. They don't have to do the washing up. The potato goes into a pan with a brick of

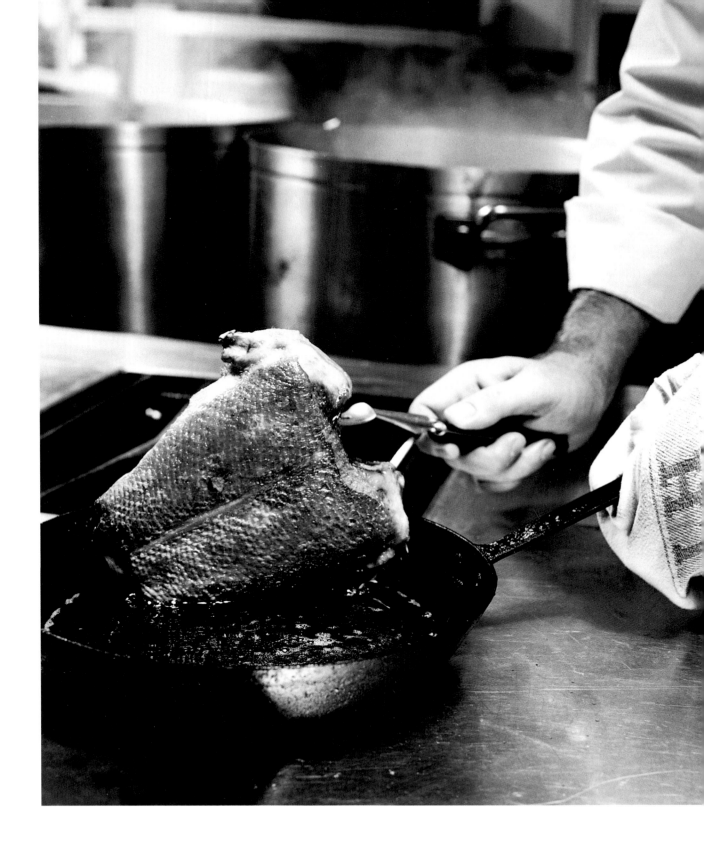

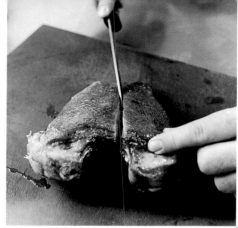

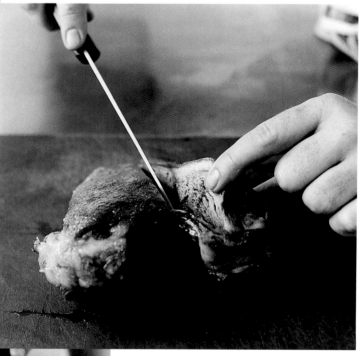

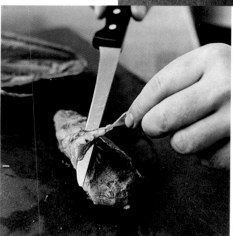

REMOVING THE DUCK BREAST FILLETS FROM
THE BREAST PLATE: FIRST WORK THE KNIFE
DOWN EITHER SIDE OF THE BACKBONE (TOP)
AND THEN SLOWLY EASE THE BREAST AWAY
FROM THE BONE EITHER SIDE (ABOVE). IT IS
IMPORTANT THEN TO TRIM OFF THE SILVERSKIN
SINEW, OR THIS WILL CAUSE THE MEAT TO
CONTRACT WHEN COOKED FURTHER

butter the size of a child's fist. Paul salts it with the characteristic trail between forefinger and thumb from a foot or so above the potato. He seasons everything in this manner because it distributes the salt more evenly.

He sloshes cider and water into the pan, and moves it to the hottest part of the hot plate. It has to boil as rapidly as possible, to cook the potato, to infuse it with flavour, to evaporate the water and to colour it a clear toffee brown. The butter melts rapidly, forming a pattern like a yellow snake's skin on the surface.

'The fondant potato came through the craze everyone had for them a few years back. I first came across them about eight or nine years ago at Broughton Park, when Stephen Docherty came up to cook. He was head chef at Le Gavroche in those days, and he was doing a daube of beef which he'd brought up ready-cooked. I asked him what other ingredients he needed, and he said potatoes and a box of butter. He specified this special Normandy butter. He used copious quantities to cook these bloody potatoes. He went through half a box. Anyway, it was just a matter of adapting that basic technique. You can cook them in anything with butter – cider, apple juice, anything.'

He turns back to the work surface, selects some Granny Smith apples, rapidly peels and quarters them, then flicks out the cores. He carefully pares away a thin strip off each sharp edge so that they become slightly angled. Paul Heathcote likes Granny Smith's. Grannies hold their shape and bring an acidic sweetness that helps balance the dish. The apple peelings go into the colander with the chopped vegetables for the sauce.

He pulls yet another blackened frying pan from the oven and whacks it on the hot plate. He dribbles another spoonful or so of olive oil into it, and this is soon smoking. He dusts some icing sugar over the hot oil. Immediately it melts, bubbles and begins to darken. He turns the apple segments into the pan, rolling them over and over with practiced flicks of the wrist. The apples start turning brown and then darken rapidly, as the sugar caramelizes on their surfaces. They are put to one side.

'If you didn't caramelize the apple like that, burning the sugar out, you'd end up with it being too sweet. It's the same with potato.' You begin to realize that the qualities of balance and flavour of cooking of the highest class lie in unremitting attention to all the details of a dish. Even small variations can unbalance the final harmony of flavours. This is not something the home cook naturally worries about. Nor should we. That's why we go to restaurants.

The nuggets of duck carcass have now taken on their own caramelized brown. To them he adds the mirepoix of vegetables, the apple trimmings and herbs, and stirs them so that they pick up a gloss of duck fat and juices. As the elements settle in the pan, they have the beauty of a Dutch still life and the air is suddenly full of the aromatic smells of thyme.

He takes the duck crown out of the oven and puts it on the side to relax. It has been cooking for a total of about fifteen minutes. It'll still be pink inside, almost raw in places, but that's fine. Each breast will be brought to the proper point for eating later on. Now it has to rest, to allow the partial reversing of the protein coagulation that has taken place during roasting, and let the muscle fibres – which had tightened up in the intense heat – relax, recover their fluids and change from tough to tender.

'If it hadn't been on the bone, it would be about half the size already. Don't worry if it's a bit underdone. It'll cook up under the grill at the end.'

He turns over the browning vegetables and herbs in the sauce pan. He checks the fondant potato, placid in its furiously boiling liquid. The cider-and-water mixture is already noticeably reduced and has been turned a rich buttercup yellow by the butter.

The kitchen is full of steam. At any one time the chef has to carry precise notes of the state of anything up to two dozen individual constituent parts of the dishes on the menu. Paul Heathcote looks relaxed, but his eyes are constantly alert and focused.

Now it's time for the choux-pastry dumplings. He melts another small brick of butter in a cup or so of water in a saucepan on the hot plate. He carefully sifts drifts of flour into it, then stirs the mixture rapidly and vigorously with a wooden spoon black with use.

He puts this choux pastry mixture to one side, turns the vegetables and carcass bits over and over. The vegetables are touched with brown here and there, and they are glossy with the fat released by the meat. They are beginning to develop a sweet, roasted flavour. He adds a glug of cider, just covering the meat. The clear amber liquid quickly darkens as Paul scrapes the bits off the bottom of the pan, and soon it is seething away.

Without pause, he adds two whole eggs to the dumpling mixture and beats it again, his hand a blur. The albumin gives the dough a sheen. He scrapes in the chopped leg meat, and beats again, and then adds a couple of tablespoonfuls of chopped parsley, beating between each. The mixture is a creamy yellow, flecked with green and brown.

'I've been thinking of doing a version with orange and cardamom, a variation of duck *à l'orange* type of thing. In that case, I'd probably add coriander to the dumpling instead of the parsley. Or a little tarragon might go nicely. Some things just seem to go together.' And some chefs can just taste things in their head.

The tempo is beginning to move up a notch or two. Paul checks the pan with the sauce ingredients in it. He adds a bit of water. He moves the duck crown to the chopping board, steadies it with his left hand, rapidly slices down the centre of the breast with a thin-bladed knife. With rapid flicks of the tip, he disengages the flesh from the bone underneath. One breast is now free. You can see the deep, moist burgundy of almost raw meat at the centre, edging out through pink to pinky-brown towards the skin. The skin itself is a deep golden-brown.

Paul trims off some of the fat around the edges, shaping the breast into something more regular, almost geometrical. He cuts out the sinew that runs underneath the breast meat, where the wing once joined the breast. They would tighten up when the breast is heated again later, forming a tough, chewy knot.

'The relaxing is something I learned through Sharrow Bay, the Connaught and the Manoir. They all had the same principles. Perhaps removing the sinew is taking that little bit of extra care.'

The liquid around the fondant potato is almost gone. The potato itself has begun to take on the colours of yellow and amber of the butter and cider. Paul tests whether the vegetable is cooked with a larding needle.

From a drawer in the chill cabinet, he takes out four tiny turnips like fat white

buttons which have already been trimmed, peeled and blanched. He finds a plastic carton of turned and trimmed baby beets, which have been cooked and cooled in chicken stock.

In the pan in which the sauce is gradually taking shape, the colours of the vegetables seems to have leeched out into the liquid. They are pale, washed out shadows of their former selves, and the sauce is looking warm, dark and robust. He strains off the liquid into another saucepan. The yellow fat lies on the surface with the flattened-out quality of a photograph taken from a satellite. He tips up the pan and carefully spoons off the fat. He checks the potato again. It has an orange-amber crust on all sides. The liquid is reduced to a heavy honey-brown, viscous froth. He moves it off the heat to keep warm.

It's time to cook the dumplings. That means another pan of salted water. While that comes to the boil, Paul spoons the dumpling mixture into a piping bag. The water in the saucepan for cooking the dumplings is now burbling away. Holding the piping bag in his right hand, he squeezes freckled dough out through the nozzle, slicing it off into sections about 3 cm long as it emerges. The sections plop into the almost boiling water, sink to the bottom for a moment, and then bob back up to the turbulent surface, swirling about in the current.

'We had already done these dumplings a long time ago. In fact, they were on the very first menu when we opened, with wild mushrooms and foie gras and Madeira sauce. They didn't last very long.'

As soon as the dumplings float, he skims them off, sliding them into cold water to stop them cooking any more and to keep them fresh. Then they are left to dry on a piece of blue kitchen towel.

More pans, to heat the turnips in a little butter, a second for the beetroot, a third for the dumplings, a fourth for a few leaves of luminous jade-green spring cabbage that has already been blanched. The heat coming off the hot plate has a dense, solid quality to it.

The breast goes under the grill to finish cooking. The burgundy bloom at its centre will soften and modulate into the moist grey of cooked meat. The skin will crispen and go peat brown. The florid, creamy smell of duck billows out.

Like a juggler, Paul flips the dumplings over in their pan, the beetroot in theirs, the turnips in theirs. The dumplings puff up like doll's bolsters, with a neat line of brown running down one side. He fetches a plate from the other side of the room. It is quite deep, its pure whiteness startling against the scarred surface of the cooker on which it rests.

In the plate, he arranges the cabbage leaves first, with considered delicacy. He places the beetroot with careful deliberation. Their colours glow the more vividly against the white background. Now the turnips, then the dumplings with the tan lines down the side, followed by the fat amber commas of apple. It's like watching a jigsaw being put together. You realize that the visual relationship between each element has been meticulously thought out. He gently levers the potato up from the goo at the bottom of its pan, and lays it on top of the cabbage.

All this time the duck breast has been crackling away under the grill. He lifts it out and places it on a clean orange chopping board. He grips one end with a cloth to hold it steady, and then slices it across and down at an angle into eight. Salt, pepper, and then, using a palette knife, he lifts it and drapes it over the

fondant potato, holding it in place for a second or two, pushing down gently with the palm of his hand. The slices looks like interlocking sections of glossy brown armour.

'The reason you cut it at the angle like that is that when you put it over the potato, it gives it some kind of structure to hold it on top, otherwise it'll just fall off. It also means you can season each slice more accurately. He tastes the sauce, swirls it around and pours it over.

The frame of the plate now holds the dish like a picture: the duns, browns; the creamy, green-flecked dumplings; the imperial purple beetroots; the brilliant green corners of cabbage leaf; the contrived topography of shapes; the glistening pool of sauce; the little tendrils of steam rising up, carrying a fugue of odours. The arrangement is anything but casual. The relationship between each element has been meticulously thought out, but the result does not have the contrived artistry that defies the eater to meddle with the artwork. This is a dish that has been fashioned to be eaten.

The dry skin on the first slice of breast rustles faintly as you bite through it. The flesh underneath has a melting tenderness. It almost dissolves into fibrous moistness. The flavours fill the mouth with the subtle sweetness, lightly overlaid with musk, like smoke, and the tang of apple through the sauce. Now a slice of duck and a slice of cider-cooked potato together. The tang of apple is more insistent, but made round and rich with butter. It envelopes the duck without submerging it. The texture of the potato is firmer, dryer than the duck. They push against one other for a moment, then combine, dissolve.

Take the two other root vegetables in quick succession: a turnip, acrid and sweet and earthy at the same time; beetroot, fruity and sweet and earthy. The flavours link to each other and through to the duck and potato. It's like hitting individual notes in a harmony.

The dumplings next, one, two, three of them. They are crisp on the outside, fluffy dandelion heads inside. They release light herbal breaths of parsley as you bite through them, and carry the nutty grains of duck leg flesh. Now for a sliver of apple. It crunches, green acidity gushing past the sweet burnt toffee coating it. Against this the cabbage tastes almost neutral, but with the duck it holds a halfway house between the grassiness of the parsley and the earthiness of the root vegetables.

It is subtle, allusive, unassertive in a dish of strong individuality, where the idiosyncrasies of each ingredient are reconciled either through their shared characteristics – the provenance of the root vegetables – or through the cooking process – cider and apple and the duck-stock sauce. The consequence is a balance of flavours, of sweetness and acidity, of the opulence of the meat and the austerity of the root vegetables.

This is classically English in the range of ingredients and flavours. They are consistent with our climate and our seasons. You can trace their place to the cooking of Saxon and Norse invaders. Apples, potatoes, turnips, cabbage have been staples throughout the country, throughout the centuries. There is nothing novel or exotic about anything in this dish. Even the duck owes more to Norfolk than it does to the more conventionally favoured Barbary.

The finished dish, too, has all the hallmarks of English classicism. Its shape;'

with vegetables, meat and sauce coming together on the same plate; the way in which elements link to one another, the textures and well as the flavours, these are things we recognize as familiar.

However, the techniques employed to achieve the characteristic integrated nature of the dish are those of any professional kitchen, i.e. French in origin – preparing vegetables individually; the choux pastry for the dumpling; making the sauce separately through browning the ingredients and fierce reduction; the different techniques used to cook the duck; the slight undercooking of the breast; and even the way it is sliced. These are all French. This is the way a national cooking culture can renew itself, bring new influences to familiar ideas, adapted, modified refocused so that the familiar ideas are themselves transformed.

Familiar or unfamiliar, all dishes still have to subscribe to basic laws of restaurateuring, the most powerful of which is the law of economics. 'You've got the duck, which will cost you the best part of £5. So each breast will cost you £2.50, for the sake of argument. No, say £2, because you'll use some of the leg meat in the dumpling, and the rest we'll confit and use in the canapés. Half an apple, a bit of beetroot, a couple of turnips, a bit of cabbage, and probably about 50p for the potato, what with the butter and the cider. So, say about £1 on the garnishes. Then you've got another 50p in the sauce. Altogether, then, the basic cost of the dish is £3.50, probably more like £3.75. Normally one person would be responsible for the butchery and cooking the ducks. We can get through seventeen of them in a week. The same person would make the stock, 144 pints of it at a time. And another guy would do the vegetables. And you'd need two people to put it together.'

The plate is cleared. Not a trace remains except for the abstract smears of residual sauce and the knife and fork neatly laid together. 'I've yet to eat any duck dish in a restaurant that I feel as satisfied by. We've done variations. We've done it with jasmine, and there's this orange-and-cardamom idea, but I can't see any point in changing the basic recipe, unless it can satisfy me as much. Having said that, I had a duck breast the other day in a kind of spiced red wine sauce, and that got me thinking ...'

Paul Heathcote

A Chef for All Seasons

Paul Heathcote on cooking: 'One of the bees in my bonnet is that too many chefs want to cook what's in fashion. They want to put plenty of olive oil and roasted peppers on to their menus, and every restaurant you go to has a similar kind of feel to it. Why can't we use things the same way chefs do in France and Italy, in the villages, bistros and places. They cook with what their suppliers have in season.'

Paul Heathcote on management: 'I'm a big believer in people having responsibilities.'

Paul Heathcote on customers: 'It's about making you feel at ease, as if you want to enjoy yourself.'

Paul Heathcote on Paul Heathcote: 'People have said that I'm a great catalyst, but I don't know about that. I think it's a matter of doing what you want. Because I wanted certain products, I was prepared to go to all lengths to get people to supply them.'

The first thing that strikes you about Paul Heathcote is his modesty. There isn't much of the media-star, mega-chef, temperamental creative artist about him. You get the impression he isn't too different from you or me.

He has a formidable physical presence, barrel-chested and powerful, he moves with immense determination, if not exactly panther-like grace. His face is open. He smiles easily and often. He is immediately approachable and likeable. Everybody says so, friends, competitors, colleagues. In summer, he plays cricket for Chipping. When he can't play cricket, he plays squash for Longridge. He follows the football fortunes of Bolton. He's married. He's got a daughter, and his wife is pregnant again. He's a good bloke.

You almost have to shake yourself that this bloke has more accolades for his cooking than most of us have had hot dinners. This bloke has squeezed stars out of the notoriously francophile *Guide Michelin*, but doesn't cook French food. This bloke has two very successful brasseries, as well as the smart gaff on the hill in Longridge, and that's in between the TV cook-ins and the charity cook-up and chairing this committee and that for his industry. This bloke has reinvented what we understand as English cooking practically single-handed, for heaven's sake! So you have to look at him again and ask, where did that all come from?

In truth, as Paul would say, it's all a bit of a mystery. Ask him why he turned his attention to English cooking specifically, and he says, 'To be different. It's a challenge. No one else is doing it.' Ask him how he comes up with ideas and he'll tell you a long story about eating Häagen-Dazs strawberry cheesecake ice-cream, and how that gave him the idea for the apple crumble ice-cream, which was 'bloody awful', which eventually became apple crumble sorbet, 'which is terrific'.

Read a cookery book? Oh, well, occasionally. Culinary archaeology?

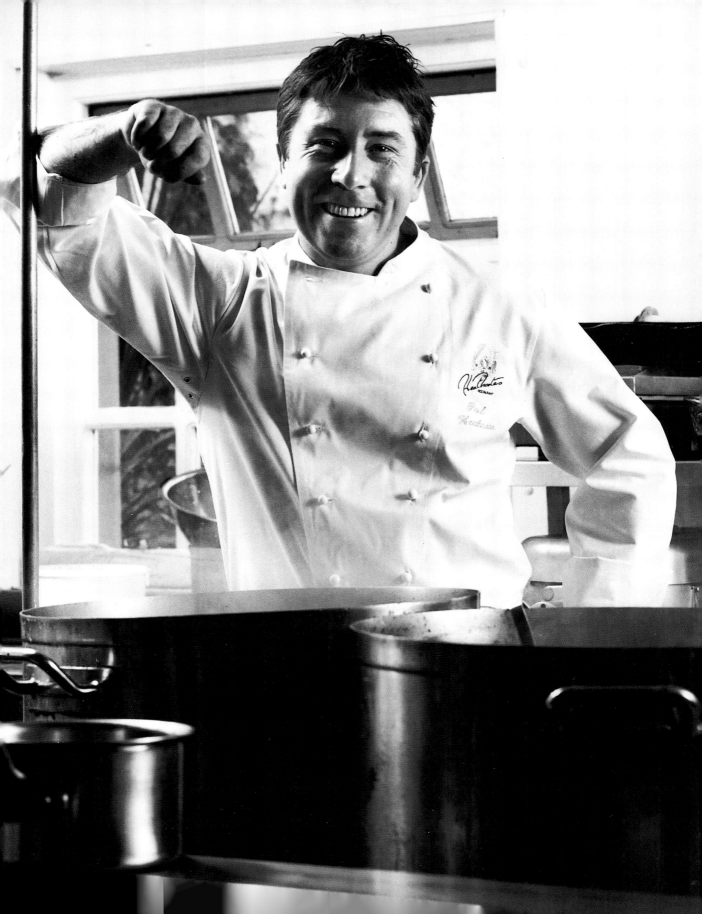

Thumbing through musty old tomes? Digging up long-forgotten recipes? Bollocks to that, only he's much too polite ever to say 'bollocks', except in the heat of the moment in the kitchen, when he'll say far worse. No, Paul is too pragmatic for fancy theorizing or posturing. So the ideas come from all over the place; what he's read, what he's eaten, what he remembers.

What he remembers ... what he remembers is the black pudding in Bury market, along with the weesand and the cow-heel pie. Now how do you turn black pudding into a star turn? That's an interesting one, the black pudding.

It all came about, he remembers, when he was asked to join a team of chefs going over to Champagne to show the Champenois that the British could cook as well as the French, and the fellow organizing suggested that they might like to run through the usual gamut of luxury ingredients, Paulliac lamb, foie gras, lobster, truffles and such, because the wines had already been chosen and Paul said he was damned if he was going to because these were all French ingredients and the French chefs could knock that stuff up any day of the week.

'So what are you going to cook, Paul?' asks his team-mate. 'Black pudding,' says Paul. The only trouble was, he had never cooked black pudding in his life. But, being Paul, he set about it, working on the dish for twenty days straight, until he got it right, until it became a classic.

To make Michelin-star black pudding, you stud it with sultanas soaked in white wine vinegar and bay leaves, and little chunks of blanched sweetbread, rosemary, thyme and rolled oats. You poach the full sausage, and slice it into thick discs. Grill those and mount them on a hummock of crushed (crushed, mark you, not mashed) potato, which you have boiled in their skins, and peeled and mixed with plenty of unsalted butter.

Along the way you have cooked some white haricot beans, and remember to reduce your veal stock along with more bay leaves, and you deftly arrange these around the potato hummock, along with some diced carrot and button mushrooms, and there you have it, black pudding of sweetbreads on a bed of crushed potatoes with baked bean and bay leaf sauce. Nothing to it, really.

What he remembers is fish and chips. Well, we all remember fish and chips, but what can you do with them? First off, you make sure your fish is a prime piece of cod, so fresh its pearly white flesh is taut and bouncy. `This piece of cod should sparkle at you. You wrap it in scales of potato, which have been blanched in chicken stock, and bake it until the potato scales are golden brown. You serve with buttery cabbage made slightly smoky with bacon, and with a sauce of lamb stock scented with rosemary. There you go, fish and, well, potatoes.

What he also remembers is his father cooking for the family on Thursday nights. 'You could say I owe my cooking career to tripe. My dad used to cook for us on Tuesday and Thursday nights. Tuesday and Thursday nights were Ladies' Nights in the Health Studio, and my mum used to go to help out. And my dad gave me and my sister, Karen, tripe. It stank the house out. The only one who benefited was the dog. He kept getting fatter, and we kept getting thinner. I reckoned I could do better.'

That's how it all started. Out of self-preservation he helped with the cooking, and found that he actually quite liked it. In those days, boys weren't really supposed to be interested in cooking, not at school anyway, and he wasn't

allowed to go in for domestic science classes, as they were then called.

Paul was born about twenty miles away from Longridge, in a back-to-back terrace with an outside lavatory in Farnworth, near New Bury, Bolton. New Bury wasn't very civilized in those days. 'It was the kind of place you didn't walk through at night in them days. Even a dog was no good because it'd get knifed. My auntie got through five of them.'

At school, he was more interested in fighting and being a guitarist and a goalie than anything else, although he was keen on art and design. This didn't go down hugely well with his mum and dad. 'They were worried I'd turn into a pot-smoking hippie.'

Meet his mum and dad, and you can see where Paul gets many of his qualities. The softer side, the warmth and humour, they're Brenda's, his mum's. The discipline, the sense of focus, the strength, they're Ken's, his dad's. Not that Brenda isn't without a pretty strong streak herself, and that Ken doesn't have his softer side, too, beneath the I'll-not-be-wasting-my-words exterior.

Ken Heathcote mixed brickieing and body-building with a good deal of success. At one point he was Mr Junior North West. Then he discovered an aptitude for running the gym in which he used to train. He had the inspiration of transforming this gym into a health centre, the first of its kind, at just about the time when Britons were starting to latch on to the health and fitness lark.

This was the beginnings of a business that eventually allowed the Heathcote family to move out of Farnworth, to the rather more salubrious surroundings of Bromley Cross.

On leaving school at sixteen, Paul showed that independence and bloody-mindedness that seems to be the hallmark of Heathcote males. 'He's stubborn, this one is,' says Brenda. 'Takes after his dad.' Instead of joining the family business, he struck out on his own, doing a three-year catering course at Bolton Tech. It wasn't that he didn't admire his father or the business that he had created. He just wanted to be his own man.

From college he went to a dead-end job at Lockerbie, just north of the border. It was while he was at Lockerbie that he had a Pauline conversion, when he met his parents for lunch one day at the Sharrow Bay Hotel on the shores of Ullswater in the Lake District. It's typical of the family that he should go there with his dad. Disappointment and disapproval are never allowed to get in the way of family loyalty or support. Paul has received unstinting support from both his parents throughout his life.

Sharrow Bay has been a haven of civilized values for fifty years. It was run until recently by the remarkable Francis Coulson and Brian Sack. Its charm, standards, comfort, warmth and very particular character opened Paul's eyes to the possibilities of his chosen profession, and provided him with the ideal he has pursued ever since.

'I'm strongly influenced by Sharrow Bay. I remember the first time I went there. I remember how I felt as I walked in, nineteen or twenty. I was quite insecure going up to that door. And people were smiling and bringing you in, and suddenly I felt at ease in spite of it having all these trappings and antiques. It was a lesson in what a restaurant should be.'

In fact, for two years he pursued a job at Sharrow Bay with characteristic

determination, being finally rewarded by a position in the kitchen there in 1982. There he stayed for two very happy seasons – 'Brian and Francis spoil their staff as much as their guests' – and began to learn about the higher nature of the hospitality business.

In 1983 he swapped the familial atmosphere of Sharrow Bay for the more exacting disciplines of London's Connaught Hotel. Whatever the demands of the more brutal kitchen culture of a large metropolitan hotel, the standards of the Connaught were those of the highest, in the grand traditions of French *haute cuisine*, and these added their own polish to his growing culinary skills.

He lived on £14 a week, supplemented by dinners when his father was in London, who, characteristically, had promised to take him out for a meal once a month. 'So he'd say, "Let's go to the Le Gavroche this time, or to the Savoy."' Perhaps most importantly he learned about discipline and authority. 'I learned how to use authority, how to tell someone what to do and get them to do it.'

Then, in 1985, he found his second profound culinary influence. He moved to Le Manoir aux Quat' Saisons at Great Milton in Oxfordshire, which was galvanized by the protean energies of Raymond Blanc. This is a kitchen through which have passed a good deal of the cream of chefs operating in Britain – Marco Pierre White, John Burton Race, Bruno Loubet, Richard Neat, Aaron Patterson and Michael Caines, among others, all of whom have gone on to run their own one-, two- and three-star establishments.

The contrast with the high-gloss regimentation of the Connaught could scarcely have been greater. Raymond Blanc's own approach to cooking is as mercurial as his personality. It runs along a knife edge between the brilliant and the merely very good. Recipes are never finished, never achieve a final form set in aspic. However, no matter how volatile and changeable the approaches to individual dishes might be, there has always been one constant running through Raymond Blanc's approach to cooking – 'taste, taste. taste'. You have to taste what you are cooking all the time. This is something that Paul instils into his brigade to this day.

He also learned about flavours, how to appreciate them and respect them,

how they can be enhanced, but never transformed. If you have the very finest ingredients, why turn them into something they are not? It may seem quite simple; the practice is much harder, but it is an approach which has come to pay spectacular dividends when applied to the often overlooked qualities of our own native products.

Raymond Blanc and Paul did not always see eye to eye. 'I'd always had this kind of robust side to my cooking, but at that time the fashion was for baby leeks and baby carrots everywhere, and *very* refined dishes. Anyway, I was sauce chef one day and I braised this oxtail in red wine, and we put a few baby leeks and carrots and turnips around it to make it look pretty. Then Monsieur Blanc came into the kitchen and created almighty hell. He threw the dish across the kitchen and said this wasn't the Manoir's style of cooking. That's changed a bit now.'

However, Paul's respect for the principles behind Raymond Blanc's cooking has not diminished, and he began to put what he had learned into practice when he moved back up north to Broughton Park Hotel near Preston in 1987. Broughton Park has been important in more ways than one. 'I suppose I came to a turning point in my career, when I needed to make a reputation for myself. There's no point in working in top-quality establishments and then not doing anything with it. It was a choice of whether to go to London or move back home. I came home.'

In the first place, it gave him the time to find the suppliers who could provide him with the quality of raw materials he needed, a quality and a range that were virtually unheard of in the Ribble valley in those days. Eddie Holmes, Reg Johnson, Chris Neve all go back to those days. 'When I moved from the Manoir to Broughton Park, my first introduction was to our poultry man, Reg Johnson. He was a farmer delivering turkeys and chickens, as he'd been doing for the last – oh, I don't know how many years. I asked whether he did corn-fed chickens. I'd been used to poulets de Landes or poulets de Bresse. When I asked him the question, he looked at me as if I had two heads or came from another planet.

'To his credit, he came back two weeks later and said, "About these corn-fed chickens, I've been doing a bit of reading up about them and I'd like to have a

go," and would I give an opinion on them. To start with, I know he had an extremely high mortality rate because he was using this very rich corn feed for the chickens. We slowly turned things around, and nine or ten years down the line we have fabulous corn-fed chickens, and ducks too, which he now sells all over the country. That's one of the reasons why I could never take Goosnargh chicken or duck off the menu. He showed loyalty to me. You've got to give it back.'

Broughton Park has also proved to be the most brilliant recruiting ground for his subsequent interests. Andy Barnes, his alter ego at Longridge; Andrew Morris, the manager at Manchester; Paul Wilshire, his sommelier at Longridge and now wine-buyer for the group; Geoff Bond, the group systems manager: all are graduates from Broughton Park. Most importantly, it gave Paul the opportunity to move towards the kind of cooking that has become his hallmark.

'We have very arable agriculture. There's an enormous amount of good dairy and good meat produce. We have a lot of good fish around. We are an island, after all. When you think of vegetables, they tend to be potatoes, carrots, swedes and such, aside from cabbage, and the very short seasons for asparagus and peas. We have less in the way of fruits too. There are soft fruits in summer, and apples and pears, and after that you start to run out of examples. So why not use what you've got?' Even if it means turning away from the staples of other multi-starred establishments.

One of the remarkable things about Heathcote's menus is the absence of luxury ingredients. There is usually one foie gras dish and one lobster dish. The ubiquitous pig's trotter is not stuffed with morels or sweetbreads or the fancy folderol, but with ham hock and sage. You're more likely to find cabbage and carrots as the seasonal vegetable elements in each dish, rather than anything more exotic. Potatoes may be Jersey Royals in season, or roasted in dripping at other times.

He's not rigid about it. There are any number of dishes which show Paul can turn his imagination to international influences as well as any chef, but it is in the taste and sophistication he brings to distinctively British ingredients and methods of cookery that his particular genius has made itself most evident.

All this he explains quite simply: 'Since I started, I picked up one or two influences, and they remain important to me. But my real heart lies in creating British dishes, Northern dishes in particular, because that's where my roots are.'

Still, to borrow £200,000 and set up your own, as he did in 1990 at the age of twenty-nine – in Longridge, in a recession – takes conviction to the point of fool-hardiness. Something like 80 per cent of all new businesses go bust within two years of starting up, and something like 40 per cent of that 80 per cent are restaurants. The failure rate is the highest of any industrial sector in the country. And, let's face it, whatever the attractions of Longridge, it does not leap to mind as the natural spot for a restaurant with the ambitions Paul Heathcote had for it.

It seemed even less of a good idea when, nine days after opening, on Friday, 13 July, brand, spanking new Heathcote's went up in flames. Not quite up altogether, as the firemen were able to put out the flames pretty quickly. The chef-proprietor and his staff had the place ready for business again in forty-eight hours.

Since that point, Heathcote's has been pretty well unstoppable – first Michelin star in 1992, Newcomer of the Year in the Catey Awards given by the industry to

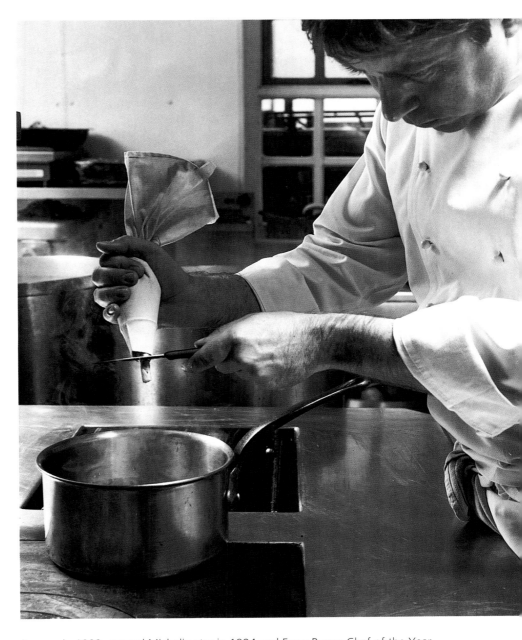

its own in 1992, second Michelin star in 1994 and Egon Ronay Chef of the Year, and so on. The critical recognition may be balm to the egotist's soul, but it butters no parsnips. There was no disguising the fact that running a restaurant of the quality of Heathcote's in Longridge was never going to be a financially rewarding affair, even with his mother doing the accounts, as she did until last year.

The economics are quite simple. In order to stand still, Heathcote's has to take £6,000 a week. That's just to cover wages, food and wines costs, laundry,

cleaning, wages, insurance, administration, and so on and so forth – before you start putting anything aside towards paying for re-covering the sofas in the reception area, a new set of chairs, a replacement mixing machine in the kitchen; and those come before the chef-proprietor can take anything out for himself.

Heathcote's is probably the cheapest restaurant of its quality in the country. That doesn't make it cheap, but by the standards to which it aspires and achieves it is very good value for money. Two related reasons for that are the position and the clientele. To charge more would kill the market it seeks to serve. If Heathcote's were in a comparable town in France, there would be signposts pointing you in the right direction from the nearest motorway access-point. Longridge itself would be plastered in more signs celebrating community pride and commercial interest. That is not the British way. The British way is to ignore success, to regard it as something vaguely embarrassing, particularly when it comes in the form of food.

It is equally British for Paul to show a stubborn obstinacy in refusing to let this lack of local recognition divert his energies. That's where the next quality comes in, the ambition. Friendly, accessible, unegocentric and amiable he may be, but you don't achieve what he has achieved without a pretty firm backbone, a good deal of confidence, a clear mind and a larding of ambition of one kind or another. It isn't an ambition to make money. It isn't even, really, an ambition to build an empire, or only coincidentally. It is to create something that other people recognize for its quality, to be the best, like his dad.

The cooking is only a part of this, although possibly the most important part. After all, it is responsible for Paul being where he is, for achieving what he has achieved. So he works closely with Andrew Barnes, whose feeling for the kind of food he wants to create is akin to his own. Between them they take the original idea and – bringing all that formidable skill and the resources of French haute cuisine learned in the kitchens of Sharrow Bay, the Connaught, Le Manoir aux Quat' Saisons, Broughton Park – polish it and perfect it until the dish takes on an entirely different lustre and complexity, until it sparkles on the plate and dances on the tongue.

However, great cooking is only part of the business of running a successful restaurant. The bankruptcy lists are full of chefs who can cook up a storm, but who cannot keep a similar degree of concentration on the accounts. For Paul, the trick is to maintain the standards suitable for a particular kind of restaurant and at the same time make money. A restaurant must run as a business. There's no point, in Paul's book, in having the best establishment in the world and going bust. That is unprofessional. Having the two brasseries now helps. The cash-flow these generate provides a wider financial base. They also help create a career structure for his staff.

The management structure in a kitchen is quite short – apprentice, commis chef, chef de partie, second chef, head chef, chef-proprietor, and that's it. It doesn't take that long for any reasonably talented and ambitious young man or woman to bang their heads against the management ceiling of a particular kitchen. You're lucky if you manage to keep someone for two years. That's two years of investment on the part of the owner, plus the time you need to spend training the replacement.

How much more sensible if you can offer a talented young chef a place at another contrasting restaurant that you own. You continue to get a return on your investment. You solve your recruiting problem for the second place. You are keeping a potential competitor from competing for the time being. And, naturally, you're furthering your staff's own culinary education.

Drawing on his father's own experience, Paul devotes a good deal of time to motivating his troops, encouraging them, setting them targets, giving them responsibilities, keeping them moving along. He is also extremely loyal. There is a practical side to this. It's not that easy to attract top-quality chefs and waiters to central Lancashire, even if the restaurant has Michelin stars. So, if you find them, you want to keep them.

However, his loyalty goes well beyond what is normally expected. He will stand by a member of staff through difficult personal patches, even when they are adversely affecting his or her performance. Conversely, his judgement is decisive if he feels someone has let him down. Either way, he thinks through each course of action he is going to pursue. He does nothing precipitately.

It is part of Paul's all-round professionalism that he does the TV appearances, the flesh-pressing and public duties. He deals with these matters with cheerful ease and charm. But he does not live for this kind of exposure, unlike some of his peers. He does not yearn for the limelight. He does not have an ego that blooms with the arc lights. He will do most things necessary to keep his restaurants thriving, as long as they don't involve absurd degrees of prostitution and humiliation. In spite of all the trappings of rock'n'roll cheffery, however, he is a very private man.

He keeps his feelings well guarded. He keeps in close touch with his mum and dad, as well as with his sister Karen and her family. He has a group of very close friends who have been such for many years. In 1995, he married Gaby Bellini, bringing to an end a period of fairly riotous bachelor life. He credits her with bringing him a new stability. Gaby also has a background in catering and that, together with her involvement in Paul's burgeoning empire, pre-empts pressures that many marriages in the restaurant world feel only too keenly. They live in a house well away from the hurly-burly of work, and Paul devotes as much time as he reasonably can to his family. Given the enormous pressures on him, he is remarkably well balanced, and has a remarkably balanced life.

There is, however, no getting away from the fact that what he does is immensely demanding. This does not disturb him. The penchant for hard graft is another family trait. 'We didn't think of it as hard work,' Ken Heathcote said about his own early struggles setting up his business. 'It was necessity.' And Brenda added, 'You were just expected to get on with it.'

Eddie Holmes

'Half-past-four-in-the-morning Tomatoes'

Eddie Holmes has been up since 4 a.m. He comes into the ramshackle office at the back of the shop at 4.30 to get any overnight orders off the answerphone, and then it's off to Preston market by 5.30 a.m. to make sure he gets the best of whatever is on offer. He's a great believer in the early bird, is Eddie Holmes.

'H. Holmes' read the large black letters on the green board above the shop. H. Holmes was Henry Holmes, Eddie's father. Henry Holmes was a florist.

'When my father was making a bouquet of flowers for a lady for a wedding, 'e always wanted to see 'er.'

Eddie Holmes is a short, middle-aged man, made bulky by the layers of shirt, sweater, jacket and blue overall worn on a bitterly cold day. His head is covered by an ancient blue woollen hat pulled right down to just above his eyebrows. He exudes energy, cheer and bustle. His eyes dance and flicker as he peers over the top of the half-moon spectacles balanced on the end of his nose.

''E'd ask 'er "Are you the bride?" And she'd say yes. And he would picture her in his mind's eye, and if she were a big, busty woman, well 'e'd make 'er a big bouquet. And if she were a little delicate lady, he'd make 'er a nice little delicate bouquet.'

It's 7 a.m., and deliveries are already under way. Barely discernible figures huddle over the stacks of assembled orders. Four vans of varying antiquity are lined up higgledy-piggledy in the yard in front of pallets stacked with sacks of potatoes bearing the legend 'Ibbotsons'.

The doors of the vans gape open, ready to receive '10 boxes of Cyprus lemons, 2 boxes of Red Chief apples, 2 boxes of mange-tout, 2 of radicchio, 2 Dutch aubergines, 3 Italian fennel, 2 fresh herbs.' The neat, handwritten invoice rests on top. There are no short cuts with Eddie. 'Get it away.' He repeats the phrase like a mantra throughout the morning.

'I couldn't do it.' He pushes the woollen head-cosy back on his head, scratches his forehead, and then pulls the hat back to its customary position again, resting on the eyebrows. 'I couldn't see the colours. It's like painting, it's an art, is floristry. My father used to show me these arrangements and things 'e'd made, and 'e'd say, "Can you see 'ow that lifts that an' that does that," and I'd say, "No, father, it all looks the same to me." So 'e says, "You'll never be a florist, so you might as well go out to work."' So, in a roundabout way, Eddie Holmes became a fruit and veg supplier.

At first glance his shop doesn't strike you as being anywhere special. Outside, there is an array of boxes with the regulation range of cabbages, leeks, oranges, tangerines, potatoes. Inside, appearances aren't much more revealing. The

OPPOSITE:
EDDIE HOLMES, FRUIT
AND VEGETABLES

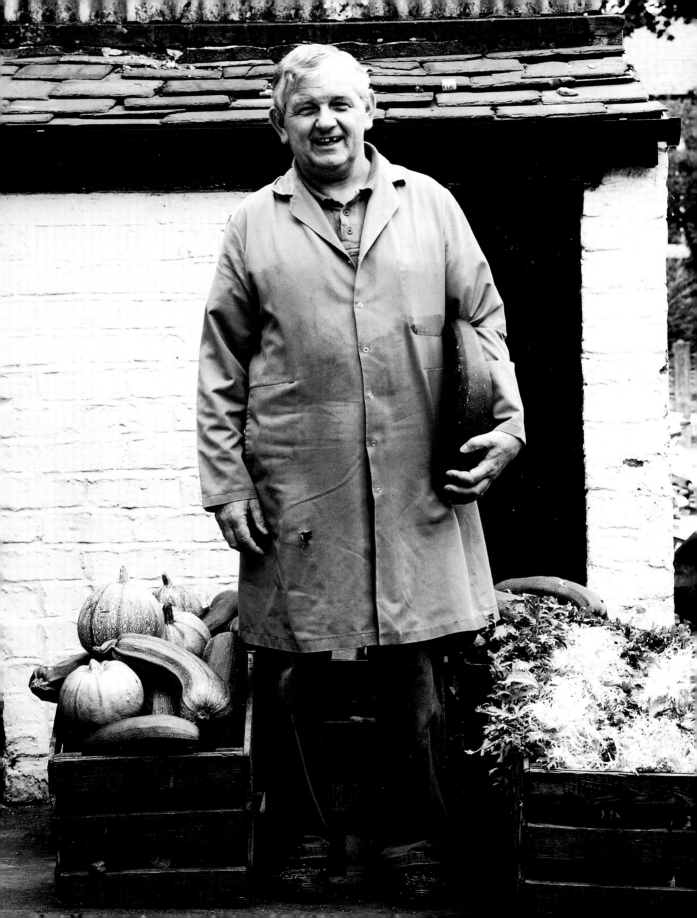

concrete floor is cracked and pitted. There are more ramshackle displays of apples, lettuces, tomatoes and mushrooms, supplemented at odd corners by bottles of Heinz salad dressing and ketchup and tins of baked beans.

And then you begin to notice oddities – boxes of Perruche sugar cubes, with the distinctive florid parrot on the box, and bottles of Leblanc extra-virgin olive oil, balsamic vinegar and great jars of French mango concentrate. And the satsumas have their dark, shiny leaves with them. And those sacks of potatoes standing higgledy-piggledy against the wall are carefully and neatly labelled 'Egyptian new', 'Scottish Maris', 'Cara washed', 'Maroc new'. There are maybe seven or eight varieties.

Actually, it's out the back that Eddie keeps the really fancy stuff – 'queer gear', he calls it – the baby carrots and leeks, the feuille de chêne lettuce and cicoria di Treviso, washed baby spinach leaves, French watercress bound in striking pink twine, glossy lambs' lettuce, fennel from Riso Giovanni, mushrooms from Ets Monteuil, tarragon and chervil and chives and thyme from Ian and Sue Lloyd in Guernsey. And tucked away among the boxes and plastic containers, which are stacked from floor to ceiling in the cool room, are some saucisse de Montbeliard, Dutch redcurrants, cherry tomatoes from Israel.

He can get anything now. 'Octopus, squid, foie gras, olives, herbes de Provence, anything – there's nothing I can't get.' He has deliveries three times a week, Mondays, Wednesdays and Fridays, from the great French wholesale market of Rungis. He puts his order in, and the people that supply him also do drops in Carlisle for the Lake District trade, and then head for Scotland, filling up the van for the return trip with venison, game and wild mushrooms in season, and shellfish, which, as Eddie points out, then get reimported back into Britain 'in fancy French boxes at twice the price'.

'Cath, can you get some of the writing-up done. I'll get the peppers,' and out he goes, striding across the yard with purposeful determination. He dodges past a youth in a black-and-red check shirt, jeans and heavy boots, lopes out with a box of Jamaican bananas and opens the side door of a van. The air is cut by the smooth clatter of disco music.

It wasn't always like this. When he started, he didn't know the difference between a globe artichoke and a Jerusalem artichoke. Now he's persuading local farmers to grow baby leeks and fancy lettuces and courgettes, with their brilliant-yellow trumpet flowers still attached to them. And that's all down to the influence of Paul Heathcote.

They met when Paul first went to Broughton Park, the smart hotel just up the road. Eddie had been supplying the chef before, and was called in when the young whirlwind hit the kitchen. It was a bit of a culture shock. 'It's been a learning curve, really. 'E's taught me a lot, in a roundabout sort of a way. 'E's very demanding. All good chefs are. People probably say that I'm hard to manage, hard to work with. But when you want perfection, you are. You try to be perfect. I can be awkward, but I just want it right. And if we send Paul anything that isn't right, it's not long before 'e's on the phone givin' you earache. And we'll 'ave to change it. Not tomorrow, not this afternoon. Now. 'E wants it changin' now.'

When Paul came, and he wanted all these fancy things, Eddie told him that they weren't available in Preston. 'So I used to take meself off to Manchester

market, where there were fresh 'erbs and fresh lettuce, but it still wasn't good enough, what we were finding. This sort of cooking 'adn't arrived in Preston in those days. Or Manchester, for that matter. 'E said that when 'e worked at Sharrow Bay, up in the Lake District, we used to get them for that place. So I got in touch with this chap who supplied Sharrow Bay, and as result I jumped in a van with these men from Carlisle and went off to this place, Rungis. It's a 200-acre site. And the buyers come on bikes. They draw up in their vans or wagons, and then they get a little bike out and cycle round this site.'

Eddie picks over a tray of grey oyster mushrooms, loading the best ones on the scales. He adds some pink and yellow ones to the mix, and the dish on the scales looks like a coral garden. He pulls out a bunch of parsley like green bushy hair, weighs it and then carefully wraps it in newspaper.

''E 'asn't just transformed me. 'E's transformed lots of establishments in the area. They've followed 'is lead, so 'e's improved the standard of lots of restaurants in the area, probably without 'im knowing. And that's true of some of the farmers as well.

'There's this fellow, John Cookson, who used to grow fields and fields of cabbages. An' 'e'd come to me in September, and say to me, "Eddie, I can't sell these bloody cabbages. What are we going to do." An' 'e'd finish up by ploughing them all back in. At the time I 'adn't an answer for 'im, but times 'ave changed an' 'e now grows lollo rosso, oak leaf, baby leeks and lots and lots of vegetables these chaps can use.'

Suddenly the yard is empty of vans. Eddie begins to put together the order for Heathcote's: 2 boxes of slightly soft, ripe tomatoes 'for soup', 4 globe artichokes, 2 packets of rocket, 6 baby fennel, 6 large fennel, 10 spring cabbages, 1 iceberg, 5 pounds of carrots, 2 packets of chervil. The invoice is painstakingly written out, checked and double-checked.

But the learning curve hasn't been all one way. Eddie leans back against a shelf in the cold and cluttered office at the back of the shop. When Paul Heathcote arrived at Broughton Park, one of his first duties was to cook the annual dinner for the local cricket club. 'They 'ad roast potatoes, beef, Yorkshire pudding, carrots and Brussels sprouts. That was on the Monday evening. And then on Tuesday morning I 'ad ten people who 'ad been to this function arrive at my shop with their Brussels sprouts in their pockets and asking, "Eddie, 'ow the bloody 'ell can we eat them?" and slapped these sprouts in my 'and. Paul, 'e'd done them al dente, crisp and 'ard. They said, "These buggers a' not cooked." I said, "I only peel 'em. I don't bloody cook 'em." What they wanted, you see, was a big plate of roast beef, mashed potatoes, lashings of gravy, some soft sprouts and mush it all up. Nothing fancy. They didn't want it fancy. After that, Paul would ask me, "I've got such a body in. What do they like?" I was born in Preston. I lived 'ere most of me life. I've been a sportsman and a referee. I know all these lads and I know what they like."

Semi-transparent blue plastic sacks bulging with discs of yellow peeled potato and others with sticks of carrot are hoicked into the back of a van. The silence is broken by the cheerful chunter of the motor. The elderly driver in a puffy jacket has some doubts as to where the drop has to be made.

There are seasons to this eating-out business, you see. 'In the springtime,

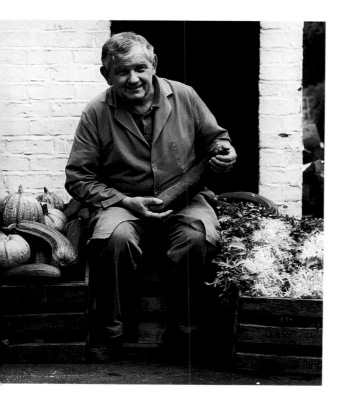

that's the wedding season. And then we go to what we call the Masonics, and sportsmen's dinners, in August and September time. Then we have the Christmas season. And then, from Christmas to Easter, that's our quietest time.' Not that it's ever really quiet at H. Holmes.

The yard at the back of the shop is cluttered with delivery vans and sacks of potatoes on pallets. The 'queer gear' is, in fact, a small part of his business. Eddie employs ten people in all, six full-time, who start at 6.30 in the morning to prepare the vegetables to the specifications of the local eateries – 'Château potatoes, pommes parisiennes, cut them to roast size, peeled new potatoes, peeled carrots, baton carrots, ringed carrots, peeled onions, ringed onions, peeled parsnips, baton parsnips, everything in the vegetable line. All they 'ave to do is cook them' – and to pack the orders.

'We supply the traditional meat'n'patater pie places. We take up to 2 tons a day to these establishments in and around the Preston area, and slice them or dice them, depending. The potatoes we use for the piemen are the yellow-fleshed ones like Wilja, and they don't 'ave to put as much butter in them. For the hotels we use mostly Maris Piper, which is a good all-round patater. And for chips we use Maris Piper, which come from Lincoln. But if they want a waxy patater for some dishes, we use red ones called Desiree. There are so many varieties, and they all do a different job. The best roasting patater, I'd say, is Maris Piper. It's got a high sugar content. Baking, well, Paul's favourite is Pentland Dell. Mine is Cara or Estima. They don't grow many proper King Edwards these days. They grow one with a red eye, a Cara, which a lot of people pass off as a King Edward, but they aren't really a King Edward. A proper King Edward 'as big pieces of red on it, a quarter of the potato 'as to be red.'

Then there are four part-time drivers who deliver the stuff, making, maybe, two or three or four trips to the same place a day. Chefs aren't always that hot at getting their supplies sorted out. Nor are all of them as aware of the price of things as they might be. 'When one of these chefs rings up and says, "Eddy, these tomatoes are a bit dear." I say, "Do you want half-past-four-in-the-morning tomatoes or eight-o'clock-in-the-morning tomatoes?" And they say, "What do you mean?" And I say, "If you want half-past-four-in-the-morning tomatoes, they're the best, and as it gets nearer eight o'clock they get worse, soft, the odd bad one in them, they've 'ad them a day or two." I say, "If you want them, they're £2 cheaper. If you want crap, it'll cost you more money in the end. When the posh lady's sat there in 'er evening dress, and it goes splat and it goes all down 'er dress, it'll cost you £60 to clean it, and she won't come back."'

'My father said to me, "People only remember the bad things." 'E said, "I once bought a bloody shirt in a shop, and it must be fifteen years since I wore it once and washed it and it was like a pocket 'ankerchief." 'E said, "That shop 'as probably changed 'ands four times since I bought that shirt, but I've never been back in it since."'

At 9 a.m. a massive Artic truck pulls up outside the shop. It's bigger than the shop. It's the delivery from Rungis. Eddie's order is already sorted. Off come boxes of leaves of every description, a wall of vegetables, £750 worth. Eddie inspects it and checks the boxes against his order. 'Eee, I get a buzz out of this,' he says. And then, catching sight of the proprietor of an Asian grocery store in another part of Preston, 'Oh, Mohammed, your chervil's arrived.'

'Then, I turn work away. I feel that if I got too big, I'd lose control of my little business and I wouldn't be able to do the job properly and I'd begin to let people down. That's where I win,' snorts Eddie. 'All the people that I know that are in this job 'ave' gone 'ome now, they're finished. But that's not the job, is it? That's why I've got all those order books, because we're quite prepared to go out again. That's what it's all about.'

Eddie Holmes's Treacle Toffee

175 g / 6 oz butter, plus more for the pan
2 tbsp treacle
2 tbsp malt vinegar
450 g / 1 lb soft brown sugar
2 tbsp double cream

Generously grease a Swiss roll pan with butter.
Put the 175 g / 6 oz of butter in heavy-based pan and melt over a moderate heat. Add the treacle, vinegar and sugar with 2 tablespoons of water. Bring to the boil and boil rapidly, stirring with a wooden spoon to prevent burning. Test a teaspoon of the mixture in cup of cold water; if it hardens immediately, it is ready. Stir in the cream and pour into the prepared pan. When very cold, mark out into squares.

Eddie Holmes's Lancashire Hot-pot

6-8 middle neck lamb chops
675 g / 1¹/₂ lb potatoes, sliced
225 g / 8 oz onions, sliced
salt and pepper
300 ml / ¹/₂ pt chicken or lamb stock
30 g / 1 oz dripping, melted

This dish was traditionally cooked in a tall brown earthenware pot from which it would be served. It is best accompanied by lashings of pickled cabbage.

Preheat the oven to 190°C/375°F/gas 5. Trim any excess fat from the chops and fry them on both sides in their own fat for a few minutes.
In a suitable ovenproof pot, start layering potatoes, onions and chops, seasoning between each layer and finishing with a layer of potatoes. Pour over the stock and brush the potatoes with the melted dripping.
Cover with a lid or foil and bake in the oven for 2–2¹/₂ hours.
Remove the lid or foil, increase the oven setting to 230°C/450°F/gas 8 and allow the potatoes to brown for a further 20–30 minutes.

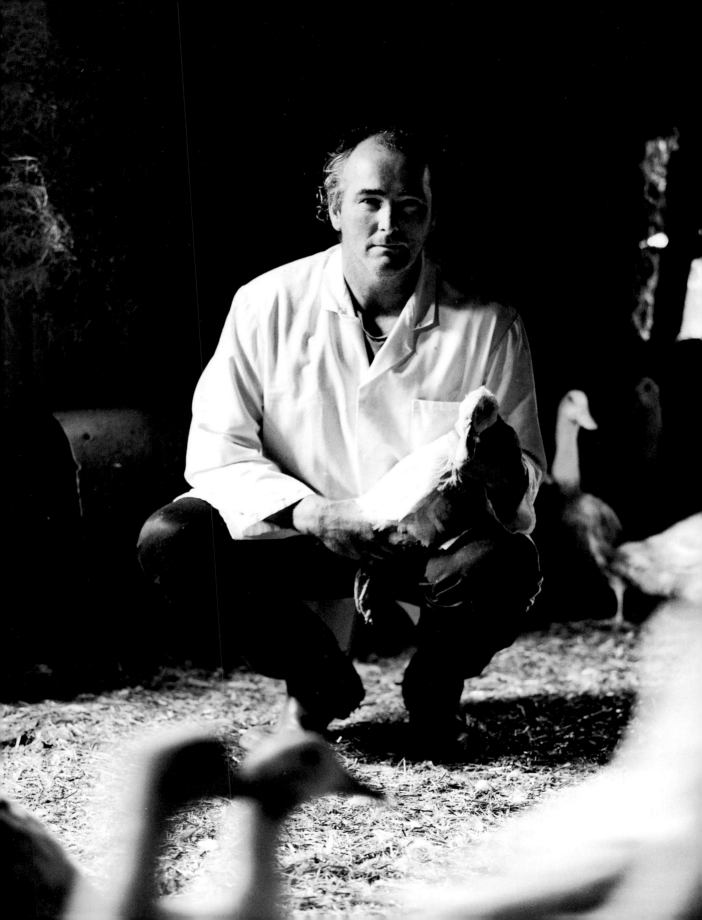

Reg Johnson

A Dignity of Ducks

You don't say Goosnargh. Or rather, the people who live there don't. They say 'Goozna'. They say it with a pleasing rhythmical softness, a local variant in which the 'r's seem to flutter on indefinitely, as in 'Coming in for a brrrrrew?', and 's's become 'z's, as in 'Take uzz as you find uzz.' That's how Winnie, Reg Johnson's mother, spoke, as she stood in the yard of Goosnargh Farm, duck feathers sticking to the toe of her green wellies, light-blue plastic coat billowing above a heavily floral pinnie.

Raising the best ducks and chickens in the North-west is not a picturesque business. Reg Johnson's Goosnargh ducks and maize-fed chickens are not to be seen pecking their way over the sun-drenched greensward of rural idyll. Not for them the supplementary diet of worms and beetles, odds and sods. For one thing, the surrounding greensward – and there's plenty of it – is more likely to be rain-drenched than sun-drenched. And that way of rearing birds is too open to chance for Reg, too open to disease and the attention of predators. Reg has other ways of achieving the quality and flavour demanded by Paul Heathcote.

The chickens and ducks are gathered inside a series of low, rather ramshackle outbuildings set haphazardly around a pitted and rutted farmyard, where puddles and poultry slurry create a Somme-like landscape after rain. Each contains two hundred or so birds at different stages of development – one day old, one week old, three weeks old, and so on, and what Reg calls finishing off, just before they are finished off permanently!

These sheds may not have the romantic quality that our conventional visions of poultry husbandry might like to see, but Reg's ducks and chickens grow up in warm, dry conditions with plenty of room to move about in, should they want to do so, which mostly they don't.

They are fed only foodstuffs free of chemicals and growth promoters. They grow at their own natural pace and are killed at proper maturity – fifty-six days for the ducks (because they start growing a new set of feathers after that, and that alters the texture of the flesh), sixty-three to seventy days for the chickens. Their normal life expectancy would be rather shorter on farms not so dedicated to producing the quality of bird that Reg is determined to achieve – and that Paul demands. 'It's all in the feed and letting them grow properly,' says Reg.

When he first started raising birds for Paul Heathcote, they carried out extensive tastings with different breeds for both ducks and chickens, but found that it didn't make the amount of difference they had originally assumed it would. So the ducks are a cross between an Aylesbury and a Peking. 'We tried an Aylesbury/ Gressingham cross, but it was going nowhere. It kept on reverting to the wild bird' – and the chickens are, well, chickens. The breed seems non-specific.

There is a restless edge to Reg. His small grey eyes are set deep in his broad, handsome face. They move quickly and incessantly. His forehead is becoming

OPPOSITE:
REG JOHNSON, GOOSNARGH
CHICKEN AND DUCKS

more pronounced as his dark, wavy hair recedes. He talks fast, his observations studded with bits of local lore and history. 'This was formed by the glaciers.' He waves an arm at the fields rolling away from the edge of the farm, green and grassy, although not as green as they will be in a few weeks. It is early spring now, and the new season's growth has yet to show, the hedges and trees have yet to take on the pale-green dusting of new leaves. 'There's Longridge. The Romans called it Longridge because it's at the end of the long ridge. There's Beacon Fell, there's Chipping. You know what the Abbot of Whalley said about Chipping folk in the fourteenth century? He described them as being wild, intransigent and few. They haven't changed a lot.' He should know. Like Paul Heathcote, he plays cricket for Chipping.

Reg inherited Goosnargh Farm and its fifty acres on the edge of the village when his stepfather, Thomas Swarbrick, died a few years ago. He and the family rent a few more acres on which to graze the dairy herd of fifty Holstein cows looked after by his brother, Bud. Both sides of his family have farmed in the area for several generations. When he took over the farm, it was mixed – a small dairy herd, a few battery chickens for their eggs, some sheep.

'It's a boring business, is farming. I'd've got out of it if we'd stuck with that. Found something else to do. I don't know what. Something.' Instead, he found Paul Heathcote and poultry. And now Paul wants squabs, young pigeons, and corn-fed quail. 'I tell him I'll get round to it when I've got the time. But that's what I haven't got, time.' He took his first two days away from the farm since his stepfather died to go with Paul to the Cup Final at Wembley. It was supposed to be a break, but he took a couple of trial orders from London restaurants while he was down there.

Reg is ambivalent about the chickens. He is proud of their quality, the fact that they are dry-plucked and hung to bring on their flavour. He is even proud of their livers and other innards, which have the bloom and delicacy of true health about them. But he does not warm to them as he does to his ducks. With five hundred of either bird at varying stages of growth in the farm in any one week, chickens do not take on an individuality for him, but he admires ducks as a species.

'They're magnificent creatures,' he says, looking into one of the sheds, where a hundred ducks in straw litter sit for the most part, chattering in a sociable way among themselves, heads raised in curious contemplation of the figures standing looking in at them. 'They die nobly, do ducks, no fuss at all. We used to electrocute them before killing them, like you're supposed to, but they'd come to, and just look at me as if they were saying, "Why are you doing this to me?" Not the killing, the indignity. Now we just break their necks. It's clean and quick. It's over right away for them.'

The birds are hatched for him by another farmer, and he takes them on when they are a day old. As they grow, they will be moved three, perhaps four times, to different sheds. The chickens will be killed when they get to three or four pounds, and the ducks when they weigh about five to six pounds . Then they are hung to bring on the flavour, for about four days, and plucked ready for delivery. They're packed and delivered all over the North-west, to ICI at Fleetwood, and to Manchester Airport, to Broughton Park and Northcote Manor. But Paul

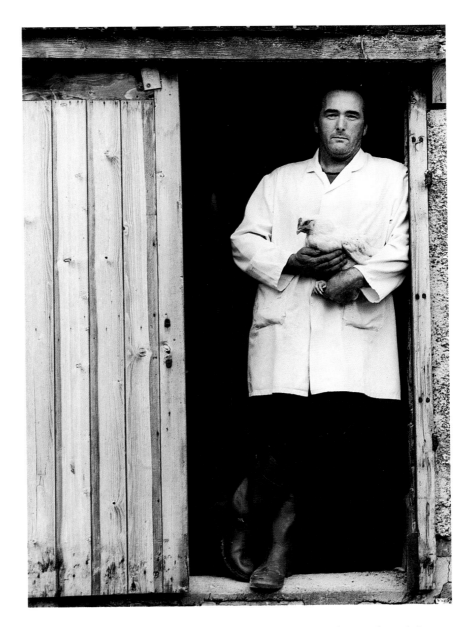

Heathcote gets the pick of the bunch. 'We drop everything for Heathcote's,' says Winnie, standing in the packing room with a pile of plucked ducks like a mound of curiously shaped melted wax on the stainless-steel packing table in front of her.

Reg picks up a duck in one hand and drops it into the palm of the other. It makes a satisfying smack. 'That's how I tell whether they're good enough for him. The breast should fill the palm, whereas if it hasn't finished up properly, then it doesn't feel right.'

He hauls out another bird to show you what he means. You can feel the breastbone rather than the breast meat, as it hits your hand, and it is unbalanced. 'He should be able to get two seven- to ten-ounce fillets out of that, should Paul,' says Reg, putting the first bird back in the shallow crate in the cold room.

'He likes his produce right, does Paul,' says Winnie, who still does a full day's work on the farm. There's Bud, too, and Auntie Nellie, who drops in from time to time. And then there are two other full-time staff, including Neville, champion plucker from Blackburn. Winnie has the same quick grey eyes as her son. Like him, she crackles with energy. She tucks the last duck away in the delivery box and presses down the lid. 'Are you coming in for that brew?' she says.

She bakes every morning. A brew goes hand in hand with ginger cobs, Eccles cakes, a scone loaf as light as thistledown and sponge cake of ethereal airiness, with a thick layer of whipped cream bursting out of the middle. 'Go on, you've got to try a bit of that,' she says. 'But I'm not happy with the Eccles cakes. My puff pastry wasn't quite right.'

I help myself to another. The rich pastry flakes away between my teeth. The glaze is fruity, matching the currants studding the inside. It may only be Winnie's second-best. It may not win any prizes in the Johnson and Swarbrick households, but it's as good an Eccles cake as I have eaten since my grandmother died.

Winnie Swarbrick's Eccles Cakes

FOR THE PUFF PASTRY:
225g / 8oz flour
350g / 12oz unsalted butter or margarine

FOR THE FILLING:
225g / 8oz currants
30g / 1oz butter
85 g / 3 oz caster sugar, plus more for sprinkling
freshly grated nutmeg

Winnie Swarbrick is disarmingly specific when it comes to details, so her recipes are re-created out of a good many 'Oooh, I don't know how much … I've never measured it … Just when it feels right … No, I've never timed it … You just know when it's right, don't you?'

First make the puff pastry in the usual way, but WITHOUT salt, making sure you fold and roll it at least three times. Put to rest in fridge for at least 1 hour.
Make the filling: wash the currants, drain and pat them really dry. Put them in a bowl. Melt the butter and pour it over the currants. Add the sugar and grate nutmeg to taste over the currants. Mix well.
Roll out the pastry to a thickness of about 1 cm / 1/2 inch. Using a saucer as a guide, cut it into rounds. Put a tablespoon of the prepared currants in the centre of each round, and gather the edges in over the top. Press the edges to seal together and put them into the fridge to rest for 30 minutes.
Preheat the oven to 220°C/425°F/gas 7. Brush the rested cakes with milk and make three little cuts in the top to allow the steam to escape. Sprinkle them with sugar and bake for 20 minutes.

Winnie Swarbrick's Goosnargh Cakes

275 g / 10 oz flour
225 g / 8 oz butter, cut into small chunks
4 tsp caster sugar
2-3 tsp caraway seeds
caster, granulated or icing sugar, to dust

Preheat the oven to 150°C/300°F/gas 2.

Sieve the flour into a bowl and add the butter. Mix the butter and flour until the mixture has the texture of fine breadcrumbs.

Add the caster sugar and the caraway seeds, and mix in. Work the mixture until soft.

Roll out on a floured board to a thickness of about 1 cm / $^1\!/_2$ inch. Cut into rounds about 7.5 cm / 3 inches across. Dust each round with caster, granulated or icing sugar.

Bake for about 20 minutes, until pale gold. Dust again with caster, granulated or icing sugar while still hot.

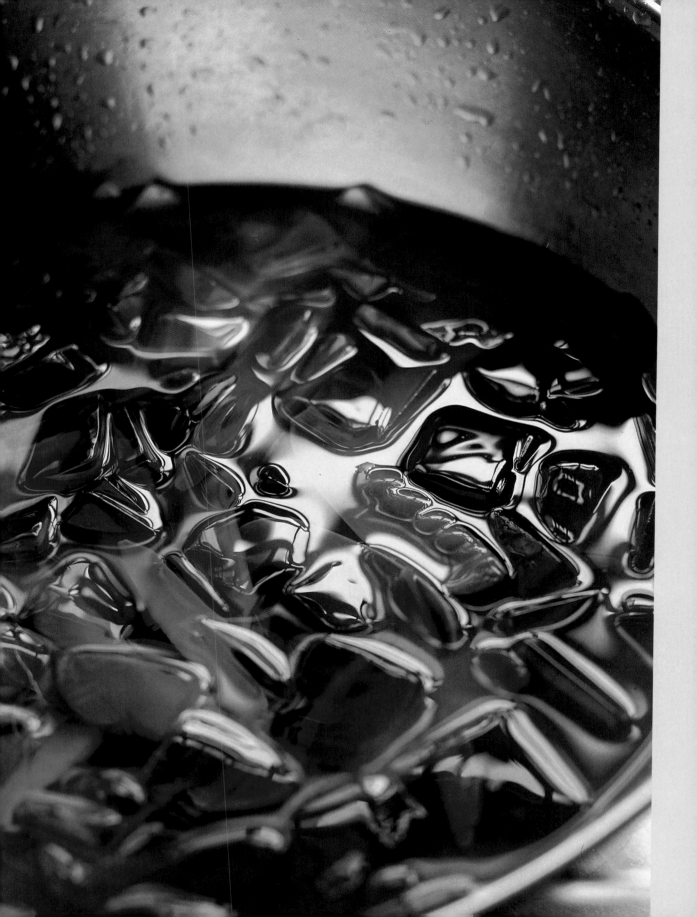

Spring Menu

First Courses

Char-grilled Asparagus on a Bed of Champ with Chervil Sauce

Pressed Terrine of Ham Hock with Parsley Potatoes and Mustard Dressing

Hollandaise and Chicken Soup

Warm Salad of Trout and Celeriac with Tartare Dressing and Anchovy Croûtons

Main Courses

Roast Fillet of Cod with Warm 'Potted Shrimps', Red Wine Sauce, Spring Cabbage, Carrots, Celery and Peas

Char-grilled Fillet of Halibut on a Bed of Spinach, with Jersey Royals, Spring Vegetables, Tarragon and Chervil Juice

Fillet of Salmon Poached in Duck Fat, Served with Roasted Scallops, Fondant Potatoes and Red Wine Sauce

Breast of Goosnargh Duckling with Fondant Potatoes, Dumplings made from the leg and Mead-scented Sauce

Roast Rack of Spring Lamb with Spring Vegetables, Hot-pot Potatoes, Braised Lentils, Roast Shallots and Rosemary Juice

Desserts

Baked Egg Custard, Scented with Rosewater, Served with Elderflower Sorbet and Crystallized Strawberries

Rich Chocolate and Orange Pots with White Chocolate Ice-cream

Bread and Butter Pudding Served with Clotted Cream and Compote of Apricots

Compote of Caramelized Rhubarb with Elderflower Cream and Rhubarb Sorbet

Char-grilled Asparagus on a Bed of Champ with Chervil Sauce

16 large asparagus spears
1 tbsp olive oil
salt and freshly ground black pepper
45 g / 1½ oz butter

FOR THE CHERVIL SAUCE:
25 g / 1 oz butter
4 shallots, thinly sliced
125 ml / 4 fl oz white wine
250 ml / 9 fl oz chicken stock
125 ml / 4 fl oz whipping cream
25 g / 1 oz chervil

FOR THE CHAMP:
2 large Maris Piper (or any other floury type of) potatoes, unpeeled
125 ml / 4 fl oz milk
3 tbsp whipping cream
6 spring onions, chopped

1 First make the Chervil Sauce: melt the butter in a heavy-based saucepan over a low heat and sweat the shallots until softened but not coloured. Add the white wine and boil rapidly to reduce by half. Add the chicken stock and reduce by half again. Finally add the cream and reduce until the sauce has the consistency of pouring cream. Pass through a sieve and allow to cool. Pick over the chervil and blanch the leaves in boiling water until soft. In a blender or liquidizer liquidize with the reduced sauce base and pass through a sieve.

2 Preheat a char-grill or ridged grill pan until very hot. Trim the pointy ears from the asparagus and trim off the stalks to produce spears of uniform length, making sure any remaining grey stalk is removed. Brush the asparagus with oil, season and cook on the char-grill or ridged grill pan for 3 minutes on each side, until nicely seared.

3 Make the champ: cook the potatoes, still in their skins, in boiling salted water until tender. Drain and, when cool enough to handle, discard the skins and put through a ricer or vegetable mill, or mash well.

4 In a large pan, mix the milk and cream and bring to the boil. Add the potatoes, mixing continuously until a smooth creamy texture is obtained. Add the spring onions and some seasoning.

5 To serve: reheat the sauce gently. In the centre of each serving plate place a disc of potato about 5 mm / ¼ inch thick and with a diameter just shorter than the length of the asparagus stalks. Put a small knob of butter in the middle and arrange the asparagus in parallel on top of the potato. Spoon a cordon of the chervil sauce around the potato.

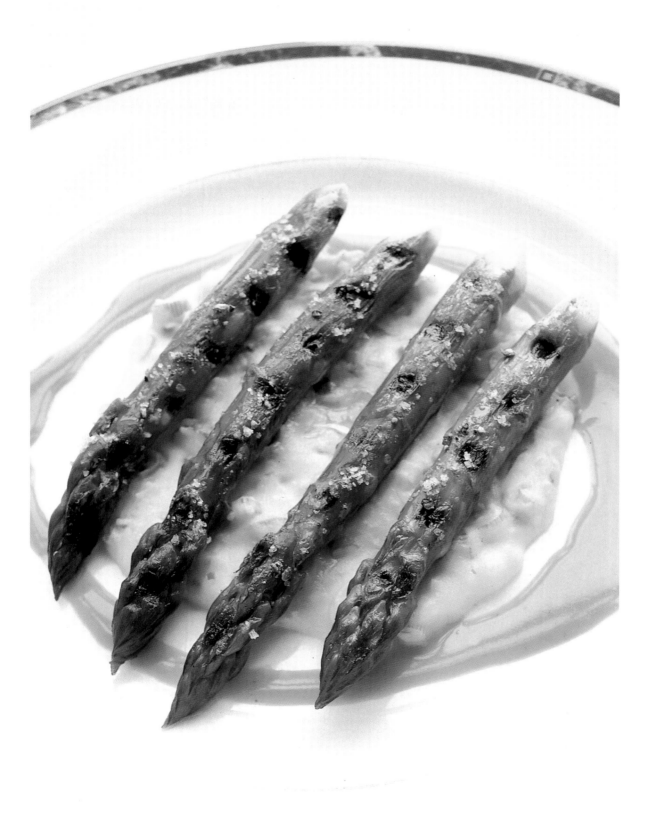

Pressed Terrine of Ham Hock with Parsley Potatoes and Mustard Dressing

MAKES ABOUT 16 SERVINGS

6 ham hocks
1 onion
2 carrots
2 sprigs of thyme
225 g / 8 oz parsley, stalks removed and reserved and leaves chopped
6 black peppercorns
900 g / 2 lb leeks, green parts split lengthwise but kept whole at root end
900 g / 2 lb carrots, kept whole but pared with a cannelle knife into flower shape at the tops
900 g / 2 lb small new potatoes
2 leaves of gelatine

FOR THE MUSTARD DRESSING:

2 tbsp grainy mustard
1 tsp white wine vinegar
1 tsp sugar
3 tbsp olive oil
salt and freshly ground black pepper

FOR THE POTATO SALAD:

10 new potatoes
1 shallot, finely chopped
1 tsp chopped chives
200 / 7 fl oz mayonnaise (page 207, omitting the capers)

1 Make the terrine at least the day before you plan to serve it: place the ham hocks in a large pan, cover with water and bring to the boil. Lift the ham out the pan, discard the water and replace the ham in the pan. Cover with fresh water, add the onion and the carrots with the thyme, parsley stalks and peppercorns, and bring back to the boil. Skim off the scum and simmer until the small bone of the ham hock can be easily removed. Take the hocks out of the liquor and allow to cool.

2 Pass the ham stock through a fine sieve, return it to the pan and bring it back to the boil. Check the stock is not too salty, adding some more water if it is. Cook the leeks, carrots and potatoes separately in it until each vegetable is just tender, then drain well. Roll the potatoes in the chopped parsley.

3 Flake all the meat off the ham hocks, discarding any tough sinew, and set side.

4 Taste the ham stock and reduce it down to concentrate it slightly if it is not too salty. Measure out 1.25 litres / 2 pints into a bowl and add the soft leaf gelatine to the warm stock.

5 Line the base and sides of a 30 x 10 x 10 cm / 12 x 4 x 4-inch terrine mould thickly with a layer of ham, then pack in the vegetables in layers, but ensuring that there is always ham between the vegetables and the mould. Pour over the ham jelly, cover the top with film and a suitable tray or sheet and weight, then refrigerate for at least 24 hours.

6 Make the mustard dressing: using a whisk, mix all the ingredients together with 2 teaspoons of water (add a touch more water if the dressing is too thick).

7 Make the Potato Salad: cook the unpeeled potatoes until just tender and drain well. While they are cooling, make the mayonnaise as described on page 207. When the potatoes are just cool enough to handle, slice them thinly into a bowl. Add the shallot and chives, with enough mayonnaise to coat and bind the ingredients together well. Season to taste and mix well.

8 Serve the terrine cut into slices about 1.5 cm / ⅝ inch thick, with the mustard vinaigrette spooned around it and with some potato salad and green salad leaves.

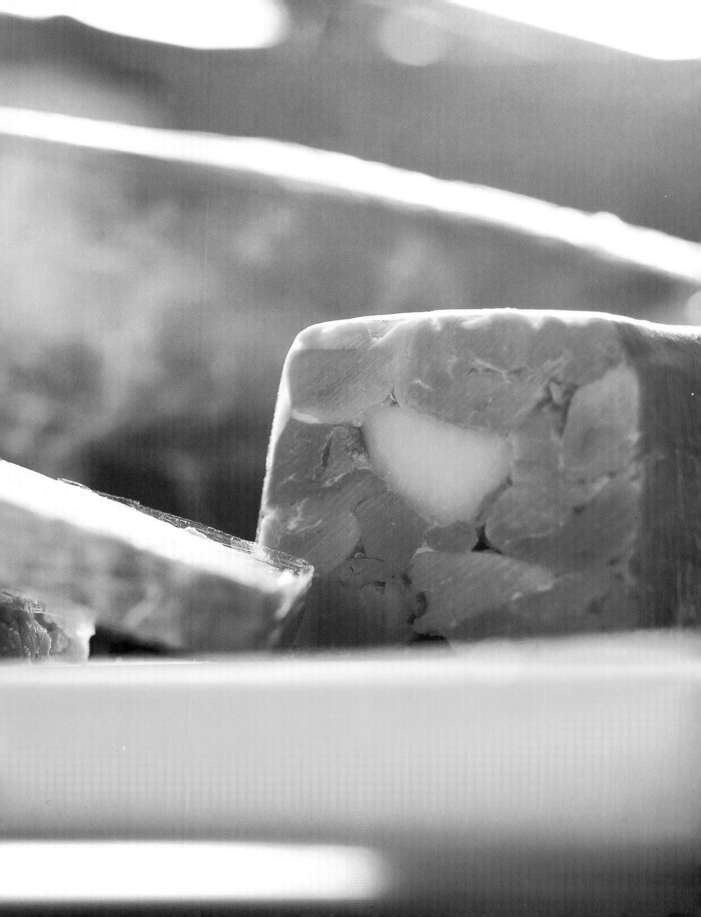

Hollandaise and Chicken Soup

50 g / 2 oz butter
50 g / 2 oz flour
1.25 litres / 2 pints chicken stock
2 egg yolks
300 ml / $\frac{1}{2}$ pint whipping cream
salt and freshly ground black pepper

FOR THE GARNISH:
50 g / 2 oz shelled peas
50 g / 2 oz shelled broad beans
50 g / 2 oz diced carrots
50 g / 2 oz diced celery
50 g / 2 oz diced leek
50 g / 2 oz diced cooked chicken
good sprig of tarragon, chopped
good sprig of chervil, chopped

1 First prepare the garnish: cook each of the vegetables separately in boiling salted water until just tender. Drain.

2 Make a roux: in a heavy-based saucepan, melt the butter over a gentle heat and add the flour. Stir for a few minutes to cook the flour through without allowing it to colour.

3 Slowly add the chicken stock to make a smooth soup. Simmer for about 10 minutes, then pass the soup through a fine sieve.

4 In a bowl, mix the egg yolks and cream together to form a liaison. Bring the soup back to a simmer, add the liaison and whisk up. DO NOT ALLOW TO BOIL! (this would separate the cream to give a grainy texture). Season to taste.

5 Pour the soup into warmed serving bowls and scatter in the garnish, finishing with the chopped herbs.

Warm Salad of Trout and Celeriac
with Tartare Dressing and Anchovy Croûtons

225 g / 8 oz celeriac, cut into julienne strips
150 ml / ¼ pint mayonnaise (see Caper Mayonnaise, page 207, but omit the capers)
1 tsp grainy mustard
salt and freshly ground white pepper
200 g / 7 oz mixed salad leaves
vegetable oil for deep-frying
2 whole trout, skinned (but skin reserved and well scaled), filleted and pin bones removed
flour, for dusting
cayenne pepper
celery salt
25 g / 1 oz butter

FOR THE TARTARE DRESSING:
100 ml / 3½ fl oz extra-virgin olive oil
100 ml / 3½ fl oz white wine vinegar
25 g / 1 oz capers
1 dessertspoon not-too-finely chopped parsley
25 g / 1 oz gherkins
1 shallot
½ garlic clove

FOR THE ANCHOVY CROÛTONS:
45 g / 1½ oz olives
1 anchovy, bottled or canned in oil, drained
¼ garlic clove
1 tsp thyme leaves
8 thin slices of French bread, toasted

1 Mix the celeriac with the mayonnaise and mustard, then season with salt and pepper.
2 Make the dressing by whisking all the ingredients together, then toss the salad leaves with a few drops of the dressing and some seasoning.
3 Heat the oil for deep-frying, run the trout skin through the flour seasoned with cayenne and celery salt and deep-fry until crisp and golden.
4 Make the Anchovy Croûtons: in a bowl, chop the olives, anchovies, garlic and thyme together to form a fine paste. Spread some of the paste on the toasted croûtons.
5 Preheat a hot grill. Cut the trout fillets in half and place them on a greased tray. Put a small knob of butter on each fillet and cook under the hot grill for about 1 minute without turning.
6 Arrange the dressed salad leaves on the serving plates with the celeriac on top. Then place a piece of trout on top of that. Pour some of the remaining dressing over and around the trout. Garnish with the fried trout skin and scatter the croûtons around the plate.

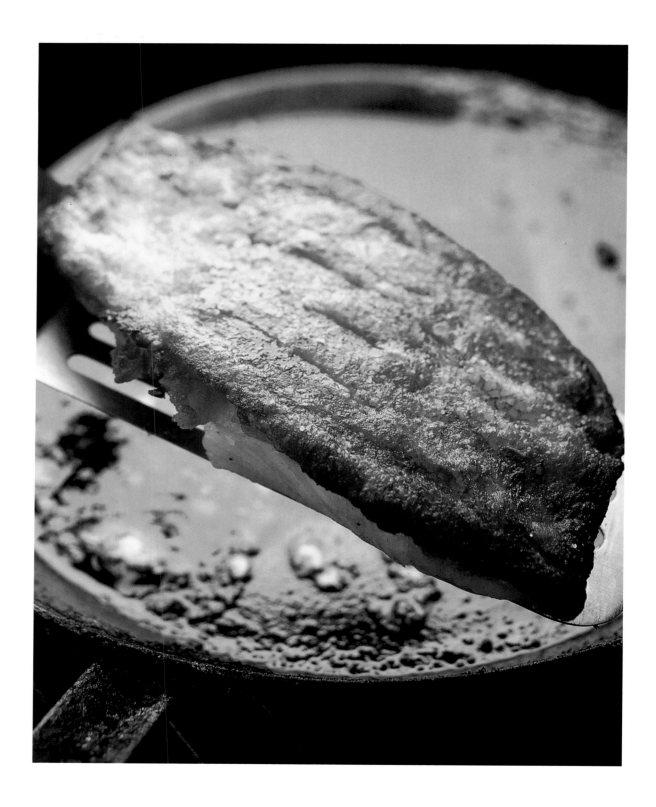

Roast Fillet of Cod with Warm 'Potted Shrimps', Red Wine Sauce, Spring Cabbage, Carrots, Celery and Peas

350 g / 12 oz cod fillets
450 g / 1 lb rock salt
4 stalks of celery, trimmed, strings removed and cut into 5-cm / 2-inch lengths
125 g / 4½ oz fresh peas
8 baby carrots
1 spring cabbage
2 tbsp oil
knob of butter

FOR THE RED WINE SAUCE:
25 g / 1 oz butter
3 shallots, chopped
1 garlic clove, chopped
2 star anise
zest of ½ orange
1 small sprig of thyme
125 ml / 4 fl oz red wine
125 ml / 4 fl oz fish stock
4 tbsp veal stock
salt and freshly ground white pepper
small pinch of sugar (optional)

FOR THE WARM 'POTTED SHRIMPS':
50 g / 2 oz cold butter
1 small shallot, finely chopped
2 tsp white wine vinegar
2 tbsp white wine
about 1 tsp whipping cream
cayenne pepper
good squeeze of lemon juice
85 g / 3 oz cooked shelled brown shrimp
25 g / 1 oz chopped parsley

1 Using the back of a knife and going from tail to head, remove all the scales from the cod. Remove the pin bones using pliers. Rinse the fillets in cold water and pat dry. Score the skin with a sharp knife and place skin side down on some rock salt. Leave for 1 hour.

2 Make the Red Wine Sauce: heat the butter in a heavy-based pan and brown the shallots and garlic in it. Add the star anise and orange zest and stir for about 1 minute. Add the thyme and red wine and reduce by half. Add the fish stock and reduce by one-third. Add the veal stock and reduce until it has the consistency of pouring cream. Taste and adjust the seasoning, adding a small pinch of sugar if necessary. Pass through a fine sieve and keep warm.

3 Make the 'potted shrimps': melt a knob of the butter in a heavy-based pan and sweat the shallot in it until softened but not coloured. Add the vinegar and wine and reduce down until only one-fifth remains. Add the cream and whisk in the remaining cold butter, diced. Season with salt, pepper, cayenne pepper and lemon juice. Add the shrimps and chopped parsley. Toss to coat them well and set aside in a warm place.

4 Cook the celery, peas and carrots in boiling salted water until just tender. Blanch the cabbage whole for 2 minutes only. Refresh them all immediately in iced water and drain. Shred the cabbage.

5 Wipe excess salt from the fish and cut each fillet across into 4 chunks. Heat a frying pan over high heat until very hot, then add a little oil. When that is good and hot, put the pieces of cod in the pan, skin-side down (lay them in away from you to avoid splashing yourself), and cook until golden and crisp for about 4–5 minutes. Turn them over and cook the other sides for 15 seconds only.

6 To serve: reheat the vegetables in a pan with a knob of butter and 2–3 tablespoons of water. Season to taste. Place a piece of fish in the centre of each serving plate, then arrange a pile of vegetables on one side and some shrimp on the other side. Spoon some red wine sauce around the plate.

Char-grilled Fillet of Halibut on a Bed of Spinach, with Jersey Royals, Spring Vegetables and Tarragon and Chervil Juice

SERVES 6

6 halibut fillets, each about
175g / 6oz
good knob of butter
350g / 12oz spinach, stalks removed
1 garlic clove
900g / 2lb Jersey Royals, scrubbed
but not peeled
12 asparagus tips, pointy ears
removed and cut into 3
115g / 4oz green beans, halved
115g / 4oz broad beans, podded
50g / 2oz shelled peas
juice of ½ lemon

**FOR THE TARRAGON AND
CHERVIL JUICE:**
175g / 6oz cold butter
4 shallots, sliced
150ml / ¼pt white wine
300ml / ½pt fish stock
1 tsp whipping cream
salt and freshly ground white pepper
4 sprigs of chervil, chopped
4 sprigs of tarragon, chopped

1 First make the Tarragon and Chervil Juice: melt a knob of the butter in a heavy-based pan and sweat the shallots in it until softened but not coloured. Add the white wine and reduce by half. Add the fish stock and reduce by half. Add the cream and whisk in remaining butter, diced. Adjust the seasoning and pass through a fine sieve.

2 Cook the spinach: melt the butter in an non-aluminium pan and add the spinach and garlic with some salt and pepper. Fry gently until just softened.

3 Prepare the other vegetables: cook the Jersey Royals, asparagus and green beans in separate pans of boiling salted water until just tender. Drain. Blanch the broad beans and peas in boiling salted water for 30 seconds only. Pick off skins. Keep the vegetables warm.

4 Char-grill the halibut fillets on a preheated hot griddle pan for about 3-4 minutes on one side and then turn over and cook the other sides for about 15 seconds only. Season with salt and lemon juice.

5 While the halibut is cooking, finish the sauce by stirring in the chopped herbs.

6 To serve: put a bed of spinach on each of the serving plates. Stir the other vegetable garnishes into the sauce and spoon half of this around the plates. Place a halibut fillet in the middle and spoon the remaining sauce and garnish around and over the top.

Fillet of Salmon Poached in Duck Fat,

Served with Roasted Scallops, Fondant Potatoes and Red Wine Sauce

4 salmon fillets, each about
200 g / 7 oz
500 g / 18 oz duck fat
1 tbsp olive oil
12 scallops
salt
good squeeze of lemon juice

RED WINE SAUCE (PAGE 57)

FOR THE FONDANT POTATOES:
2 medium Maris Piper (or other floury)
potatoes, thickly sliced
100 g / 3½ oz butter

1 First make the Red Wine Sauce as described on page 57. Keep warm.
2 Start preparing the fondant potatoes: put the potato slices in a single layer in a heavy-based pan and cover with water. Add the butter and seasoning. Boil rapidly until all the water has evaporated and only butter is left. Turn down the heat and cook gently until the potatoes are golden. Turn them over and cook the second side until golden. (If the potatoes should stick, don't try to free them by shaking the pan; just take the pan off the heat for a minute and the potato slices will free themselves.)
3 While the potatoes are cooking, put the duck fat in a pan and heat it up to about 85-90°C/185-195°C (the surface is just bubbling gently). Add the salmon fillets and leave to poach for about 5–10 minutes until just pink in the centre. Remove from the fat and drain well. Keep warm.
4 When the potatoes and salmon are cooked, put a little oil in a hot frying pan, add the scallops and cook on one side to get them golden-brown and caramelized. Turn the scallops over and cook for a few seconds more on that side. Season with salt and lemon juice.
5 Arrange the potatoes in the centre of the serving plates with the scallops scattered around them. Season the salmon with salt and lemon juice and place on top of the potato. Spoon some sauce around the plate and serve.

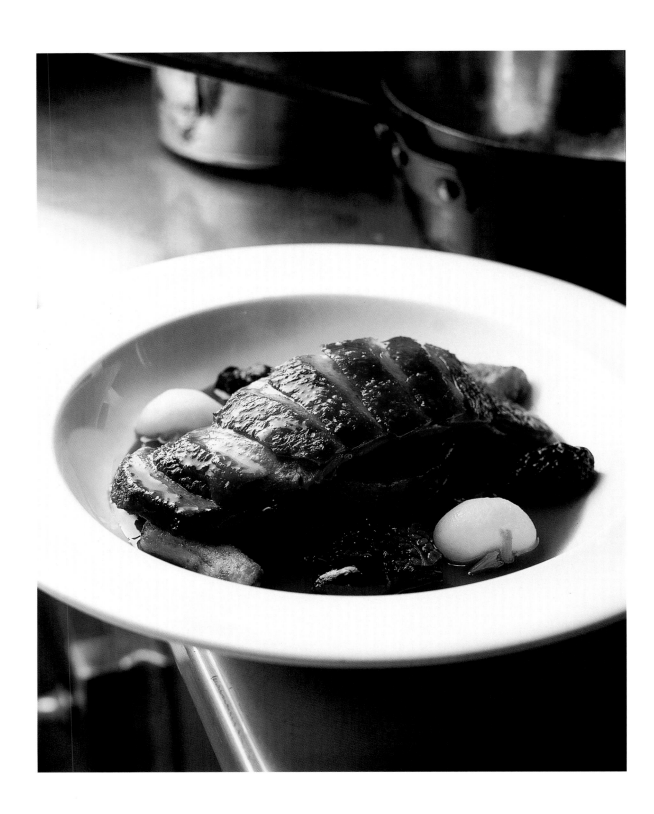

Breast of Goosnargh Duckling with Fondant Potatoes, Dumplings made from the Leg and Mead-scented Sauce

4 duck breasts (use double crowns on the bone, see pages 16-20)

FOR THE MEAD-SCENTED SAUCE:

2 duck carcasses, broken up
a little oil
4 shallots, sliced
1 carrot, sliced
2 garlic cloves, lightly crushed
1 celery stalk, sliced
1 sprig of thyme
100 ml / 3½ fl oz mead
about 500 ml / 18 fl oz chicken stock
1 tbsp honey

FOR THE DUMPLINGS:

25 g / 1 oz chopped onion
115 g / 4 oz butter
150 g / 5 oz flour
4 eggs
salt and freshly ground black pepper
115 g / 4 oz cooked duck meat or chopped ham

FONDANT POTATOES (SEE PAGE 59)

FOR THE VEGETABLE GARNISH:

4 baby beetroots
4 parsnips, cut into barrel shapes
2 apples, preferably Granny Smith's, peeled, quartered and cored
a little oil
1 tsp sugar
knob of butter

1 Make the Mead-scented Sauce: preheat the oven to 190°C/375°F/gas 5 and roast the duck bones until brown, about 20–25 minutes.

2 In a large heavy-based pan, heat a little oil and brown the shallots, carrot, garlic, celery stalk and thyme until golden. Add the mead and reduce by half. Add the roasted bones and cover with stock or water. Bring to the boil and skim off the fat. Allow to simmer for at least 1 hour, frequently skimming off the fat.

3 Strain out the bones and vegetables and reduce the stock down until it has a good strong flavour and pouring consistency. Stir in the honey.

4 Preheat the oven to 230°C/450°F/ gas 8. Roast the duck breasts, skin-side down, for about 14–18 minutes in the hot oven. Allow to rest for at least 10 minutes in a warm place before carving.

5 While the duck is roasting, make the dumplings: first briefly blanch the onion in a small pan of boiling water. Drain well. Put the butter in a pan and add 300 ml / ½ pint of water. Bring to the boil. Add the flour and beat in well. Take off the heat and, when cooler, slowly add in the eggs. Stir in the blanched onion the chopped meat. Season to taste.

6 Put the mixture in a piping bag fitted with a 1-cm / ½-inch straight nozzle. Bring a large pan of salted water to the boil and pipe the dumplings into it, snipping off the mixture in short lengths. Poach the dumplings until they float to the surface, about 2 minutes. Remove with a slotted spoon and pat dry with kitchen paper.

7 Prepare the vegetable garnish: cook the beetroots and parsnips in separate pans of boiling salted water until just tender. Drain well. Heat a drop of oil with the sugar in a frying pan until foaming and toss the apples and parsnips in it. Remove from the heat. In another pan, toss the beetroots in the butter with a very little water.

8 While the duck is resting, finish the dumplings: heat some oil in a frying pan and fry the dumplings briefly, until golden brown all over, about 45 seconds.

9 To serve: preheat a hot grill. Carve the duck from the bone as described on pages 16-20. Place the breasts under the grill, skin-side up, and cook until reheated and the skin is crisp.

10 Slice each breast into 8 pieces, arrange on the plates and season with salt and pepper. Scatter the fondant potatoes, vegetable garnish and dumplings around the plates and pour the sauce over the duck.

Roast Rack of Lamb with Spring Vegetables, Hot-pot Potatoes, Braised Lentils, Roast Shallots and Rosemary Juice

one 8-bone best end of neck of lamb
115 g / 4 oz mange-tout peas
8 baby carrots
1 spring cabbage
knob of butter
salt and freshly ground black pepper

FOR THE BRAISED LENTILS:
250 g / 9 oz lentils, preferably Puy
50 g / 2 oz smoked bacon, chopped
into fine lardons
½ large onion, finely diced
1 carrot, finely diced
1 garlic clove
1 bay leaf
600 ml / 1 pint lamb or chicken stock

1 The day before: put the lentils to soak in cold water overnight.
2 The next day: start making the Rosemary Juice (see overleaf): preheat the oven to 200°C/400°F/gas 6. Chop up the lamb bones as small as possible and roast them in the oven until golden, about 1 hour (make sure you don't allow them to burn, or scrape off any burnt bits if you do; otherwise the stock will be bitter).
3 Chop the onion, carrots, celery and garlic. Place them in a heavy-based pan and brown in a little oil. Add the chopped tomatoes and cook till most of the liquid has evaporated. Add the wine and reduce down by half. Add the thyme and most of the rosemary. Place the browned bones in the pan, cover with water and bring to the boil. Skim off any fat and scum, reduce the heat and simmer for about 4 hours. Pass the stock through a sieve into a clean pan, return to the heat and bring to a simmer again, continually skimming. Taste the stock now fairly regularly as it can get too strong, or sometimes over-salty due to the natural salts in meat. When it has a good strong flavour, pass it through a fine sieve. Check the consistency; if it is too thin (it should have a thin pouring consistency) thicken it with a small amount of arrowroot.
4 While the lamb stock is reducing, start the Hot-pot Potatoes: preheat the oven again to 200°C/400°F/gas 6. Butter an ovenproof dish about 20 cm / 8 inch round and 10 cm / 4 inch deep and season it with salt and pepper. In separate bowls, mix the potatoes, onion and carrot with some of melted butter and season well with salt, white pepper and rosemary. Layer the larger and longer potato slices neatly in the bottom and around the side of the dish, overlapping them well. Fill with the remaining vegetables, cover with a lid or foil and bake until cooked and golden brown, about 1 hour. Allow the hot-pot potato cake to cool for 30 minutes before turning it out. (This can be assisted by warming up the bottom of the dish for a few seconds.)
5 At the same time, prepare the Braised Lentils: drain the lentils and put them, together with all their other ingredients, in a large pan and bring to a simmer. Cook until the lentils are tender, about 30 minutes depending on type. (You may have to keep topping up the pan with boiling water to prevent the contents drying out.)
6 About 25 minutes before you want to serve, prepare the shallots (see overleaf): preheat the oven again to 200°C/400°F/gas 6. Melt the butter and sugar in an ovenproof pan until golden brown. Add the shallots, and toss to colour them well, then cover with water and braise in the oven

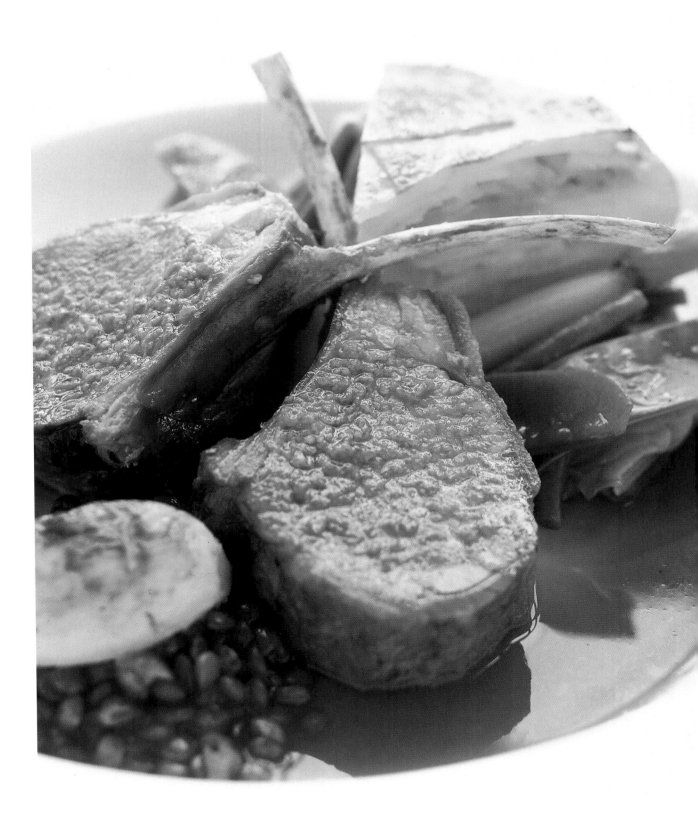

FOR THE ROSEMARY JUICE:

2.5 kg / 5½ lb lamb bones
1 large onion
2 carrots
2 celery stalks
4 garlic cloves
a little oil
5 over-ripe tomatoes
150 ml / ¼ pint white wine
1 sprig of thyme
2 sprigs of rosemary
a little arrowroot (optional)

FOR THE HOT-POT POTATOES:

115 g / 4 oz butter, melted, plus more
for the pan
salt and freshly ground white pepper
450 g / 1 lb Maris Piper (or other
floury) potatoes, sliced
½ onion, thinly sliced
1 carrot, thinly sliced
sprig of rosemary, chopped

FOR THE ROAST SHALLOTS:

50 g / 2 oz butter
45 g / 1½ oz sugar
12 shallots, peeled

until reduced and shining, about 15 minutes. Season to taste with salt and pepper.

7 While the shallots are braising, cook the peas and carrots in boiling salted water until just tender. Blanch the cabbage whole for 2 minutes only. Refresh them all immediately in iced water and drain. Shred the cabbage.

8 Cook the lamb: season the rack and roast in the oven with the shallots for 8–10 minutes, until done to taste. Remove from the oven and allow to rest briefly, covered with foil to keep it warm.

9 While the lamb is roasting, cut the hot-pot potato cake into wedges with a sharp knife and reheat in the oven with the lamb.

10 To serve: finish the rosemary juice, pick the remaining rosemary off the stalk, chop and add to the sauce. Reheat if necessary. Reheat the vegetables in a pan with a knob of butter and 2–3 tablespoons of water. Season to taste. Carve the lamb into individual chops.

11 Arrange a pile of spring vegetables just to one side of the centre of each plate and arrange two lamb chops, bones crossing, resting on the pile of vegetables. Put a wedge of hot-pot potatoes in the space between the bones and a pile of braised lentils on the other side of the plate, topped with some roast shallots. Spoon some rosemary juice around the plate.

Baked Egg Custard, Scented with Rosewater, Served with Elderflower Sorbet and Crystallized Strawberries

FOR THE CRYSTALLIZED STRAWBERRIES:
450 g / 1 lb ripe firm strawberries free from blemishes
625 g / 1 lb 6 oz granulated sugar
2 tbsp orange-flower water

FOR THE ELDERFLOWER SORBET:
250 ml / 1/4 pint elderflower cordial
250 ml / 1/4 pint water
200 g / 7 oz caster sugar

FOR THE SABLE PASTRY
250 g / 9 oz softened butter
300 g / 10 1/2 oz flour
125 g / 4 1/2 oz icing sugar
1 tbsp whipping cream
1 egg yolk

FOR THE CUSTARD:
450 ml / 3/4 pint whipping cream
150 ml / 1/4 pint milk
1 vanilla pod
12 egg yolks
65 g / 2 1/4 oz caster sugar
1 tbsp cornflour
10 drops of rosewater essence

1 At least 3 weeks ahead: start making the Crystallized Strawberries:

ON DAY 1 – wash the fruit in cold water, do not hull. Place in a large shallow bowl, but do not heap the strawberries up too much to avoid squashing the fruit at the bottom. Prepare a syrup by dissolving 175 g / 6 oz sugar very slowly in 300 ml / 1/2 pint of water, stirring continuously with a metal spoon. Bring to the boil and pour the syrup over the fruit, making sure that the fruit is covered completely. Leave to soak for a full 24 hours.

ON DAY 2 – drain off the syrup into a saucepan and add another 50 g / 2 oz sugar. Dissolve it slowly over gentle heat, stirring continuously. Bring to the boil and pour the syrup back over the fruit. Leave to soak for another 24 hours.

ON DAYS 3 TO 7 – repeat the draining and boosting of the soaking syrup with another 50 g / 2 oz of sugar every day for the next 5 days, so that the syrup gradually gets stronger and stronger.

ON DAY 8 – drain off the syrup and add 85 g / 3 oz of sugar (instead of 50 g / 2 oz you have been adding up to now). Dissolve it and then add the fruit to the syrup in the pan. Simmer gently for 3–4 minutes. Carefully return the fruit and syrup to the bowl. Leave to soak for a full 48 hours.

ON DAY 10 – repeat the same procedure with 85 g / 3 oz of sugar. Then add the orange-flower water and leave to soak for 4 full days. This is the last soaking and you can leave it longer if you wish, up to about 2 weeks. The fruit becomes sweeter and sweeter the longer it is left. Finally drain off the syrup and spread the pieces of fruit out on a wire rack. Place the rack on a tray and cover the fruit without touching it – use an inverted roasting tin, a tent of foil, a plastic box, anything to protect it from dust and flies etc. Leave the fruit in a warm place, such as an airing cupboard or a warm corner of the kitchen, until thoroughly dry – about 2 or 3 days. Turn each piece 2 or 3 times while drying. When completely dry, carefully pack the candied fruits in boxes, with waxed paper or parchment between each layer.

2 At least the day before, make the Elderflower Sorbet: warm all the ingredients together in a pan until the sugar has dissolved. Mix well and let cool. Freeze in a sorbetière or in a suitable container in the freezer, taking out at regular intervals and mixing to break up the crystals.

3 On the day you want to serve the dish, about 4 hours ahead, first make the pastry: in a large mixing bowl, mix the butter, flour and icing sugar and work to crumbs. Add the cream and egg yolk to the mixture, stir in but do not overwork. Allow to rest for 1 hour.

4 When then pastry has rested, preheat the oven to 160°C/325°F/gas 3. On a floured surface, roll it out and use to line a 23-cm / 9-inch flan tin. Line with baking paper, weight with beans and bake blind for 20–25 minutes. Remove the beans and paper and allow to cool.

5 Make the custard: preheat the oven to 130°C/275°F/gas 1. Put the cream and milk in a pan with the vanilla and bring to the boil.

6 Whisk the egg yolks with the sugar until pale. Pour on the boiling cream and milk, sieve and skim. Stir in the cornflour and rosewater essence.

7 Pour into the baked pastry case and cook in the oven for about 30 minutes, until the custard is just set. Allow to cool before serving.

8 Allow the sorbet to 'ripen' in the refrigerator for about 10 minutes before you plan to serve the dish.

9 Serve the custard, cut into wedges, with sorbet on the side, decorated with the crystallized strawberries.

Rich Chocolate and Orange Pots
with White Chocolate Ice-cream

You can use Terry's Chocolate Orange in place of the dark chocolate and orange essence.

FOR THE CHOCOLATE AND ORANGE POTS

175 ml / 6 fl oz whipping cream
125 ml / 4 fl oz milk
4 egg yolks
85 g / 3 oz caster sugar
125 g / 4½ oz dark chocolate, broken into pieces
1 tsp orange essence

FOR THE WHITE CHOCOLATE ICE-CREAM:

500 ml / 18 fl oz whipping cream
500 ml / 18 fl oz milk
12 egg yolks
400 g / 14 oz sugar
300 g / 10½ oz white chocolate, broken into pieces
5 tbsp white crème de cacao or Cointreau

1 Well ahead of time, make the White Chocolate Ice-cream: put the cream and milk together in a pan and bring to the boil. Cream the egg yolks and sugar together until pale and frothy. Pour the boiling cream and milk over the creamed mixture, whisking continuously. Pour the mixture back into the pan and cook until it coats the back of a spoon. Pass through a fine sieve. Add the chocolate and the liqueur, whisking until it has all melted. Place in an ice-cream machine and churn until frozen. Freeze for at least 4 hours.

2 Make the Chocolate and Orange Pots: put the cream and milk together in a pan and bring to the boil. Cream the egg yolks and sugar together until pale. Pour the boiling cream and milk over the creamed mixture. Stir in the chocolate and orange essence until the chocolate melts. Pass through a fine sieve and pour into ramekins or small pots. Allow to cool.

3 Preheat the oven to 130°C/275°F/gas 1, then cook the chocolate pots in a bain-marie in the oven for about 30 minutes, until just set. Leave to cool for a few hours and then chill for at least 3 hours.

4 Allow the ice-cream to 'ripen' in the refrigerator for about 20 minutes before serving. Serve the chocolate and orange pots with a good scoop of ice-cream on the side.

Bread and Butter Pudding served with Clotted Cream and Compote of Apricots

5 thin slices of white bread
65 g / 2¼ oz butter
100 g / 3½ oz sultanas
225 ml / 8 fl oz cream
225 ml / 8 fl oz milk
3 eggs
50 g / 2 oz sugar
1 vanilla pod
25 g / 1 oz icing sugar
50 g / 1 oz apricot jam
about 200 ml / 7 fl oz clotted cream

ENGLISH CUSTARD (PAGE 169)

FOR THE COMPOTE OF APRICOTS:
250 g / 9 oz dried apricots
½ vanilla pod
zest of ½ orange
½ cinnamon stick

1 At least 2 hours ahead, make the Compote of Apricots: bring 250 ml / 9 fl oz water to the boil and pour over the apricots in a heat-proof bowl. Leave to stand for about 30 minutes. Add the remaining ingredients, pour into a pan and bring to the boil. Simmer for about 10 minutes. Leave to cool and remove the vanilla and cinnamon.

2 Preheat the oven to 190°C/375°F/gas 5. Butter the bread and remove the crusts. Place one layer of bread on the base of a 25x15 cm / 10x6 inch rectangular earthenware dish about 6 cm / 2½ inches deep and cover with a layer of sultanas. Place the rest of the bread on top.

3 Mix the cream, milk, eggs and sugar, and pass through a sieve. Slice the vanilla pod down the centre and scrape out the seeds. Add to the custard mixture and pour over the bread. Allow to soak for 5 minutes.

4 Place the dish in a bain-marie and cook in the oven for about 30 minutes. Remove and allow to cool for about 15 minutes.

5 Preheat a hot grill. Dust the pudding with icing sugar and glaze under the grill until golden (if it starts to soufflé, remove from the grill and let it cool a little longer before repeating the glazing process).

6 Spread the top with the apricot jam and serve cut into wedges, with a quenelle of clotted cream (mould it with 2 tablespoons) and the compote of apricots. Spoon some English custard around the plate.

Compote of Caramelized Rhubarb
with Elderflower Cream
and Rhubarb Sorbet

SERVES 6

750 ml / 1¼ pints whipping cream
1 vanilla pod
12 egg yolks
225 g / 8 oz caster sugar

**FOR THE CARAMELIZED
RHUBARB**

900 g / 2 lb cooked rhubarb, trimmed
(peelings reserved), strings
removed and chopped
1 tbsp vegetable oil
about 15 g / ½ oz icing sugar
good handful of fresh elderflowers or
about 150 ml / ¼ pint elderflower
cordial to taste
150 g / caramel (see page 169),
ground to a powder

FOR THE RHUBARB SORBET:

250 g / 9 oz rhubarb peelings (from
above)
250 g / 9 oz caster sugar

1 Well ahead of time, make the Rhubarb Sorbet: boil the rhubarb peelings in 500 ml / 18 fl oz water with the sugar until the rhubarb is soft. Place in a liquidizer and purée, then pass through a fine sieve. Make the strained purée up to 600 ml / 1 pint with water and churn until frozen. Store in the freezer until required.

2 Bring the cream and split vanilla pod with the elderflowers or cordial to the boil in a heavy-based saucepan.

3 In a large bowl, cream the egg yolks and sugar together. Pour the boiling cream on the yolks and sugar and then return the mixture back to the pan. Continue stirring the custard over a low, even heat until it is thick enough to coat the back of a spoon. Sieve into a container and allow to cool (cover with cling film, punctured here and there, to avoid a skin forming).

4 Make the Caramelized Rhubarb: cook the rhubarb in simmering water until just tender, but still firm. Drain and pat dry. Heat a large frying pan, add the oil and tilt to coat the base. Sprinkle over a dusting of icing sugar. When this turns golden, add the rhubarb. Toss quickly to coat well and remove.

5 Spoon the cooked rhubarb into the bottoms of 6 flameproof serving dishes. Just cover with the cold custard and refrigerate. When this is set at the bottom of the dishes, top up with the remaining custard. Refrigerate for at least 4 hours.

6 When ready to serve, preheat a hot grill. Sprinkle the tops of the custards with powdered caramel and place under the hot grill for 20 seconds until the caramel has melted. Serve with the sorbet in separate bowls.

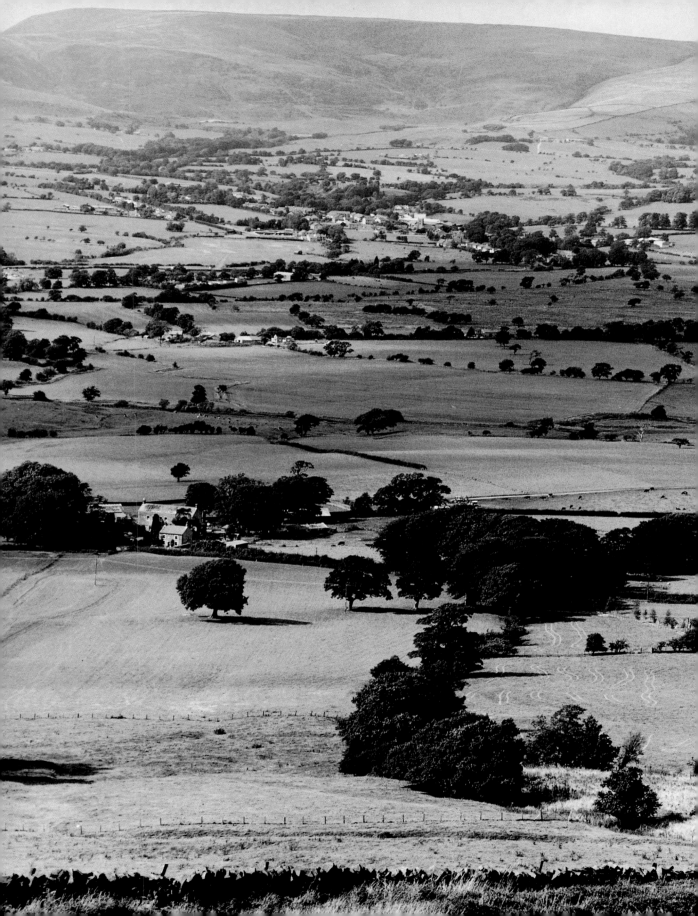

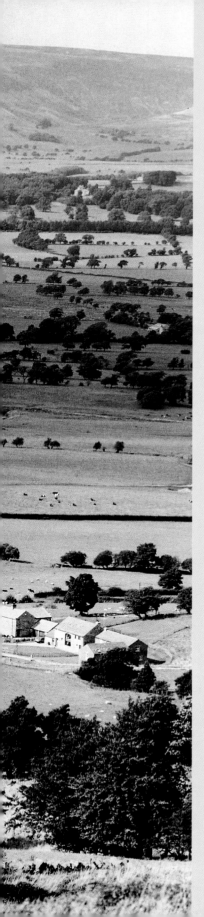

Summer

Let it stay hidden there like strength, below
Sale bills and swindling; something people do,
Not noticing how time's rolling smithy-smoke
Shadows much greater gestures; something they share
That breaks ancestrally each year into
Regenerate union. Let it always be there.

SHOW SATURDAY, Philip Larkin

Show Time

Judging Cheese at the Chipping Show

It rains at the Chipping Show. It has rained at the Chipping Show every year for the last fourteen years. It doesn't matter what sort of summer we're having, it rains at the Chipping Show. Some years are sloppy years and some years are squelchy. This was a squelchy year. That's what the folk who man the tents and stalls, and bring their cattle, pigs, sheep, shire horses, hens, ducks, cheeses, flapjacks and cakes all say, and they don't let it bother them.

Chipping is a small village on the edge of the Trough of Bowland. 'Chipping,' says the *Ribble Valley Guide*, 'is a picturesque village on the slopes above the River Loud.' And so it is, with its seventeenth-century school and almshouses, twelfth-century church, stone-built houses and three pubs.

You might think three pubs a touch excessive for a village of six hundred or so, but they all seem to be doing well, catering to the locals at weekends and a good deal of passing tourist traffic during the summer months. Each of them reeks of history too. It is said that one is haunted by the ghost of Lizzie Dean, although no one has seen her recently. It's a classic story, though, the kind that leaves you unsurprised to hear there is ghost at the end of it.

In 1835 Chipping was probably a bit busier than it is today. Lizzie Dean was a serving girl in the Sun Inn. She fell in love with a local chap and they got engaged. On the morning of her wedding she woke to hear the church bells pealing forth. She looked out of the window and saw her fiancé leaving the church with another woman as his bride on his arm. She hanged herself in the attic of the pub. Before she did, however, she asked to be buried under the path to the church so that her betrayer would have to walk over her every time he went to church. You'd have thought he'd done that already.

Chipping's industrial past, when there were five watermills trundling away along the Chipping Beck and cotton was spun, corn milled, and nails, chairs and spindles were all made here, is largely gone. There's the furniture factory of H. J. Berry & Sons and the Post Office-cum-general store, but for the most part Chipping is a conservation area these days. Even the agriculture of the surrounding area is not what it once was. What with BSE and milk quotas and suchlike, there are more families leaving farming than there are coming into it, and those who know no other way of life are having to struggle to stay the right side of the bank manager.

Still, changing times and changing weather or not, everyone puts their best foot forward, clad in wellies if they're sensible, at the Chipping Show. This year it's bigger and better than ever. You get a grand view of the pennanted tents and show rings and cars beginning to line up in the car park from the road across

Wolf Fell, above Chipping. The show is actually about half a mile outside the village, on the Longridge Road, right in the middle of the valley of the River Loud.

At the heart of it is the show ring, with a wide path right round it. Then there is an outer ring of tents and marquees: Fairplus 200, Corthwaite's Cow and Farm Supplies, the NFU marquee, Ribble Valley Leisure, all slightly higgledy-piggledy, with pennants wagging uncontrollably in the high wind as if they had Tourette's syndrome, and the blue Cheshire public address van at the far end opposite the President's tent. Beyond them are the car parks. There are plenty of car parks – parks for the exhibitors, parks for the visitors, parks for the horseboxes over by a second ring where the riding competitions will be held.

It's early, but all the car parks are already pretty full. There's every type of vehicle there: four-wheel drives, yes, plenty of them, Japanese and British, and a good smattering of the Mercedes-Benz, Jaguar, Rover class, and then a large number of Renaults and Nissans, Vauxhalls and Fords, the cars of the masses, all ranged democratically in somewhat wiggly ranks, with plenty still cautiously edging over the bumps and skirting the really muddy bits, to take their place.

It's the seventieth annual show at Chipping. You know that because it says so on the cover of the catalogue, price £1. It's an impressive document, nothing fancy, but a mine of information, starting with the Timetable of Events:

> **9.30** Judging of Cattle, Sheep, Light Horse and Pony Sections.
> **10.00** Horticulture and WI Cheese/Poultry Close for Judging
> **10.30** Judging of Shire Horse
> **1.00** Tom Alty's Pigs
> **1.30** Novelty Dog Show
> **1.30** Tug of War
> **2.15** Tradesmen's Turnout
> **3.00** Grand Parade of all Prize Winners
> **3.30** Hounds and Whips
> **4.00** Tom Alty's Pigs
> **4.30** Gymnastic Display – Given by Garstang Gym Club, Coached by Mandy Gornall
> **5.00** Terrier Racing
> **5.15** Egg Catching

It's what you'd call a packed schedule. But that's just the beginning of the seam of riches that runs through the catalogue. All of life is in it, particularly if you're a cow or a sheep, from insemination through to foot trimming, to the Clitheroe Auction Mart Co. Ltd. and Robinson Bros, High Class Butchers. Still, there's a long way to go before any of that. It's show time for the cattle and sheep, dogs, pigs, horses, hens, ducks, geese, cakes, tarts, carrots and leeks.

There are nine parts to the Cattle Section alone, including Champion and Special Awards, with 128 entries. There are almost as many in the Sheep Section, with classes for Blue-faced Leicester, Swaledales and Suffolks, Lonk and Jacob, Texel and Euro. Euro? Yes, Euro.

Then there's Equitation, Handicrafts, Cakes and Preserves (Open), to include Biscuits and Cakes (Four Ginger Biscuits, Four Pieces of Flapjack, and on and on

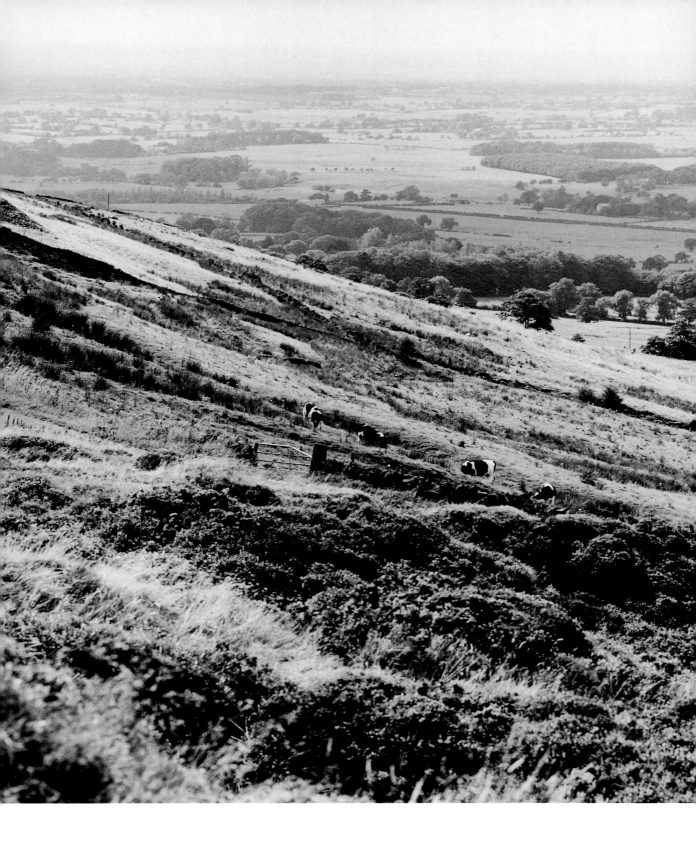

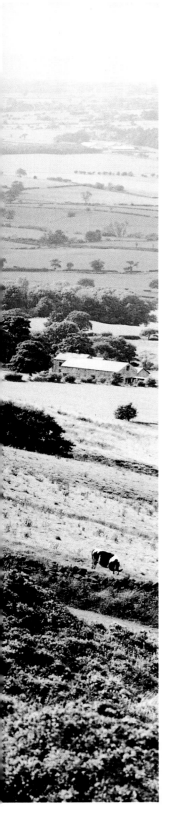

through jam tarts, flans, shortbread, fruit scones, all before we get to Custard Pie, Apple Pie, Lemon Meringue Pie, Goosnargh Cakes, Iced Bakewell Tart, Loaf of Bread, Swiss Roll, Cherry Cake, Parkin, Victoria Sandwich. There are classes too, for Dundee, Carrot and Decorated Chocolate cakes.

Let's not forget the Children's Section (Pictures, Decorated Paper Plates, Drawings of My Mother, Collage, Fruit & Veg Man, Handicraft, Decorated Stone, Decorated Doyly, Celebration Card, Needlework, Jam Tarts, Miniature Garden and Handwriting), and a Horticultural Section, with prizes for Vintage Farm Machinery, prizes for Eggs, Challenge Cup, Challenge Shield, Challenge Tankard and Challenge Trophy for poultry. And there's the Cheese Section.

There are seven classes, with sixty-six entrants all bandaged or waxed or plastic-armoured, laid out in splendid isolation on trestle tables covered with white cloths round the edge and down the middle of a tent that sways and buckets as the wind catches it.

Paul Heathcote is judging the cheeses for the second year running. It may seem odd, but he's more of a Chipping man than he is a Longridgian. He plays cricket for Chipping and is a mean machine with the ball, begrudging every run he gives away, and is no incompetent with the bat either. He's a competitor. It doesn't matter what he's at, he competes, and doesn't like being beaten. Not that he broods or complains. A game's a game, and then it's over and it's back to real life.

It's been a full year for him already, and we're only just over half-way through it. He's got married. He and Gaby have had a baby, Georgia. They have moved house once already and are now gearing up to move again, because they have just found the place they really want to live in, just up there, on the side of the hill. And then there's the Manchester brasserie to get organized and the Preston brasserie to keep organized. This year he's chairman of the judges for the American Express Young Chef and Young Waiter of the Year competition, and of course there's the filming of *Here's One I Made Earlier*. And judging the cheeses at the Chipping Show, and turning out for the team on the cricket pitch during the week, and doing his bit behind the stove at Heathcote's, because he knows that without Heathcote's as a flagship, the other projects would have a much harder time of it.

Anyway, he's judging today, not competing. He squeezes a nub of one of the cheeses in the Traditional Lancashire class between finger and thumb. It looks like yellow Plasticine. He sniffs the squidged blob.

'Squeezing helps bring out the smell,' says Bob Kitchen, one of two fellow judges, and someone who knows something about cheeses. 'And you're looking at the texture. Now I'd say that this was too soft.' Then Bob goes off into a long explanation about texture and fat content and water content, with Paul nodding and nibbling.

It's very serious, this business of judging cheeses. Chipping isn't Nantwich, the great dairy-industry cheese show, or the Tesco-sponsored Cheese Awards, which are more directed at the consumer. Chipping is small-scale. Chipping is friendly. Chipping is local.

'When you pull out the cheese iron, you're looking for the trace of fat on the back of the iron,' says Bob. 'That'll tell you whether it's well made or not. You

want a bit, not too much mind. It shouldn't be greasy.' He presses a section of the cheese out of the curl of the iron, breaks it into three, offering a piece each to Paul and Gordon Kynaston, the third judge. They squeeze and sniff and squeeze again, and then pop tiny morsels into their mouths.

Paul's eyes focus on some indefinite spot on the violently undulating roof. 'Hmmm,' he says. 'That's OK. That's not bad.'

'Butler's, if I'm not mistaken,' says Gordon. 'Nice cheese, is that.' And he scribbles on the marking sheet. There are a lot of varieties lining up for the judges in the Lancashire Cheese class: Lancs with peppers, sage and Lancs, Lancs and celery, Lancs and garlic, Lancs and onion. You wonder what happened to good old plain cheese, like Mrs Kirkham's cloth-bound, buttered wonders. Only Mrs Kirkham doesn't enter competitions. It's not that she's too proud or anything. It's just that she can sell all the cheese she makes several times over, and she doesn't want to disappoint more people than she has to. The rain clatters against the tent with a dry, susurrant insistence. Outside it's getting definitely squelchy.

Out in the main ring Tom Alty is putting his rare pigs through their paces. 'Pigs are free spirits,' his voice booms forth over the public address system, and a Tamworth called Princess proves him correct by doing a runner just as she was supposed to be going through a kind of drainpipe. 'Now you're in trouble,' booms Tom Alty, as she heads towards the crowd packed around the edge of the ring. But no one budges. They've seen runaway pigs before, and they're not going to budge for a Tamworth called Princess. So Princess comes to a halt and starts hunting around for something to eat, with a faintly ashamed expression on her face, while eager hands reach out to pat her.

'The Berkshire,' Tom announces, welcoming the next animal, and slips in a splash of agricultural history. 'One of the most important pigs before the War. You can always recognize 'em. They've got a white band on the snout, white socks and pointy ears.'

Next comes a Gloucester Old Spot: 'The only pig with built-in apple sauce, because they love to feed on windfall apples.' And after the Gloucester Old Spot comes Marshlands Lucky Maid, a Little Middleback, – 'another very nice pork pig, but don't tell her that,' – and then the largest, fattest pig you ever saw, Marschelin Matilda, a Large Black, quiet and biddable.

Back in the cheese tent, Paul and the other cheese judges are patiently masticating their way through their forty-oddth cheese, patience and diligence undiminished. He wrinkles his nose at something billed as Red Leicester.

'Aye, it's a bit dirty,' says Bob. 'It should have a nice clean flavour, but I think this one's had a bit of trouble with the acid.'

And on they move, only another thirty or so to do.

The judging is over in the poultry tent, and the crowds are sauntering along the rows of cages and marvelling at the contents. There's one fugitive from the pony competition, her number still strapped to the back of her neat grey jacket. She stares at one cage in wonder.

The hens are incredible. Some birds look like two white chrysanthemums stuck together, others like brown feather dusters. There are hens with feathers so shiny they're iridescent. There's a cock with a comb so high that it looks as if two had been stacked together. There are black- and white-speckled hens and

hens of shades of fine tortoiseshell with pink eyes. There are even the classic reddy-brown jobs lifted from the pages of a kid's storybook.

Just round the corner, in the same tent, is a table set with eggs from end to end, three to a plate, one on each plate broken, the yolks standing proud above the whites. Who would have thought there could be so many variations on white and brown? No two sets of eggs look the same, and yet they are all white or brown.

Biscuits and Cakes are away as well, with Margaret Fazackerley taking the trophy for the best chocolate cake. Preserves and Wine are still being tested by the peerless palate of Mrs F. Gornall of Pilling. The baking and the home preserves probably generate the fiercest competition in the entire show. No quarter is asked or given, but everyone has to abide by the WI rules. As one competitor later observed sourly, 'They're so rigid, the rules here', while peering disconsolately down at her rosetteless entry.

Meanwhile, Mrs Bright of Lea is examining one of Harold Fazackerley's three offerings in the Picture in any Medium except Embroidery class, while across the other side of the Handicraft tent Mrs Collins of Longridge is casting a critical eye over Charlotte Haynes's collage which will help make her joint-winner of the Children's Shield, along with Nicola Roe.

Outside it's all action. In an outer ring, surrounded by horse boxes and four-wheel-drive vehicles, the Equitation and Ridden Horse and Pony Classes are still up for grabs, the Newlands Challenge Trophy, W. J. France Challenge, the Three Bags of Spiller's Horse Nuts and Two Bags of Spiller's Horse Nuts, and the Saddle Cup donated by Mr and Mrs D. Hirst to the Champion Working Hunter in the Working Hunter section (Prize Money kindly sponsored by Clock Garage [BMW] Ltd of Accrington).

Prize money: now there's a tale. The prize money in the Shire Horse section is £30 for the first prize, £25 for second and £20 for third, and if six horses or more are entered in any Class, a prize of £5 will be awarded to fourth place. Only £5 and it costs £3 to enter. Even £30 can't make much impact on the costs of keeping these giants, gleaming as if crafted from some fabulous, glossy, malleable mountain, their tails as neatly plaited as a schoolgirl's hair, manes all decked about with ribbons, and hooves polished until they gleam in the mud. It makes you wonder if their teeth are cleaned and their breath is scented.

They stand quiet and impassive, immutable in all the hullabaloo and changing

weather. Yes, the rain has swept over again, and a small boy stands watching a single Brobdingnagian animal, which must appear to him as a hairy mammoth might to an adult, silently, mouth slightly open, oblivious of the water running down his hair. Eventually the horse shakes its head as if to say 'Get along with you' and breaks his reverie, and he scuttles off.

Out there, beyond the line of horseboxes for the heavy mob, there's another ring, marked by its own line of trailer and boxes, in which the Thelwell girls go through their paces, their legs sticking out at right angles to their fat little ponies, or their more serious elder sisters, feet and calves encased in gleaming black leather, the bulge of the white jodhpurs above the knee masking thighs taut and aching with the effort of grasping the saddle, the flared black hacking jacket, hair smooth inside its bun, the trim, hard rounded riding bowler with its curling brim sending wavelets of rain cascading down the neck as they canter round and round, weaving in and out of each other's way, keeping warm before their big moment when they are out there, alone, in front of everyone – well, Mum and Dad and sister Florence – just like Pat Smythe, Virginia Leng and Lucinda Green.

There are men too, but they don't look so sleek, the epitome of old-fashioned male virtue, perhaps, straight-backed and square-jawed, and nicely nipped in at the waist as they bounce round and round, but somehow they lack the dream-like quality of the ladies. Actually no one seems to be paying them that much attention. No, the mums and dads and brothers and sisters, welly-booted and draped in mud-coloured waterproofs, clutching violently coloured umbrellas, stand chatting to one another, oblivious to the feats of muscular control, balance and daring going on in the ring. And all for £6 at most.

'And it's not for the sake of a ribboned coat,/Or the selfish hope of a season's fame.' No, it can't be, not in this weather. It's because this is the kind of thing that people do, at the Chipping Show, and the Longridge Show, and all the other shows hereabouts. It is a declaration that there are other values and pursuits that metropolitan folk can never recognize.

Or so you might think – except, wandering about among the exhibitors' displays and consulting Gypsy Rose Lee's daughter, or waiting patiently by the van dispensing French-style crêpes, or the Scout tent with its sausage barbecues, or making their way from the Handicraft tent to the Poultry tent and from the Poultry tent to the WI tent, or standing under an insufficient awning waiting for their children to emerge from the bouncy padded cell which reels back and forth with their exertions, their screams of pleasure from within muffled by the walls and the tapocketatapocketa from the pump keeping the whole thing up, are plenty of families who clearly have never got muck or manure on their trainers, until now, that is.

Trainers, I ask you, in these conditions. You can tell the townies from the countrymen. The countrymen wear ties and the women wear scarves and they both wear wellington boots, mostly of a khaki or green colour, and the rest of their clothes would let them fade quietly into the prevailing colour of the surrounding countryside, which at present is a waterlogged kind of green. Among them are patches of colour so cheerful they make you blink. Whole families move about in differently coloured cagoules and anoraks, like exotic flowers being irrigated. These, I guess are non-country folk.

Still, nothing seems actually to dampen anyone's spirits. 'We've been here two hours and this is as far as we've got,' says one woman in a electrifying purple number and straining jeans to a friend with a buggy she has bumped into in the mouth of the Crafts marquee. Their respective husbands stand silent behind them, impassive, resigned expressions on their faces. ''Ere, you two, quit that,' she snaps in time-honoured fashion at her two bickering sons. 'Keep that up, and there'll be real trouble. Darren, I said no. Honestly, little vermin. No, so I said …' and the rain drips from the hood of her anorak on to her nose.

Outside everything progresses in the ring at a leisurely pace beneath an apparently vertical mass of dirty grey clouds. The big prizes for the cattle – the Earl of Derby Cup, the F. Bamber Challenge Cup, the Sir W. Brass Cup, the S. Bullock Cup, and the Semex UK Shield (together with £100-worth of semen) – have already been awarded. The groomed and glossy animals, with musculature and definition that Arnie Schwarzenegger would envy, and the placid disposition of a dozing granny, have been taken back to their tent and bedded down in their straw while their minders and handlers and their friends and admirers and gawpers stand about in the sweet straw-and-milky-animal fug.

There's Sandcrest Duchess 9, who was in the Best Heifer in Milk in the Holstein and Holstein Friesian class, and Eavshall Magique in the Best Uddered Heifer in the Open Dairy class, and Ince Leroy in the Best Bull under 15 Months in the Charolais class. They are all now at rest, dozing and munching contentedly. Daleview Tesk Kilt Beauty has a rosette for 'first' pinned to her stall. Daleview Sleeky 2 is slumped on the ground before the champion's rosette in the Open Dairy class, her udder spread across the straw like a great veined, black-and-white hot water bottle.

The sheep are hardier, less pampered, and relegated to pens out in the open, wool slicked down by wind and rain. Here are Blue-faced Leicesters, Suffolk, Cross-bred Horned Sheep, Swaledale and Lonk, Euro and Texel, with J. T. Kevill's Suffolks going off with the accolade of Supreme Champion, the Heyes Silver Challenge Cup, the Society Rosette and a princely £17 in prize money all in. That's nice, because the Kevills are almost a local family, from the village of Whitechapel down the road. Will their champions end up on John Penny's chopping board?

Meanwhile, Paul and Bob and Gordon have just about come to an end of their long haul through the Cheddars, other varieties of Hard-pressed Cheeses, Blue-veined Cheeses, and one Additive Cheese, Any Variety. God, the things they add to cheeses. No wonder they look a bit relieved.

Someone is setting up a cheese-making demonstration on the far side of the tent, and folk are already taking their place, looking as relieved as the judges to be able to take their weight off their feet.

'Well, it has been interesting, I'll say that,' says Paul Heathcote.

'Better Lancashires this year,' says Gordon.

'Oh, I'd say the standard was way up right across the board.' says Bob.

'Aye, but there are some right rum cheeses among that lot,' says Paul.

'Oh, aye, there are that,' the others agree, and they thank each other, and Paul makes his way out and off to the President's tent, where he has arranged to meet Gaby and Georgia.

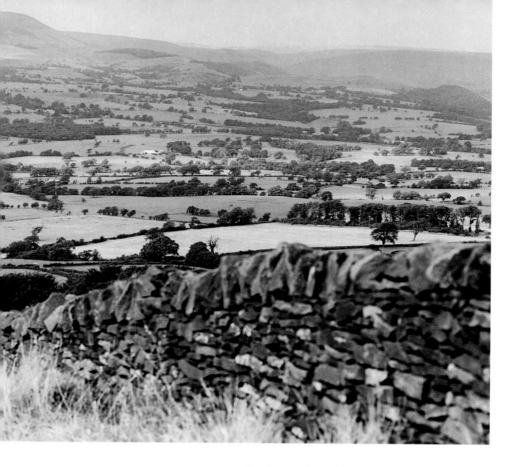

This involvement in local activities is profoundly important to him. Such things help anchor him to the region. It's all very well being a TV star and a Lancashire hero, but what's that all worth if your feet aren't planted firmly on the ground, if you aren't part of somewhere? Born in Farnworth, brought up in Bolton, he may be, but really he's a Chipping man now. What was it Reg Johnson quoted the Abbot of Whalley as saying about the folk of Chipping? That they were 'wild, intransigent and few'.

Well, Paul Heathcote's not wild, not any more anyway, but he could be said to be intransigent. Intransigent in the sense that he sets himself very high standards and expects himself to keep up to them rigorously. As he makes his way along the quagmire path to the President's tent, every now and then someone spots him. 'Ooh,' you can see them saying to themselves, 'that's Paul Heathcote, the one that's been on telly,' but he gives no sign of noticing. If anyone stops him, he gives his bright charming smile, radiates modesty, and moves on as swiftly as is seemly.

'I regret to have to announce,' booms forth the public address, 'that the Children's Sports have been cancelled. The conditions are just too dangerous. The tug-of-war has been postponed until after the Grand Parade, which will take place shortly. Will all owners of champions please have their animals ready to go into the main ring.'

It's a sight to behold. The Grand Parade leads off with the shire horses, roused from their gigantic somnolence. They are magnificent, stately, elemental – everything large you care to think of. After them come the tubby Thelwell girls on their tubby Thelwell ponies, and after them their elder sisters, and after them their parents, pert and polished and splendidly caparisoned.

Over the commentary from the public address, over the buffeting of the wind, you can hear the brass band, puffing and oompahing away from their tented island in the middle of the ring. Brass bands always seem to have a slightly melancholy edge, even when they're moving to an up-tempo beat. Under these conditions, in this place, the sound takes on an elegiac, almost mournful note.

Tiddley-om-pom-pom, parp, parp, parp, papapapapahpah...

Now here come the Charolais, Holsteins, Friesians, Simmenthals, groomed to muscular elegance, testicles or udders swaying genteely. Their guardians march beside them, dressed in white coats and wellies, like priests in a kind of way. You notice there are a lot of ties about – nothing flash, you understand, but smart.

Then come the sheep and the tractors and the coaches in hand, all the winners garlanded with their rosettes. Everyone's a winner, really, just for turning out in this weather.

There are the odd muttered, 'How the bloody 'ell could they've won that?', 'Judge's a cousin, I reckon', and 'What was wrong with my Dundee cake, can you tell me that?' 'Well, I've said it before and I'll say it again, the rules are too rigid, and I don't care who knows it.' 'Oh, forget it, pet. Let's go and have a cuppa.'

Paul's got to be off, got a restaurant to run, three restaurants to run, sixty or so in at Longridge tonight, the clear tomato juice on the menu, and the char-grilled turbot, roast suckling pig, roast saddle of rabbit, and the Goosnargh corn-fed chicken with asparagus and wild mushrooms. It's enough to make your mouth water. Of course, the black pudding's on, and the pressed ham terrine, and a great bread and butter pudding. There's also going to be five Lancashire cheeses from which to choose, with maybe one more to add in from today's tasting. We'll see.

He makes his way through the gaggles of mums with buggies and kids with painted faces – devils, pirates, tigers, mice – and the blokes with flat caps and heavyweight suiting and women in sensible packaway waterproofs currently flapping in the wind.

A few cars are driving off already, bumping over the mud-slicked grass. When they get to the gate to the road, a policeman checks the road's clear, then politely waves them out and away. It all seems a world away from sleaze in Westminster, millennium domes, Test Matches and football cups, spin-doctoring, and the rest of such worldly clutter.

However, it isn't as divorced as it seems. Farming has not had it easy over the last few years. Scandal after scandal has dug a deep mine under the image of bucolic revel, and now BSE threatens to blow it all sky high. The certainties of farming life have been systematically destroyed. The honoured position of farmers as guardians of the countryside has been called into question, and the insular, seasonal rhythms of farming life have been brought into abrasive conflict with the shifting pragmatic realities of international politics.

Still, there's no doubt that the Chipping Show will be back next year, and it will be bigger and better still, more cattle, more sheep, more horses, Eccles cakes, Goosnargh cakes, Leghorns and Orpingtons, ponies and giant leeks and collages, and all the rest.

And it'll rain. It wouldn't be the Chipping Show if it didn't.

Andrew Barnes
Mr 'Do-It'

Thirty women and one man are crammed into the kitchen. They are smartly dressed, immaculately coiffured, a hairdresser's palette of tints and highlights. These women are ladies. They give the impression of being comfortable with themselves, respectable and respectful. They are paying very close attention to Andrew Barnes.

Nominally, it is the Paul Heathcote Show, a cookery demonstration. In truth, however, it's the Paul and Andy Show; Andrew Barnes does the work and gives the explanations, while Paul cracks the jokes and massages the audience.

Paul says, 'Andy always takes the dishcloths home and washes them himself to make sure we have nice clean ones for you ladies. The ones we usually use have burn marks and holes all over them, which wouldn't do at all.'

Andy says, 'Always make sure you take the lungs out of the duck.' He holds up one of Reg Johnson's Goosnargh birds. 'Otherwise they'll make the sauce bitter. Now cut off the legs, following the line of fat round. We're going to brown the carcass, and the bones and bits, to give them colour, then they'll go into the sauce and give it more flavour.'

He is a tall man, slightly stooped from having to bend to his tasks in the kitchen. His face is smilingly youthful, although his short-cropped hair is spun with grey. He speaks easily and fluently, but this is about as close as Andy wishes to get to raising his profile. He is a shy man, diffident about himself, passionate and committed to the food at Heathcote's.

He did not set out to be a chef at all. He started out working at Sinclair Electronics and then joined the RAF. When he was demobbed, he did various jobs in the building trade and ended up doing kitchen porter's jobs at Broughton Park, and that was where he met Paul Heathcote. They were a bit short of kitchen staff at Broughton Park, so he began chopping onions and doing other bits and pieces for the chef.

He found he could do it all naturally. It wasn't as if his mother had been a fabulous cook or anything, or that he had much interest in food up till then. Nor had there been anything in his past or his training. Cooking was just what he was good at, and so, bit by bit, he improved his skills and became a chef.

It helps that he has a curious, technical mind, and he is a great reader of cookbooks, particularly old ones. He may have come to the business late, and by the back door, but he has absorbed more than many who have trained from the word go.

Since the early days he has done *stages*, sort of refresher courses, at other grand restaurants – Le Gavroche, where he met Max Gnoyke, who runs the kitchen at Heathcote's Brasserie in Preston, and Le Manoir aux Quat' Saisons – and he's eaten out at most of the major restaurants in the country. He's a great believer in eating out. Not nearly enough chefs do it, he says, although Paul is very keen they should.

OPPOSITE:
ANDY BARNES TURNING OVER
FONDANT POTATOES (PAGE 59)

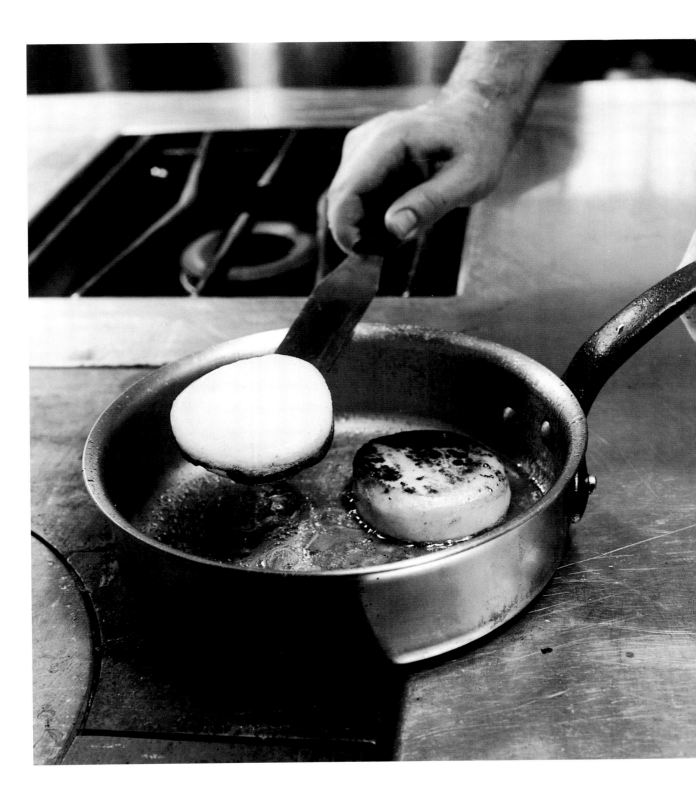

THE TOMATOES ARE SQUEEZED
WITH YOUR HANDS UNTIL THEY
ARE ALL CRUSHED

THE TOMATO AND HERB
MIXTURE DRAINING TO PRODUCE
CLEAR CHILLED TOMATO JUICE
WITH BASIL, PAGE 104

Cooking, he says, is mainly common sense. Things have to be done in a logical order. It doesn't matter what part of the process you're involved in – sauces or pastry or roasting – there's always a point at which you have to start – browning, creaming, crumbing or reducing – and, from that, the next stage will follow and the next and the next. He makes it all sound so, well, matter of fact.

It isn't, of course it isn't, but it's that kind of orderly feel for the processes of cooking that he tries to instil into the team in the kitchen – Lawrence, Tony, Lucy, Mark, Warwick, Duncan and young Lee. If you watch him at his station, nearest the door through to the restaurant, you'll see him working away steadily at his jobs for the day or during service, every now and then turning his head just to check quickly on what else is going on. If he sees someone struggling, he moves over to give them a hand, suggests an easier – no, a more logical – way of filleting fish, lining moulds, carving the breast off a duck, boning out a saddle of rabbit.

At the same time he keeps the kitchen motoring along. The pace may be more relaxed, on the whole, than in a metropolitan restaurant, but standards have to be immaculate and consistent if you want to stay up there at the top. He points out that most of the people working at Heathcote's actually come from the area, although he is one of the few who doesn't. This helps make it a very friendly kitchen, he says, with a particularly good rapport between the front of house and the back, which isn't always the case in other restaurants.

'We'll have a laugh and a joke, whatever, up till seven o'clock, and then it gets serious. There's no laughing or joking around then. Once service has started, you can't stop. You've got to keep going to the end. And then they'll all go out clubbing together on a Tuesday or Wednesday night.'

No matter how stormy the going gets, he never seems flustered, never raises his voice, never loses his temper. It's not as if he is afraid to do so. It's just that it doesn't come naturally to him. There may be a bit of the schoolmaster about him. He relishes this side of his business, whether it is imparting knowledge to the chefs in the kitchen or addressing the ladies from Hale.

He says it can be a real shock to any wannabe chef joining a kitchen with the standards of Heathcote's straight from college. Few have any real idea of the pressures with which they will be expected to cope. If they're any good, however, Andy and Paul will work hard at persuading them to stay, because most young chefs have a natural inclination to follow the path to London as quickly as possible. Of course, it helps that Heathcote's is made a bit of a fuss of in the restaurant guides, and has a good reputation. Such places look good on a CV.

It gives Andy a sense of achievement when chefs he has trained 'can do the

job' and go somewhere else. 'You can only teach them up to the level of your knowledge, and then they'll go somewhere else and they'll train up. Like Lawrence, who went to the Waterside Inn at Bray, and then he came back up, with his knowledge and maturity increased a lot.'

At demi-chef-de-partie level, he reckons they'll stay two years maximum, because they want to do each section. If they come at chef-de-partie level, it's usually about a year, because they want a sous-chef's job somewhere. In the course of the year, Warwick, Lawrence's brother, will leave to go to Chez Nico in London; Mark will go to join his girlfriend in Southampton; and Lucy will go to the Waterside Inn.

Andy, himself, has no wish to go. Although he comes from the South, he likes the Ribble valley and what it gives him and his wife in terms of community. They live on the outskirts of Preston. She has had no experience of the catering industry and has just started as a care assistant in nursing home, which means they can synchronize their lives to some extent.

It wasn't always like this. When they first got married a few years back, Andy was working six days a week and sleeping on the seventh, a pattern which he laughingly acknowledges is not ideal for a married couple.

And then there's his relationship with Paul. His own responsibilities have changed as Paul's activities have developed. Now he is the motor behind the kitchen, although he acknowledges that, in the final analysis, it is Paul's hand that controls the tempo. There is almost a state of equality between them. Certainly there is enormous respect.

Andy says that Paul is a very clever man. 'He's much more business-minded than most chefs. He puts a lot of thought into his business. The PR stuff he does is phenomenal. We don't realize half the stuff he does.'

Paul says of Andy: 'His great strengths are his mind and his temperament. Unlike a lot of chefs, he is very open-minded. He's got this very logical approach to cooking, and an ability to think things through. And he's never negative. For Andy there's always a solution to a cooking problem. Sometimes I call him "Do-it", because he can. Then, in the kitchen, he's very observant and very even-tempered. This is invaluable when you're going like the clappers during service.'

When you see them both working together in the kitchen during service, they seem to slip in and out of one another's jobs with seamless ease. One minute Andy is checking the plates on the pass, and Paul is adjusting the balance of the sauce with the chicken. The next Paul is removing minute specks of meat juice from the rim of a plate before it goes out to the dining room, and Andy is at the far end helping Lucy, who has been bombarded with a sudden rush of orders on the fish section. There hasn't been a word between them.

The same understanding extends to the development of dishes. Paul himself admits that Andy has a better technical command than he does. It may be Paul who comes up with the ideas for the recipes, his may be the defining taste, but it is Andy who works out how to do them.

Ideas come from all over the place. That's one of the advantages of eating out. 'You taste something and you think, oh, that's a nice combination, but why don't we, sort of, do it differently? Or he sees some dish that he likes the look of.

Sometimes he finds his starting point in old cookery books, although the

dishes at Heathcote's are in no way a form of kitchen archaeology. Quite the reverse, in fact, Andy and Paul are pushing British cooking into areas it has never been before.

According to Paul, 'Before we start on a new menu, we'll talk for an hour or so, jot down a few ideas, fire a few combinations around, and then we work out each dish and what's going to go into it, and make a rough version up, usually on a Wednesday or a Saturday, when I haven't got too much on, unless someone's away or off sick, like today. Tony's off sick, so I'll run the sauce. Then we taste it to see if the combinations work. Then we look at how we can work it to present it to the standard we want.'

Many of the new dishes start off life on the gourmand menu. This is where they can experiment with new ideas and refine them, particularly when they are coming up to the new seasonal menu change.

The menu has become more anglicized as the years have gone by, as their confidence and the restaurant's sense of identity have grown. There is a deliberate policy of sourcing as many of the raw ingredients as possible locally, without being slavish about it, which in part accounts for the Britishness of much of the cooking.

What exactly makes British food British is harder to pin down. 'It's got to be based on your local produce, not stuff you've imported,' says Andy. 'This tends to be a lot hardier than, say, the French or Italian, and a lot more robust. So the food you make becomes strong-tasting, and it requires more cooking. You can't do something really delicate with what you think of as being typical British fruit or veg. Nor can you just get a really nice vegetable or piece of fruit and simply plonk it on a plate. Our typical vegetables are root vegetables, apart from asparagus, and that's about the only one. And little peas, maybe. But then there are marrow-fat peas.' Andy laughs.

The developments in Preston and Manchester have meant that he has had to take on much more of the day-to-day running of the kitchen at Heathcote's. Sometimes this has been a problem, because diners expect Paul to be there, whereas in fact he has been off at the brasserie discussing ideas with Max Gnoyke or running some of the staff home, but Andy is quite philosophical about it all. He is quite happy to keep in the kitchen.

'There's always something different going on. You never get the same problem twice. Or not very often, anyway. You get such changes in the menus. The first time we had the new menu on, it was a nightmare. But that's all part of the adrenalin rush you get, sorting through it.'

And he goes off to get on with sorting through it.

Mrs Kirkham

'Just a Bit Crumbly, That's the Way I Like It'

Mrs Kirkham makes champion cheeses. That's champion in a Lancastrian sense and champion in a competitive sense. In 1995, Mrs Kirkham's Lancashire took the Champion Cheese Award at the Tesco Cheese Awards in London. That wasn't even a special cheese she had entered herself. In fact, Mrs Kirkham didn't enter any of her cheeses. She never does.

'I daren't advertise myself any more. It worries me. I get more people ringing me up asking for cheeses, and I hate saying no.' Mrs Kirkham has a lovely light, musical, laughing voice, with a rich Goosnargh roll to it.

She exudes cheerfulness and kindliness through every square inch of her comfortable white-coated frame. Brown curls streaked with grey foam out from beneath her regulation white nylon hat, which has its peak turned up at a jaunty angle. Her face is like a cob loaf. Her blue eyes dance and laugh, but you can sense a steely resolve behind them.

The cheese that won the trophy was a morsel that Randolph Hodgson of the Neal's Yard Dairy cheese shop in Covent Garden, and a great supporter of Mrs Kirkham, cut off the block on display on his way to the judging.

'And when Randolph rang up to say I'd won, first he just said that something had happened, and I thought, "Oh Lord, there must be something wrong with the cheeses."'

Mrs Kirkham's dairy is as modest and as purposeful as the woman herself. It stands at the end of a pleasant nondescript farmyard off a quiet back road between Goosnargh and Chipping. The rank, ammoniac smell of cattle hangs in the warm air, and the afternoon quiet is broken by the occasional low, somnolent moo. Beyond the dairy is a larger yard littered with the same clutter that seems to fill every farmyard – tractors and trailers of various ages and degrees of specialization, and, rather oddly, a large BBC van.

The dairy is square, sturdy and red brick, with – slightly incongruously – a netball rim jutting out of the wall above the door. Inside, you find it is quite small and cool, sparklingly clean and filled with that rich, clotted, sour-edged smell of milk. The dairy has a pleasing, somewhat makeshift quality. Such equipment as there is – the vat, the press, the grinder, the cheese moulds – look as if it arrived piecemeal.

In fact, most of them came from her mother. 'Mum made cheese during the war, and for nine years after. When I started, eighteen years ago, she came in once to get me going. After that, I was on my own.'

Kirkhams have farmed in the areas for more than 100 years. Mrs Kirkham – Ruth – and her husband, John, have worked Lower Beesley Farm for fifty years.

She may get the credit, but, as she readily acknowledges, the success of the cheeses owes as much to him as to her. Once they did chickens, housed, like Reg Johnson's, in huts scavenged from an old Air Force base. The chicken market died on them, however, at about the same time as John Kirkham's father died, so they went back to cattle, eighty of them, Friesians, half which are dairy and half beef.

What with BSE, the cheese production has taken on a huge importance; all the milk – 110 gallons on good a day – goes into the cheeses. That may seem like a lot of milk and should make a lot of cheese, but when you think that it takes a gallon of milk to make a pound of cheese, you can see why Mrs Kirkham's remains a small-scale business.

It would be possible to expand, of course, by buying in milk from elsewhere, but Mrs Kirkham refuses to do this. She knows her own cows, and she knows their milk, and it is deep instinctive knowledge that allows her to make champion cheeses. 'I can tell just by looking at the milk what sort of cheese it will make. In fact, the quality of the milk doesn't alter the quality of the cheese, but it might alter the flavour a bit.'

The cows are kept out on the pasture only during the day. At night, they are brought in and get 'dry feed', silage and hay. 'We haven't got a big acreage,' she explains, 'only about thirty acres or so, so we started bringing them in at night three or four years ago, and we found we were making better cheeses. If they have only grass going through them, especially in spring, when the grass is really rich and moist, the cheeses can go soft with all the whey in them.'

She's no technologist, Mrs Kirkham. In fact, there isn't a single item of what you might call 'technical equipment' in her dairy: no pipettes or things for measuring acid content, or temperature controls with which the dairies of some cheese-makers glitter. The milk from the milking parlour gets piped straight into the old stainless-steel tank her mother used when she made the cheese.

To this she adds a starter and rennet, which causes the whey and curds to separate. This takes about an hour, depending on the weather. The whey is run off, mixed with warm water and used to feed the calves.

The curds, which look like thick and creamy cauliflower, are transferred to a tub lined with muslin, where they drain for twenty-four hours, until they have set like tofu breeze blocks – pale white and inert – which emit a faint squeak as Mrs Kirkham cuts them into blocks. She turns them, leaning over the edges of the tub, gently easing her hands underneath and levering them over.

She straightens up. 'Oh, it's warm. I say, it's warm', and she wipes the back of her hand across her forehead.

They drain for another twenty-four hours, during which time Mrs Kirkham will turn and break the curds twice more. Then she mills – grinds up – the curds and mixes them with salt before combining twenty-four-hour curd and forty-eight-hour curd together to get a fuller flavour, and packs them into the traditional cast-iron moulds of forty-five pounds, twenty-five pounds, six pounds and three-pound minis. They drain again, are pressed in the old-fashioned press over in the corner, bound in muslin, and pressed again, before being painted with melted butter and put to mature in the narrow tiled store next door, kept at between 10°C and 14°C by the antique chilling unit at one end.

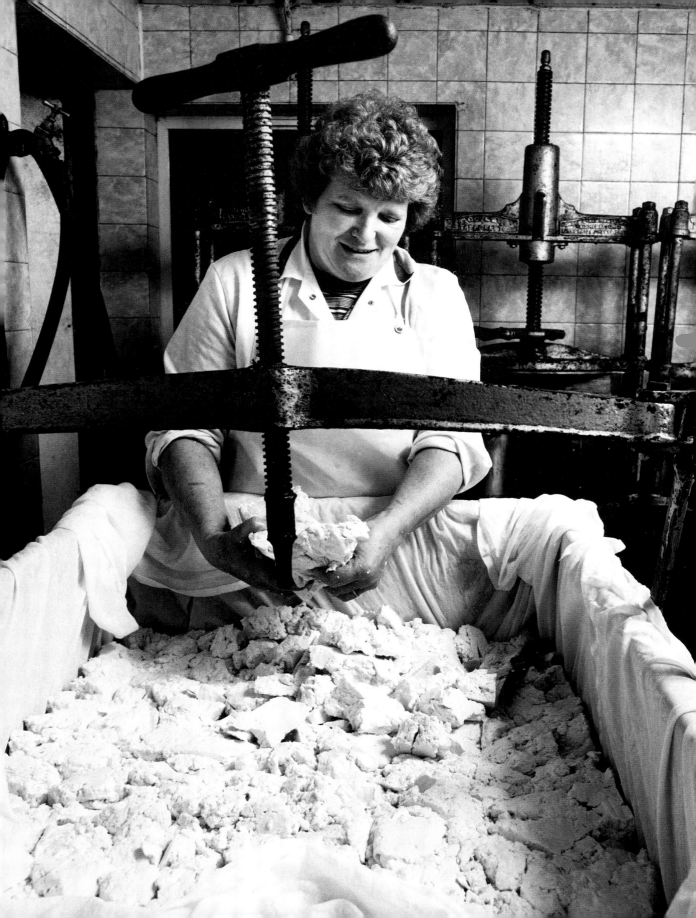

Here they will sit, each carefully dated, for at least six weeks, some for two or three months, changing slowly from the pallid white of the young cheeses, through a deep buttercup yellow, to cylinders of what look like sections of pillars, on which the white is mottled with grey and green-grey streaks.

'Six weeks, that's when I like them. London likes them a bit older. But that's London, isn't it? They like a tastier cheese.'

Today Mrs Kirkham made four medium six-pound cheeses, and eight three-pound minis, roughly the equivalent to four traditional, classic forty-five-pounders. That isn't a lot, but the curd needs careful handling if it is to achieve the distinctive combination of crumbliness and creaminess Mrs Kirkham cherishes.

It's consistency she's aiming for all the time, the balance between richness and acidity, creaminess and crumbliness, an ideal which she has firmly fixed in her – I was going to say head, but, really, it's in her whole being.

'I like a good flavour, and quite creamy. I'm not keen on it being too dry or too crumbly. Just a bit crumbly, that's the way I like it.' Spring is best, according to Mrs Kirkham, when the cows have been turned out on the new grass for the first time.

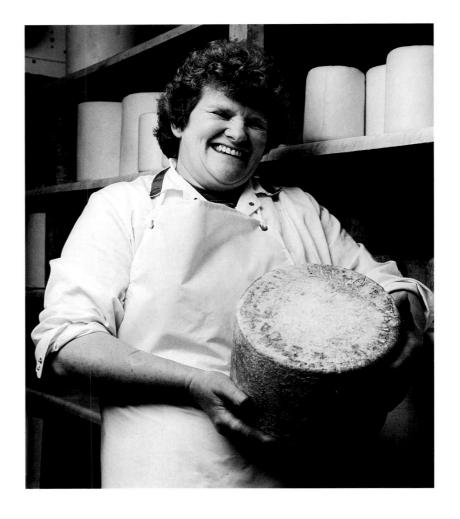

It isn't an easy business. Quality has to be fought for and rigorously maintained all the way through the process, from the pasture, the cows and their feed, through the starter, the rennet and the salt, to the finished cheeses.

Their herd has never had a single case of BSE. They have always bought their animal feed from a small, family-run local firm, they know personally, and who can assure them that no animal protein has ever been included in the mix.

Even that stage-by-stage quality control has not protected them from the fads and vagaries of the wider world. Once they thought of going over to pasteurized milk. That was at the time of the listeria scare, and no one seemed to care very much for the traditional farmhouse

cheeses of the kind Ruth and John Kirkham were making. But Randolph Hodgson saved them from that. He came up, showed that he was interested and nursed them through the difficult patch.

Then they were tempted to try vegetarian rennet, but that experiment was quickly abandoned. 'There was no comparison,' Mrs Kirkham observes drily.

Now one or two other makers are venturing back to the traditional farmhouse Lancashire. There's Shorrocks down the road, who make an unpasteurized cheese, but they wax theirs. Mrs Kirkham thinks buttering produces a more natural result. Butter allows the cheese to breathe, and any extraneous whey to seep out. Wax imprisons the whey, which, under extreme conditions, such as when it is very hot, can crack the wax coating and let in blueing organisms.

It's a far cry from the years just after the war when there were eighteen or nineteen farming families like the Kirkhams, each making their own very distinctive cheeses. The big dairies did away with them, due to the scale on which they could make cheese, and the prices they charged. Moreover, Mrs Kirkham says, there wasn't a big enough difference then in the quality between the cheeses the large dairies produced and those the small farms made.

In the end, it comes down to a matter of economics. She charges round about the £2 mark per pound for her cheese. It retails at anything between £3.10 and £5.65 a pound. You can sell your milk to the Milk Marketing Board for 82p a gallon, so the margins aren't huge.

Although there has been a wide revival of traditional small-scale cheese-making over the past ten years or so, it is still not very widely supported or even appreciated, particularly by the big cheese battalions. Specialist cheese-makers have had to fight for every scrap of the market and the position they have claimed for themselves.

In spite of that, as John Kirkham points out, they wouldn't be there if it weren't for the cheese. 'The farm next door's gone. The next but one's gone. And the next to that. And the next. There used to be fourteen farms between the crossroads and the village. Now there are two left.'

Ruth and John Kirkham work from 6.30 a.m. to 7.30 p.m., a thirteen- or fourteen-hour day, seven days a week, fifty weeks of the year. They even work on Christmas Day. Their son, Graham, helps his dad first thing in the morning, and might take on the cheese-making one day, but the two daughters aren't interested. 'They think I'm mad.' Mrs Kirkham smiles. 'The cows don't go on holiday,' she points out. 'They don't stop producing the milk.

'You only get out of life what you put into it. Making cheese isn't so bad. It may seem hard, but I say it's a job which you can set your own pace at, that lets you be with your children when they're growing up, and which you can stop and then go back to. There's not so many you can do that with,' and with that she goes back into the dairy to start turning the twenty-four-hour curd.

Outside in the sun, a dusty old dog is slumped against the wall, asleep. Near it, a Queen of Spain fritillary butterfly rests on the concrete track, warming its spread wings, looking like a large fragment of ginger biscuit. A cat and a kitten frisk in the heat. The door of the dairy suddenly opens. A hand appears and tosses a couple of scraps of curd into a patch of sunlight on the ground, then disappears again. The cats pounce on the curds and devour them with epicurean delicacy.

John Penny

'It's a Way of Life to Us, is the Meat'

Clod, shin, ribs, flat ribs, brisket, sirloin or fillet, thin flank, rump, aitch bone, thick flank, top side, shank – the thick, creamy dotted lines mark traditional cuts on the rich brown silhouette of a bull painted on wood that hangs on the wall of John Penny's office. The office is small and quite plain, apart from the bull, a pink glass paperweight, and a child's letter and drawing pinned among the faxes and orders on the notice board. It is a purposeful place, but then John is a purposeful man.

'I'll go through twenty or thirty racks of lamb for Paul, easy, before gettin' one that's good enough. 'e's very choosy, is Paul. 'e wants them quite pale, like, with a good-sized nut of meat on them.'

Like Reg Johnson, John Penny speaks with a rich uvular burr. The R's roll deeply from the back of the throat, the consonants broaden out under the roof of the mouth.

'But if someone likes what you do and they're 'appy with yer, yer tend try to do yer best for them. The Czech football team were staying at Broughton Park one time, and they decided to 'ave dinner at Longridge, an' 'e rang up wantin' these racks of lamb like yesterday. We'd already delivered there that morning. I mean, we just went out and got the racks of lamb, sorted them all out an', as soon as the van came back, they went on and they went out to 'im. That's the way we are. 'We get this 364 days a year. It's a very, very 'ard track.'

The hard track begins for John Penny and his son, Tim, at 5 a.m. every day, They 'have a quick brew in the flat up here, and then slide down the greasy pole at 5.15' to the chill and cutting rooms below, where the temperature varies between the cool and the cold, even on a summer's day.

The room in which the butchery takes place has all the functional charm of an operating theatre. It is a large white room that would look out on the high street in Clayton-le-Moors if there were a window to look out of. There isn't, but the room is searchingly lit by fluorescent tubes.

There are none of those picturesque wooden butcher's blocks either, just a series of long, narrow, pallid plastic chopping surfaces on stainless-steel frames. Against these the meat looks curiously denatured. The connection between the soft maroon commas of French-trimmed lamb cutlets, a faint line of white fat tracing their edge, thin, bare rib bones sticking up in lines in a diminutive can-can, and the living animal from which they came is no longer apparent.

It is, however, apparent to John Penny. He looks at meat with a farmer's eye because he was one once, like his father and grandfather before him, at Waddington, up near Clitheroe.

He worked for his father: 'Like, for nothing basically. Then I got married and had a couple of kids and I weren't making much money, and I was gettin' aggro from me wife, 'nd that.

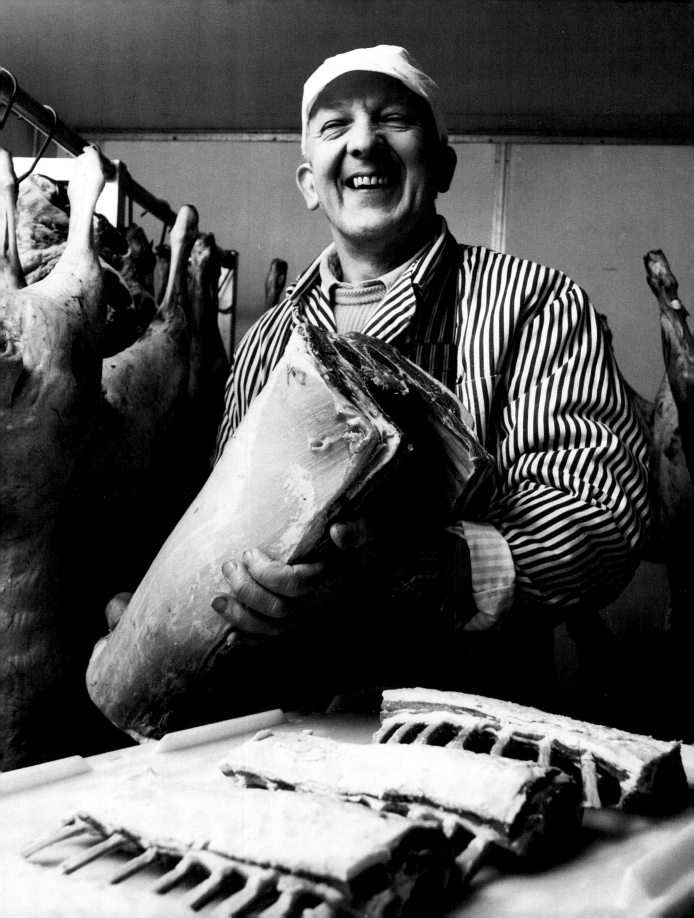

'Not 'avin' enough land to expand, I decided to go into pigs because they didn't need land, just buildings. We had been on beef and sheep. We'd never bothered with pigs like. They were an unknown thing, were pigs.

'So I went into these pigs, and we were into pigs for five or six years. And what we were doing was bringin' them on to a certain age and then sending them on to the fattener to finish off.

'Of course, I wasn't making much money out of these pigs of mine. In fact, I were losin' money. And then we thought, why don't we finish them off to pork weight? There was this little slaughterhouse about five mile away, and we'd 'ave them slaughtered and we'd cut them up ourselves and sell them to friends.

'So that's what we did. It were totally illegal, mind. I mean, the restrictions in them days weren't like what they are now. You couldn't do that today, start up like that.

'My father, 'ed always cut up pigs and lambs during the war for the black market. They always used to kill a pig or a lamb or two to sell round. So 'e'd the basic knowledge of cutting up pigs and lambs, see. So that's what we did. They were fantastic pigs, with just the right amount of fat on, and they ate really well. We built up a good trade, selling twenty or thirty pigs a week like this.

'And then people'd say, do you not do lamb or beef? This was in, what, the late '60s, when the freezer thing was just taking off. Everyone was gettin' the biggest chest freezer they could find, and fillin' it up with half a cow like.'

Sensing the commercial possibilities, John Penny converted a small building on the premises into a butchery unit, and learned how to cut up animals from Jim Parkinson, a retired butcher in Clitheroe.

'Jim would never really show me 'ow to do it, but I kept an eye on 'im, and I see 'ow 'e cut the beef up. Then one day I said, "I'm going to bone this animal out meself, whether I make a mess of it or not." And I boned the animal out and I did make a mess of it, but I learned by me mistakes. And I honed me own skills on the job, so that, even though I'm not trained as a butcher, all those butchers who work with me like my way better than what they were taught first. We do everythin' different from what it should be done.'

As he says this, his Green River boning knife moves with the smooth and absolute control of hours of practice. The thin blade lifts the silvery membrane and peels it back. A couple of deft flicks separates untidy shards of meat. Twenty seconds from start to finish, and the fillet is ready to be cut into the precise portions specified by whichever customer.

'It's going more and more the Continental way, cutting along the muscle. They've got ahead of us a bit. People want a small piece of meat, probably better trimmed, not wanting the fat.

'Before, yer slaughterhouses just used to kill yer meat and hang it in the carcass. Then it went out to a butcher like ourselves. And then they'd prep [prepare] it out into smaller joints and send it out to restaurants, and then the restaurant chefs would prep it up into the stuff you see on yer plate.

'Now it's all moved down one. We're doing the chef's work in prepping the meat. Even for Heathcote's it's 99 per cent prepped. All the shoulders are boned out. All the chumps are boned out. They have a pork dish on the menu, so they ring up and order sixty 200-gram pieces of pork.

'If we're doing 'eathcote's Longridge restaurant, Paul buys six-ounce portioned fillets off us totally trimmed. 'E only wants tournedos, cos, obviously, 'e's chargin' top-whack price, an' 'e wants perfectly shaped fillet, so we only take three fillets out of the middle of each one, which are suitable for 'im. The 'ead, we seam that out, and we might get one out of the middle of it, which wouldn't suit Paul, but is probably adequate for another place. While Paul might use ten fillets a week at Longridge, there're places which might use fifty fillets a day, so we can build them into his order.

'It's all fitting the bits in, yer see, when you've broke a piece of meat up. A normal butcher probably wouldn't be able to get shot of everything, but fortunately our trade's built up over the years, so we can incorporate all the bits and pieces.

'The legs of lamb are a good example. What we're doing now with a leg of lamb, like this,'and he props a full, rounded leg against the striped apron. The delicate tracery of fat on the outside looks like a dusting of snow on Pendle Hill. 'The shank, we take that off completely.' A butcher's chopper swings in a short arc. There's an abrupt, purposeful 'chunk' and off comes the shank. 'That is a very sought-after piece of meat these days. They're nice because they're a set portion and the meat shrinks down and looks nice.

'Then we're takin' a complete chump off it,' and with a quick silver shiver of the knife blade and a hack of a chopper, off comes the chump. 'Then we bone them.' There's the soft, slightly liquid sound of a blade going through flesh, the muffled grinding sound as it runs down the bone. The meat peels away from the whitely pink bone. Two minutes and the leg is boned out. 'We take all the skin off –' flick, flick, flick goes the knife blade – 'and then they're roasted or they're nice cooked like a 'ot-pot, like.'

Their skills aren't paraded. They are matter of fact, precise. John and his son expend no more energy than is needed, and it is difficult to gauge either the precision or the power that work of this kind involves all the time. 'Personally, I like fifty-pound backends and saddles, not the usual thirty-five to forty pounds.

'We've still got to get shot of all the surplus bits when we've finished with the leg, so we dice it all. Luckily, we've got a good trade for that too.'

The boned leg is tied in a series of short, snappy gestures, put inside a thick plastic bag, and taken over to the vacuuming machine. This exhales a short sigh, and the boned leg is now imprisoned inside its plastic armour.

When they're working flat out, the only sounds are the soft whisper of the knife, the rasp of the saw, the chunk of the chopper, the sigh of the vacuuming, the ping-ping-ping of the weighing machine, and the crash as another heavy-duty plastic box is piled up, filled with its order – 100 French-trimmed chops, ten fillets, eight boned legs, three boned pork loins. Ah, loins of pork – long, elegant, a kind of pale pinky-grey... There's trouble with pork these days.

'It's getting very, very lean is pork. It's getting so it's just skin and meat and no fat. Like all meat, if it's fatless, it's tasteless. We like a finger thickness of fat on the pork. We sell a lot of loins of pork. We've a big loin trade in boned and rolled loins, so take all the rind off, then we roll them, then we just lay the fat back on the top and pack them like that, so they can be cooked with the fat on, and then the fat taken off.'

John Penny sells only to hotels and restaurants: 'That's what our business is.' Restaurants tend to want all the prime bits, like the fillets. So you've got to look round for customers, like hotels, who'll take the cheaper cuts. Brasseries have now come in and they're taking the cheaper cuts.

He supplies meat all over the country – well, as far away as Southampton – but he buys only locally. 'We try to source all the meat from farms we know, on the hoof, through Gisburn market mainly. I don't buy it personally, mind. There're buyers now what'll go around doin' nothin' else.'

The meat business is gradually being concentrated into fewer and fewer hands. Slaughterhouses are getting bigger. All the small ones, like those at the back of a butcher's shop that used to kill the odd cow, are gone. 'But that's progress, in't it? But I don't think the quality control is as good. People are makin' things down to a price, rather than up to a quality, aren't they? Whatever you get now, people say "ow much is it?" don't they? That's 'ow the BSE 'as come around really, because people 'ave demanded a cheap product.

'If you go to a reputable butcher who's tryin' to sell 'igh-class, quality meat at a decent price, I don't think you've any fears of catchin' anything from it.'

And he knows where. John Penny is an unstoppable fountain of information and history about local slaughterhouses, butchers and personalities. He appears to have perfect recall of every twist and turn of his colleagues' and contacts' business histories.

He still has a farmer's knowledge of breeds and feeds too. He talks knowledgeably about crossing sires, the breeding qualities of Suffolk and Texel sheep, or the failings of Belgian Blue cattle.

'Me brother-in-law 'as pedigree Belgian Blues up at 'is farm. I think they're a grotesque animal. I mean, they're just a big 'eap o' lean meat. But the farmers like them because the calves are worth so much. They're stamped with the trademark of the Belgian Blue. It may be a load of rubbish, but it's a Belgian Blue.

'Personally, I don't care what it is, but it must be from a farmer that has fed the animal from day one. What a lot do, they rear the animal, like, willy-nilly, 'nd when they get to within, like, six months of slaughter, they'll feed them corn just to put a finish on them. Them animals are a waste of time.'

And it's got to be hung properly. 'There's no substitute for hanging meat. We 'ang lamb for fourteen days and beef longer, twenty-one days. We try to 'ang pork. It doesn't need 'anging as much.

'I never cease to be surprised by meat. When the beef scare was on, I got an animal off a chap what's beef is organically produced. The price was absolutely outrageous. I wanted to 'ave a look at it. I wanted to see if there was anything in this meat what is organically grown. I can tell you, it was a pile of rubbish. It was as tough as old boots. The conformation was appalling. It didn't even taste good.

'It can soon get a bit over the top, all this cookin' and cheffin', but we're committed to supplying the best. We spend an awful lot of time trying things personally to see if they, you know, eat better. It's a way of life to us, is the meat.'

John Penny's Way with the Crackling on a Pork Chop

'I love the crackling. 'eathcote's wanted a pork chop on a Sunday. They'd a cheap Sunday lunch menu, and they wanted a pork chop on because it was 'andy money. An' I said "Do you want them de-rinded, or what?" And e' said, "What do you suggest?" I said, "I don't personally. What I do with mine is I get the pork chop, and I get me knife, and I just go down all the way round with just about 'alf an inch between each cut, and then when it crisps up, the crackling is in bite-sized chunks. You can eat a piece of yer cracklin' and a piece of yer meat." It's touches like that on a plate that make it either look right or look wrong.'

Summer Menu

First Courses

Clear Chilled Tomato Juice with Basil and Summer Vegetables

Pressed Terrine of Trout, Fennel, Celeriac and Home-dried Tomatoes with Cucumber Pickle and Saffron Dressing

Salad of Avocado and Langoustine

Roasted Lobster with Dried Citrus Fruits on a Bed of Lettuce and Braised Celery and Lobster Juice

Main Courses

Char-grilled Turbot with Roast Scallops, Spiced Tomatoes, Fondant Potatoes, Braised Chard and Orange Butter Sauce

Fillet of Cod with Lettuce and a Tartare of Mussels

Roast Saddle of Rabbit filled with Herbs and Wild Mushrooms, with Fondant Potatoes, Glazed Carrots and Red Wine and Mustard Sauce

Roast Breast of Goosnargh Chicken with Cumin Sauce and Spiced Chicken Livers

Roast Local Suckling Pig with Cider Potatoes, Baked Apple, Braised Cabbage, Smoked Bacon and Herb Juices

Desserts

Hot Strawberry Soufflés with Roasted Almond Ice-cream

Hot Vanilla and Chocolate Soufflés with White Chocolate Ice-cream

Wild Strawberry Trifle

Summer Pudding

Poached Peaches with Almond Parfait and Raspberries

Deep-fried Stilton Fritters

Clear Chilled Tomato Juice with Basil and Summer Vegetables

MAKES ABOUT 3.5 LITRES / 6 PINTS

1.25 kg / 2½ lb over-ripe tomatoes
50 g / 2 oz basil, chopped
115 g / 4 oz chervil, chopped
3 sprigs of thyme, chopped
bunch of flat-leaved parsley, chopped
1 shallot, finely chopped
125 ml / 4 fl oz white wine
salt and freshly ground white pepper
pinch of sugar (optional)
more chopped chervil, basil or
tarragon, to garnish

FOR THE SUMMER VEGETABLE GARNISH:
50 g / 2 oz tomato
50 g / 2 oz carrot
50 g / 2 oz courgette
50 g / 2 oz celeriac
50 g / 2 oz peeled broad beans
50 g / 2 oz shelled peas

1 Destalk the over-ripe tomatoes and place them in a large pot or bowl. Add the chopped herbs, shallots and white wine. Season.

2 With your hands, squeeze the tomatoes until they are all crushed. Place a piece of muslin in a large bowl and tip the tomato mixture into this, then tie up the muslin into a bag. If you have a sufficiently cold room, hang this overnight with a large container underneath to catch the juices; otherwise sit it in a colander set over a bowl in the fridge.

3 Next day, strain the resulting juice and chill again until quite cold.

4 Prepare the vegetable garnish: briefly blanch the tomato, refresh in iced water, then remove the skin. Halve, deseed and dice the flesh. Cook the other vegetables in separate pans of boiling salted water until just tender, then refresh in iced water. Drain and pat dry. Dice the courgette, carrot and celeriac.

5 Adjust the seasoning of the tomato juice; if it tastes a little sharp, add a pinch of sugar. Serve a small amount of the strained juice in a consommé cup, garnished with the chopped tomatoes, cooked diced vegetables and herbs.

Pressed Terrine of Trout, Fennel, Celeriac and Home-dried Tomatoes with Cucumber Pickle and Saffron Dressing

5 whole trout, each about 225 g / 8 oz,
filleted, skinned and pin bones removed
8 fennel bulbs, separated and destringed
1 large head of celeriac, sliced across thinly
about 600 ml / 1 pint chicken stock or
water

FOR THE HOME-DRIED TOMATOES:

3 kg / 6½ lb ripe red firm plum tomatoes,
quartered and deseeded
1 tbsp sea salt
1 tbsp sugar
olive oil, for coating

FOR THE MARINADE:

400 ml / 14 fl oz virgin olive oil
8 sprigs of basil
2 sprigs of thyme
4 sprigs of sage
2 sprigs of marjoram
2 garlic cloves, crushed
salt and freshly ground white pepper

FOR THE SAFFRON LIQUOR:

100 ml / 3½ fl oz white wine vinegar
2 tsp salt
1 tsp freshly ground white pepper
about 12 strands of saffron
sugar, if necessary

FOR THE TOMATO JELLY:

5 leaves of gelatine
250 ml / 9 fl oz tomato juice

1 Ideally 2 days before you want to serve the terrine: make the home-dried tomatoes: spread the tomato quarters on an oven tray, sprinkle over the salt and sugar and leave in a hot cupboard overnight until almost dry.

2 Next day, make the marinade for the trout: mix all the ingredients in a pan and warm them through until they are just below boiling point. Leave to cool, then add the prepared trout fillets and leave to marinate for 2–3 hours.

3 Make the saffron liquor: put 300 ml / ½ pint water in a bowl and add all the other ingredients. Leave the liquor for about 30 minutes to allow the saffron to infuse.

4 Braise the fennel in just enough of the saffron liquor to cover for about 20 minutes in a covered pan. Reserve the remaining saffron liquor to use as a dressing.

5 Cook the celeriac in the chicken stock until the slices are pliable, but not soggy.

6 Wipe the seasonings off the home-dried tomatoes and toss them in olive oil to coat well.

7 Make the tomato jelly: in a bowl, dissolve the gelatine leaves in a little warm water. Strain in the tomato juice and mix together well. Season with salt and white pepper.

8 Line a 30-x10-cm / 12-x4-inch terrine mould with the cooked celeriac, then arrange alternating layers of trout fillet, fennel and home-dried tomatoes, pouring a little of the warm tomato jelly between each layer and seasoning each layer as you go.

9 Cover the top with cling-film, then with a suitable rigid cover, and weight that lightly. Chill the terrine in the fridge for about 12 hours, ideally overnight.

10 Make the Cucumber Pickle: peel the cucumbers, halve them length-wise and remove the seeds, then slice them thinly. Thinly slice the onions; deseed and thinly slice the green pepper. In a large bowl, mix these together with the salt and leave for about 3 hours.

11 Drain the vegetables and rinse them well under cold running water. Place in a large pan with the vinegar and bring to the boil. Reduce the heat and simmer for about 25 minutes, until the vegetables are soft. Add

900 g / 2 lb cucumber
2 large onions
1 large green pepper
50 g / 2 oz salt
450 ml / ¾ pint wine vinegar
350 g / 12 oz brown sugar
½ tsp ground turmeric
¼ tsp ground cloves
2 level tsp mustard seeds
½ tsp celery seeds

the sugar and spices, stir until the sugar has dissolved and bring to the boil. Remove from the heat and allow to cool.

12 Serve the terrine cut into thick slices, with a little mound of the cucumber pickle to one side and some of the reserved saffron liquor poured around the plate.

Salad of Avocado, Langoustine and Gravadlax Salmon

12 langoustine tails
about 1.25 litres / 2 pints court-bouillon (pages 154–5)
2 avocados
salt and freshly ground white pepper

100 ml / 3½ fl oz whipping cream
25 g / 1 oz dill
pinch of cayenne pepper
1 tsp lemon juice
50 g / 2 oz lamb's lettuce
4 slices of Melba toast, to serve

FOR THE GRAVADLAX SALMON:

400 g / 14 oz boneless skinless salmon fillets
2 tbsp sea salt
2 tbsp caster sugar
85 g / 3 oz dill, coarsely chopped
25 g / 1 oz chives, chopped
grated zest and juice of 1 lemon

1 Early on the day before, prepare the Gravadlax Salmon: mix all the ingredients except the salmon together to a paste and spread this over the salmon. Wrap tightly in cling-film and chill in the refrigerator for 24 hours.

2 Next day, unwrap the salmon and scrape off the paste. Rinse the fish well under cold running water, pat dry and chop it finely. Put in a bowl, cover and chill until needed.

3 To cook the langoustine tails: bring the court-bouillon to a simmer, drop in the langoustine tails and bring back to a simmer. Cook them for about 4–5 minutes, then drain and allow to cool. Shell.

4 Halve the avocados and remove the stones and the skin. Season with salt and pepper and from each half cut out a thick round with a 7-cm / 2¾-inch pastry cutter.

5 Whip the cream until slightly stiffened and season it with salt and a pinch of cayenne pepper. Add the chopped dill and the lemon juice.

6 To serve: put a ring of the cream in the centre of each plate, place the pastry cutter on top of the cream and put a layer of the lamb's lettuce in the cutter. Put a 2-cm / ¾-inch layer of chopped salmon on top of that and press down firmly. Arrange 3 shelled langoustine tails on top of the salmon, then place the avocado round on top of those. Carefully lift off the cutter to leave the layered assembly in position. Place some Melba toast on top of the avocado and serve.

Roasted Lobster with Dried Citrus Fruits on a Bed of Lettuce and Braised Celery and Lobster Juice

zest of 2 oranges
zest of 1 lemon
1 sprig of thyme
10 rosemary leaves
leafy tops from 2 heads of fennel
2 lobsters, preferably natives, each weighing about 450 g / 1 lb
salt and freshly ground white pepper
2–3 celery stalks, strings removed and cut into long lengths
1 iceberg lettuce, broken up into pieces
knob of butter
a little olive oil

FOR THE LOBSTER JUICE:
1 small onion, chopped
4 garlic cloves, chopped
1 carrot, chopped
2 celery stalks, chopped
1 sprig of thyme, chopped
a little olive oil
100 ml / 3½ fl oz brandy
900 g / 2 lb over-ripe plum tomatoes, squeezed to remove seeds and then chopped
1 tsp whipping cream
125 g / 4½ oz butter, diced
juice of 1 lemon wedge

FOR THE GARNISH:
handful of celery leaves
oil, for deep-frying

1 Well ahead, scatter the citrus zest and the herbs on a baking tray and put to dry in a very low oven until totally dehydrated, about 2 hours. Place the dried zest and herbs (including the fennel tops) in a blender or liquidizer and grind to a fine powder.

2 Cook the lobster in boiling salted water for 4 minutes, remove and drop into a large pan of iced water. When the lobsters are cold, remove all the tail and claw meat from the shell and cut each tail into 6 pieces. Reserve the shell.

3 Cook the celery in boiling salted water until just tender and refresh in iced water.

4 Make the lobster juice: preheat the oven to 190°C/375°F/gas 5. Break up the lobster shells with a mallet and roast in the oven for about 20 minutes to concentrate the flavour.

5 Brown the onion, garlic and vegetables with the thyme in a little oil in a heavy-based pan. When brown, add the brandy and reduce by half. Add the plum tomatoes and reduce again until a thick sauce-like consistency is reached.

6 Place the roasted lobster shell in the pan, cover with water and simmer until a good strong flavour has developed, about 45 minutes. Pass through a fine sieve and boil to reduce slightly.

7 Add the cream to the simmering liquid and whisk in the butter. Adjust the seasoning, add a few drops of lemon juice and keep warm.

8 Place the blanched celery and lettuce in a pan with a very little seasoned simmering water and a knob of butter. Sauté for 20–30 seconds only, then drain off any excess liquid. Keep warm.

9 Prepare the celery leaves for the garnish: preheat the oil for deep-frying to 140°C/285°F. Carefully drop in the leaves (they are full of moisture, so they will cause spattering and lost of foaming). Cook for 20 seconds only, then remove with a slotted spoon and drain on kitchen paper. Keep warm.

10 Place a little oil in a very hot frying pan and, when that is very hot, add the lobster pieces and seal them on all sides. Season with the dried citrus zest and sauté for about 1 minute.

11 To serve: arrange the celery and lettuce around 4 bowls, add the seasoned lobster and pour a little of the lobster juice around each bowl. Garnish with the deep-fried celery leaves.

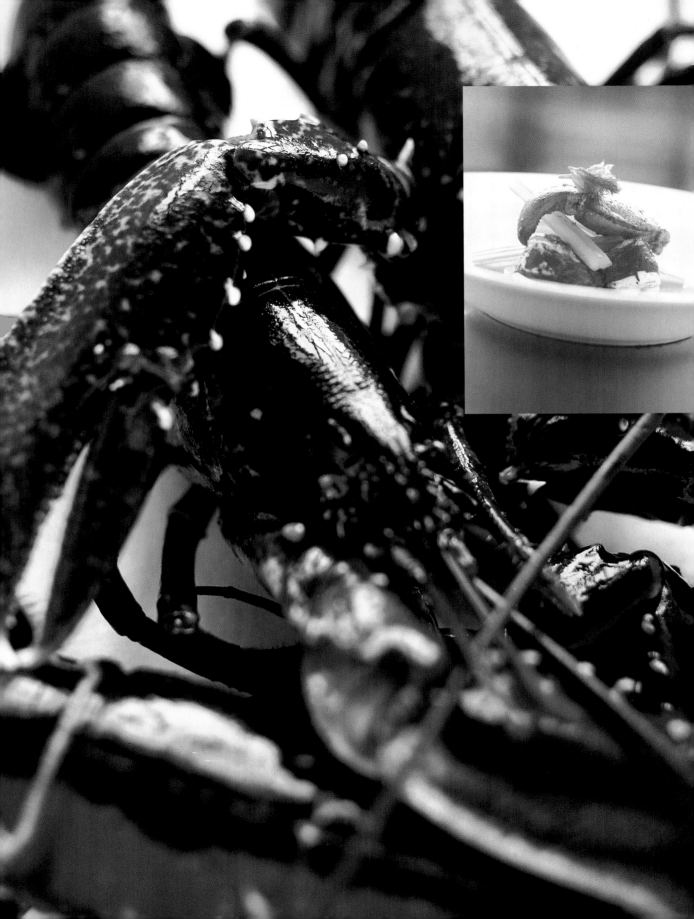

Char-grilled Turbot with Roast Scallops, Spiced Tomatoes, Fondant Potatoes, Braised Chard and Orange Butter Sauce

4 fillets of turbot, each about 175 g / 6 oz
12 shelled scallops
lemon juice

FOR THE SPICED TOMATOES:
4 ripe tomatoes, cut in half lengthwise
1 tbsp coriander seeds, crushed
2 tsp white peppercorns, crushed
50 g / 2 oz garlic cloves, roughly crushed
1 tsp chopped fresh thyme
1 tbsp sea salt
about 500 ml / 18 fl oz olive oil

FOR THE FONDANT POTATOES:
2 Maris Piper or other floury type of
potatoes, thickly sliced
100 g / 3 1/2 oz butter

FOR THE BRAISED CHARD:
500 g / 1 lb 2 oz chard
250 ml / 9 fl oz chicken stock
50 g /2 oz butter
1 tsp lemon juice

FOR THE ORANGE BUTTER SAUCE:
2 shallots, finely chopped
1 tbsp butter
finely grated zest and juice of 1 orange
2 tbsp white wine vinegar
4 tbsp white wine
1/2 tsp whipping cream
225 g / 8 oz unsalted butter, diced
lemon juice, salt, pepper and cayenne
pepper, to finish

1 Well ahead, make the spiced tomatoes: preheat the oven to 150°C/300°F/gas 2. Spread the seasonings over the base of a tray. Lay the tomato halves on top, skin-side up, and three-quarters cover with the oil. Cook in the low oven for 30 minutes, until the tomato skins are easily removed. Leave to cool slightly and remove all skins and any pips. Put the tomatoes in a clean container and cover with the olive oil (this oil becomes tomato-flavoured and can be used for salad dressings later).

2 About 45 minutes before you want to serve, make the Fondant Potatoes: put the potato slices in a heavy-based pan and cover with water. Add the butter and seasoning. Bring to the boil and boil rapidly until all the water has evaporated and only butter is left. Turn down the heat and cook until golden. Turn the slices over and cook the second side until golden. Remove from the pan and keep warm.

3 While the potatoes are cooking, prepare the Braised Chard: preheat the oven to 190°C/375°F/gas 5 and peel the chard stems. Cut them into 4-cm / 1 1/2-inch batons and place them in a pan with the rest of the ingredients. Bring to the boil, cover with a lid and place in the oven for about 30 minutes, until the chard is soft. Keep warm.

4 Meanwhile, make the Orange Butter Sauce: in a small heavy-based pan, sweat the shallots in the butter. Add the orange zest and juice, the vinegar and wine, and reduce down until only about one-fifth of the volume remains. Add the cream and whisk in the cold butter. Season with lemon juice, salt, pepper and cayenne pepper.

5 About 10 minutes before you want to serve, char-grill the turbot fillets on a preheated hot griddle pan for about 4 minutes on one side and then turn over and cook the other sides for about 30 seconds to 1 minute only, until the fillets are cooked but still moist in the centre. Season with salt and lemon juice. Keep warm.

6 Put a little oil in a hot frying pan. When that is hot, cook the scallops on one side to get them golden-brown and caramelized. Turn them over and cook for a few seconds more. Season with salt and lemon juice.

7 To serve: arrange some chard in the centre of 4 warmed serving plates. Arrange tomatoes on either side of the chard and place the fish on top of the chard. Put some fondant potato at the top of each plate and some scallops at the bottom. Spoon the sauce around the plates.

Fillet of Cod with Lettuce and a Tartare of Mussels

4 fillets of cod, each about 125 g / 4¹/₂ oz
a little oil
salt
lemon juice
200 g / 7 oz iceberg lettuce, separated into chunks
1 garlic clove
20 g / ³/₄ oz butter

FOR THE NAGE:
2 onions
1 leek
½ fennel bulb
2 celery stalks
3 carrots
4 garlic cloves
1 bay leaf
sprigs of parsley, coriander, tarragon, chervil and thyme
12 pink peppercorns
4 coriander seeds
2 heads of star anise
200 ml / 7 fl oz dry white wine
¹/₂ tsp whipping cream
125 g / 4¹/₂ oz butter, diced
salt and freshly ground white pepper
lemon juice

FOR THE MUSSEL TARTARE:
20 mussels, well scrubbed and discarding any that stay open
dash of wine
20 g / ³/₄ oz onions, finely diced
30 g / 1¹/₂ oz capers, preferably dry-salted, rinsed
30 g / 1¹/₂ oz gherkins, diced
1 plum tomato, blanched and skinned, seeds removed and flesh diced
1 tbsp chopped parsley

1 The day before, make the nage: roughly chop all the vegetables and place in a large pan with the herbs, spices and 1.25 litres / 2 pints of water. Bring to the boil, then lower the heat and simmer for 20 minutes. Add the wine, bring back to the boil and immediately remove from the heat. Allow to cool, then chill overnight.

2 Next day, chill the fish fillets in the fridge until they are required for cooking, to help firm them up.

3 Strain the chilled nage then boil to reduce it down by a half. Add the cream and whisk in the cold butter. Season with salt, pepper and a little lemon juice.

4 Prepare the mussel tartare: steam the mussels in a dash of wine in a tightly covered pan until they open. Turn out of the pan and allow to cool a little. Meanwhile, blanch the onions briefly in boiling water, then drain and refresh in cold water. Pat dry. Remove the mussels from their shells and place in a bowl with their finely strained juices. Set aside.

5 Get a frying pan good and hot, add a little oil and, when that is hot, fry the cod fillets for about 4–5 minutes on one side. Turn them over and cook the other sides for 30 seconds to 1 minute only. Season with salt and a little lemon juice.

6 At the same time, in a small pan, cook the lettuce with the garlic and the butter briefly until welted. Season.

7 Place the lettuce in the bottom of 4 warmed bowls and put a piece of cod on top. Keep warm.

8 Finish the mussel tartare: add the capers, onion, gherkin, tomato and parsley to the nage. Adjust the seasoning again with salt and lemon juice, then add the mussels with their liquid. Heat through, but do not allow to boil.

9 Pour the mussel tartare garnish and sauce over the cod and serve.

Roast Saddle of Rabbit filled with Herbs and Wild Mushrooms, with Fondant Potatoes, Glazed Carrots and Red Wine and Mustard Sauce

4 whole rabbits (see opposite)
salt and freshly ground black pepper
500 g / 1 lb 2 oz assorted wild
mushrooms, such as girolles, ceps
about 550 ml / 19 fl oz chicken stock
2 garlic cloves, halved
1 sprig of thyme
250 g / 9 oz smoked bacon
a little oil
550 ml / 19 fl oz whipping cream

FOR THE SAUCE:
a little olive oil
3 shallots, thinly sliced
2 tsp mustard seeds
2 garlic cloves, thinly sliced
550 ml / 19 fl oz full-bodied red wine
about 550 ml / 19 fl oz chicken stock
550 ml / 19 fl oz veal stock

FOR THE GLAZED CARROTS:
2 carrots
15 g / 1/2 oz butter
1 garlic clove, halved
1 sprig of tarragon

FOR THE BRAISED CABBAGE:
1 Savoy cabbage
15 g / 1/2 oz butter
150 g / 5 oz bacon lardons, chopped
into fine strips
2 shallots, finely chopped

FONDANT POTATOES (SEE PAGE 59)

1 Ask your butcher to prepare the rabbits for you as follows: skin and clean them; remove the legs and shoulders, leaving the saddle; loosen the sinew along the backbone, but retain it (to protect the meat during cooking); remove the fillets from the saddle, taking off the sinew at the top of the fillets and reserving all the belly for wrapping the stuffing in place. Chill the rabbit saddle and legs in the fridge.

2 Take the rabbit leg meat off the bone and trim off any skin, fat or sinew. Reserve the bones in the fridge. Finely dice the meat and place in a food processor. Pulse for 1 minute. Add 2 pinches of salt and pulse for a further minute, then chill in the fridge.

3 Make the sauce: preheat the oven to 190°C/375°F/ gas 5. Chop the rabbit bones and roast in the oven for 15 minutes, until golden brown. Add some oil to a hot pan, then add the shallots, half the mustard seeds and the garlic, and cook until golden brown. Deglaze the pan with the wine and reduce to a sticky consistency. Add the chicken stock and veal stock and reduce gently until the consistency of a pouring sauce. Pass through a muslin cloth, add the rest of the mustard seeds and season.

4 Prepare and clean the wild mushrooms. Reserve about a quarter for garnish. Place the mushrooms in a pan, half cover with chicken stock, add the garlic and sprig of thyme, and cook until all liquid is reduced and the mushrooms are dry. Season and allow to cool.

5 Trim the smoked bacon and cut it into fine lardon strips. Blanch in boiling water for 30 seconds, then refresh in cold water. Reserve half for garnish. Fry the rest of the bacon in a little oil in a hot pan until golden brown. Place on a pile of kitchen paper to drain off as much fat as possible, then mix into the wild mushrooms.

6 Take the pulsed rabbit meat from the fridge and pulse again, slowly adding the cream. Season and press through a fine drum sieve. Mix the mushrooms and bacon into the mousse and adjust the seasoning.

7 Take the prepared saddles from the fridge and place the fillets on top of the belly, then spread the mousse on top of them. Wrap the belly flaps back around the fillets and mousse, then wrap in foil. Replace in the fridge for 30 minutes to firm up.

8 Glaze the carrots: slice the carrots into 6-mm / 1/4-inch chunks. Half cover with water, add the butter, garlic, tarragon and salt. Cook until all the

water has evaporated and the carrots are glazed, about 15–20 minutes.

9 Braise the cabbage: blanch the leaves until tender and refresh. Drain and shred finely. Place the butter in a pan, add the bacon and sweat for 2 minutes. Add the shallots and sweat until softened but not coloured. Add the cabbage and cook gently for a minute or so. Season.

10 Preheat the oven to 200°C/400°F/gas 6, then cook the stuffed saddle for 5 minutes. Allow to rest for 3–4 minutes before removing the foil.

11 Prepare the reserved wild mushrooms for garnish. Sauté them quickly in a little oil in a hot pan. Drain off the fat and season.

12 Place a pile of cabbage in the centre of each warmed serving plate. Carve each rabbit fillet across into half and arrange on either side. Scatter the vegetable garnish and mushrooms over the plate and place some fondant potatoes at the top of each plate. Spoon the sauce around the plate.

Roast Breast of Goosnargh Chicken
with Cumin Sauce and Spiced Chicken Livers

4 breast fillets from corn-fed chicken
a little oil for frying
225 g / 8 oz scrubbed new potatoes
115 g / 4 oz green beans
knob of butter
salt and freshly ground white pepper

FOR THE CUMIN SAUCE:
6 shallots, finely chopped
1 garlic clove, finely chopped
1 heaped tsp ground cumin
100 ml / 3$^{1}/_{2}$ fl oz dry white wine
sprig of thyme
1 litre / 1$^{3}/_{4}$ pints chicken stock

CELERIAC PURÉE (PAGE 162)

FOR THE SPICED CHICKEN LIVERS:
450 g / 1 lb chicken livers, trimmed to neaten
1 tbsp ground coriander
1 tsp each ground star anise,
cinnamon, mixed spice, mace and nutmeg
$^{1}/_{2}$ tsp ground cumin

1 First make the cumin sauce: heat the oil in a heavy-based pan and brown the shallots and garlic. Add the cumin and cook briefly. Pour in the wine and deglaze the pan, then boil rapidly to reduce by half. Add the thyme and stock and boil to reduce to a good sauce-like consistency, 20-30 minutes. Strain and keep warm.

2 Make the Celeriac Purée as described on page 162 and keep warm.

3 Preheat the oven to 180°/350°F/gas4. Season the chicken breasts. Heat the oil in an ovenproof pan or casserole over a high heat and cook the breasts, skin side down for about 20 seconds to seal.

4 Turn the breasts over, place in the oven and roast until cooked, about 10 minutes. Remove from the oven, take the chicken from the pan and allow to rest in a warm place for about 5 minutes before serving.

5 While the chicken is roasting, cook the potatoes and beans separately in boiling salted water until just tender. Drain well.

6 At the same time, cook the Spiced Chicken Livers: in a large bowl, mix all the spices together and toss the livers in them to coat. Get the oil good and hot in a large frying pan and seal the livers in it on one side. Turn them over, reduce the heat slightly and cook until firm but still pink in the centre, 2-3 minutes in total.

7 To serve: reheat the potatoes and beans gently in a little water with a knob of butter. Spoon a pile of the celeriac purée into the centres of 4 semi-shallow bowls, arrange the chicken on top and the chicken livers and potatoes around them. Scatter the beans over and dribble over the sauce.

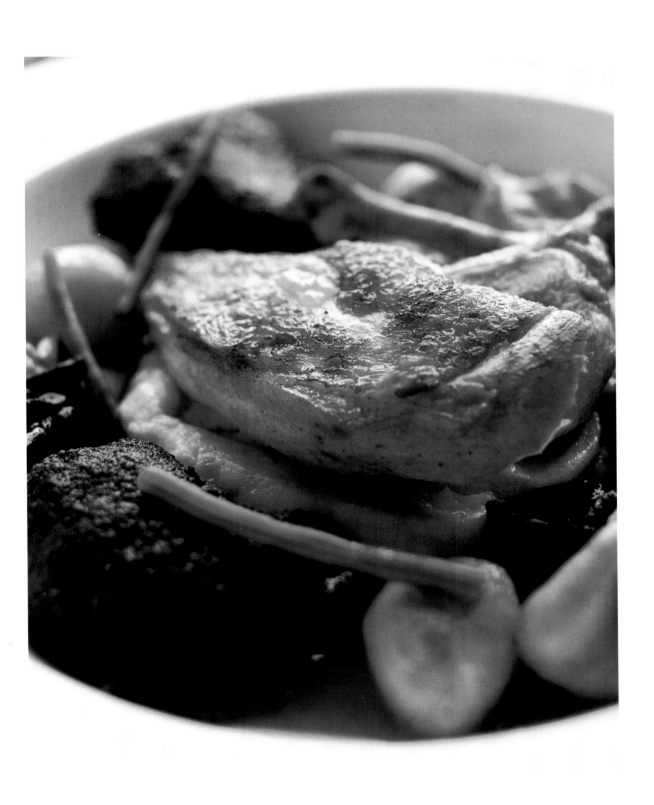

Roast Local Suckling Pig with Cider Potatoes, Baked Apple, Braised Cabbage, Smoked Bacon and Herb Juices

SERVES 6

350 g / 12 oz each shoulder, belly and leg from a suckling pig, together with 1 best end (ask the butcher to give you all the bones and trimmings for stock)

FOR THE PORK STOCK:
1 small onion, chopped
4 garlic cloves, chopped
1 carrot, chopped
2 celery stalks, chopped
a little oil
4 tomatoes, blanched, skinned, deseeded and coarsely chopped
4 black peppercorns

1 Preheat the oven to 220°C/425°F/gas 7. Remove the bone and any sinew from the shoulder. Chine the best end, leaving 6 bones. Cut the meat from the belly pork and trim to neaten. Remove the bone from leg and remove any sinew. (You can ask your butcher to do all this for you.)

2 Make the pork stock: roast the bones until golden in colour, about 20 minutes. Sweat the onion, garlic, carrot and celery briefly in a little oil in a large heavy pan, until softened but not coloured. Add the bones, tomatoes and peppercorns. Toss to coat, then just cover with water. Bring to the boil, lower the heat and simmer for about 30 minutes, skimming from time to time. Sieve and return to the pan, then boil rapidly to reduce down to about 1 litre / 1³/₄ pints.

3 At the same time, put the meat to roast at the same oven setting for about 1 hour, until the skin is crispy and the meat is cooked through. Add the best end halfway through,

4 When the pork stock is ready, make the herb juices: in a large pan, sweat the shallots in a little oil with the thyme and half the sage until softened but not coloured. Add the apple juice and reduce down until the liquid has a syrupy consistency. Add the pork stock and chicken stock and reduce again by two-thirds. Add the veal stock and reduce until it has a good pouring sauce consistency. Chop the remaining sage and the tarragon finely, add to the sauce and adjust the seasoning. Keep warm.

5 Prepare the Baked Apples: using a melon baller, take out the cores from the apples. Fill the centre of the apples with chutney. Dust well with caster sugar and bake in the coolest part of the oven with the pork towards the end of its cooking time until soft, about 20 minutes. Remove from the oven, dust again with caster sugar and place under a hot grill until golden in colour. Keep warm.

6 Make the Cider Potatoes: cut the potato slices into rounds using a 5-cm / 2-inch diameter circular cutter. Place in a large pan and cover with cider. Add the butter and salt to taste. Place over a high heat and bring to the boil. Gently reduce the liquid until it is syrupy and the potatoes have started to caramelize, turning them until they are nicely golden all over. If the potatoes are coloured but not cooked, add a little water and repeat the process. Remove the potatoes from the pan and keep warm.

7 Braise the cabbage: blanch the cabbage leaves until tender and refresh in iced water. Drain and shred finely. Place the butter in a pan,

FOR THE HERB JUICES:
5 shallots, finely chopped
a little olive oil
5 sprigs of thyme
5 sprigs of sage
500 ml / 18 fl oz apple juice
1 litre / 1³/₄ pints chicken stock
1 litre / 1³/₄ pints veal stock
5 sprigs of tarragon, finely chopped
salt and freshly ground black pepper

FOR THE BAKED APPLES:
4 Granny Smith apples, topped and tailed
175 g / 6 oz sultana and apple chutney
115 g / 4 oz caster sugar

FOR THE CIDER POTATOES:
6 large baking potatoes, peeled and cut into slices 2.5 cm / 1 inch thick
1 litre / 1³/₄ pints sweet cider
50 g / 2 oz butter

FOR THE BRAISED CABBAGE:
450 g / 1 lb cabbage, separated
100 g / 3¹/₂ oz smoked bacon, blanched and chopped
50 g / 2 oz butter
50 g / 2 oz shallots, chopped

add the bacon lardons and sweat for 2 minutes. Add the shallots and sweat until softened but not coloured. Add the shredded cabbage and cook gently for a minute or so. Season.

8 To serve: put a baked apple to one side of each plate and some cider potatoes to the other. Make a mound of cabbage in the centre. Slice the pork shoulder. leg and belly and arrange on top of the cabbage with a cutlet on top of that. Pour the herb juices around.

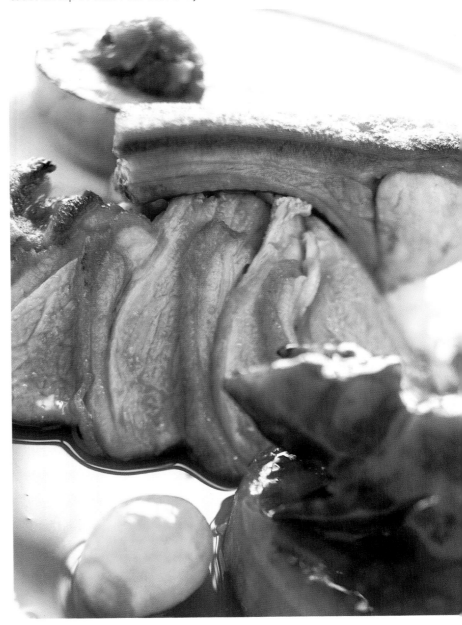

Hot Strawberry Soufflés with Roasted Almond Ice-cream

butter for greasing the ramekins
about 225 g / 8 oz caster sugar, plus
more for the ramekins
500 g / 1 lb 2 oz strawberries
1 tsp cornflour
whites of 4 eggs

**FOR THE ROASTED ALMOND
ICE-CREAM:**
100 g / 3½ oz flaked almonds
500 ml / 18 fl oz milk
250 ml / 9 fl oz whipping cream
10 egg yolks
125 g / 4½ oz caster sugar

1 Well ahead, make the Roasted Almond Ice-cream: preheat the oven to 150°C/300°F/gas 2. Roast the flaked almonds in the oven until golden, about 15 minutes (keep an eye on them, as they can burn fast).

2 Put the roasted almonds in a pan with the milk and cream, bring to just below the boil and leave to infuse off the heat for 30 minutes. Pass through a fine sieve and discard the almonds.

3 Whisk the egg yolks and sugar together in a heatproof bowl until light. Reheat the almond-flavoured milk mixture and pour over the egg mixture. Pour back into the pan and cook, stirring continuously, until the custard is thick enough to coat the back of a spoon. Remove from the heat. Pass through a fine sieve and allow to cool.

4 Churn in an ice-cream maker until frozen.

5 Make the soufflés: preheat the oven to 180°C/350°F/gas 4 and grease 4 ramekins with butter, then dust the buttered insides with sugar, shaking out any excess.

6 Put half the sugar in a pan with the strawberries and a little water. Simmer for about 5–10 minutes.

7 Liquidize in a blender or food processor, then pass through a sieve to remove the seeds. Adjust the sweetness with a little more sugar, if necessary, and cook until it has a good pouring consistency.

8 Thicken 4 tablespoons of the resulting coulis with the cornflour. Beat the egg whites to a meringue with the remaining sugar. Make a paste with the coulis and a little of the meringue and then fold in the rest of the meringue.

9 Pour into the soufflé dishes and bake until fully risen, 10–12 minutes.

10 Serve the soufflés as soon as they are ready, with the ice-cream on a side plate surrounded by a cordon of the remaining strawberry coulis.

Hot Vanilla and Chocolate Soufflés

with White Chocolate Ice-cream

butter, for greasing the ramekins
150 g / 5 oz caster sugar, plus more
for the ramekins
2 vanilla pods, split lengthwise
2 tsp cornflour
1/2 lemon
whites of 6 very fresh eggs

FOR THE WHITE CHOCOLATE ICE-CREAM:
6 egg yolks
200 g / 7 oz caster sugar
250 ml / 9 fl oz milk
250 ml / 9 fl oz whipping cream
150 g / 5 oz white chocolate
3 tbsp white crème de cacao or
Cointreau

FOR THE CHOCOLATE SAUCE:
200 g / 7 oz caster sugar
50 g / 2 oz couverture chocolate
15 g / 1/2 oz cornflour
50 g / 2 oz cocoa powder

1 Well ahead, make the White Chocolate Ice-cream: in a large heatproof bowl, cream the egg yolks and sugar until light. Bring the milk and cream to just below the boil and pour over the egg mixture, whisking continuously. Pour the mixture back into the pan and cook until it is thick enough to coat the back of a spoon. Pass through a fine sieve. Add the chocolate and the liqueur, whisking until it has all dissolved.

2 Place in an ice-cream machine and churn until frozen.

3 Make the Chocolate Sauce: put 250 ml / 9 fl oz of water, half the sugar and the chocolate in a pan and bring to the boil. Meanwhile, mix the cornflour, cocoa and remaining sugar to a paste with 4 tablespoons of water. Add this paste to the boiling chocolate mixture and cook for about 5 minutes, until thick, stirring frequently. Pass through a sieve and allow to cool.

4 Make the soufflés: preheat the oven to 180°C/350°C/gas 4 and evenly grease 4 ramekins with butter. Then coat the insides with sugar, shaking out any excess.

5 Scrape the seeds of the vanilla pods into a pan and add 200 ml / 7 fl oz water. Bring to the boil. Mix the cornflour with a little water, stir this in and simmer briefly until thick and smooth.

6 Ensure that your whisk and mixing bowl are free from grease, then rub the sides of the bowl with the cut side of the lemon. Place the egg whites in the bowl (also ensuring there are NO yolk particles) and start to whisk. Gradually add the sugar as you whisk, until the meringue mixture is standing in soft peaks. Stir in the juice from the half lemon.

7 Take one-third of the meringue and whisk it into the thickened vanilla mixture, then lightly fold in the remaining meringue. Do this gently so the air is not knocked out of the mixture.

8 Spoon a little of the chocolate sauce into the bottom of the ramekins and top up with the soufflé mix. Smooth the surface and run your thumb around the inside of the rims to ensure that the sides will rise straight. At this stage, the soufflés can be held in the fridge for a number of hours until needed.

9 Space the soufflés out on a baking tray and bake for 10–15 minutes, depending on the size of the ramekins, until well risen.

10 While the soufflés are baking, transfer the ice-cream to the fridge to soften slightly.

11 Serve the soufflés as soon as they are cooked, with the white chocolate ice-cream.

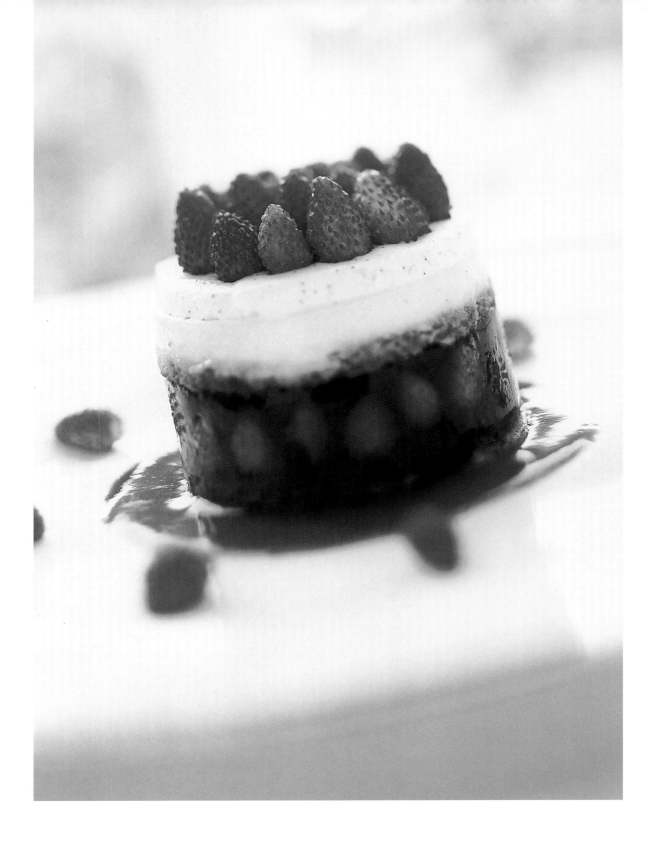

Wild Strawberry Trifle

a little dry sherry
8 large firm ripe strawberries, halved
250 ml / 9 fl oz whipping cream,
whipped until firm
about 115 g / 4 oz wild strawberries
(fraises de bois), or small cultivated
strawberries, to decorate

FOR THE SPONGE:
4 eggs
125 g / 4$\frac{1}{2}$ oz caster sugar
125 g / 4$\frac{1}{2}$ oz flour
1 tsp cornflour

FOR THE CUSTARD:
550 ml / 19 fl oz double cream
1 vanilla pod, split
9 egg yolks
25g / 1 oz flour
150 g / 5 oz caster sugar
1 leaf of gelatine

FOR THE RED WINE JELLY:
375 ml / 13 fl oz fruity red wine,
ideally a Beaujolais
200 g / 7 oz caster sugar
6 sprigs of basil
6 black peppercorns
4 leaves of gelatine

**FOR THE HOT STRAWBERRY
COULIS:**
450 g / 1 lb strawberries
about 115 g / 4 oz caster sugar

1 First make the sponge: preheat the oven to 150°C/300°F/gas 2 and line a baking sheet with baking paper. Beat the eggs and sugar together until completely aerated and light. Sift in the flour and cornflour, spread on the prepared baking sheet to make a layer about 1 cm / $\frac{1}{2}$ inch deep and bake until golden, about 20 minutes. Allow to cool.

2 Using the base of the moulds in which you are going to make the trifles (you need something with a diameter of about 10 cm / 4 inches – try a well-cleaned used can, with top and bottom removed, or new plastic drainpipe cut into short lengths), cut the sheet of sponge into rounds the size you require.

3 While the sponge is baking, make the custard: bring the cream with the split vanilla pod to just below the boil in a heavy-based saucepan. Meanwhile, in a large heatproof bowl, cream the egg yolks, flour and sugar together until light. Pour the hot cream on the egg mixture, stirring, and then pour this back into the pan. Stir the custard continuously over a low, even heat until it is thick enough to coat the back of a spoon.

4 Soften the gelatine in a little water. When it is soft, add to the custard. Sieve into a container and allow to cool. Cover with cling-film, punctured in two or three places, to prevent a skin forming.

5 To make the red wine jelly: in a pan, bring the wine to the boil with the sugar, basil and peppercorns, stirring from time to time. Then sieve the mixture into a heatproof bowl and allow to cool a little. Stir in the gelatine until well combined.

6 Place a layer of sponge on the bottom of the mould and sprinkle with sherry. Place some halved strawberries around the edge, with their cut sides outwards, and pour in some of the jelly until it reaches the level of the tops of the strawberry halves. Allow to set in the fridge for about 1 hour.

7 Place another layer of sponge on top of the jelly, sprinkle with more sherry and pour on the the custard. Leave to set once again in the fridge for another 30 minutes or so.

8 Make the strawberry coulis: put the strawberries and sugar in pan with a drop of water and bring to the boil. Cook until a syrup has formed that is thick enough to coat the back of a spoon. Purée in a blender or food processor, then strain through a sieve to remove seeds. Adjust the sweetness with a little more sugar, if necessary.

9 Remove the trifles from their mould (run a sharp knife round the inside edge and/or dip the moulds briefly in hot water to help). Spoon some of the coulis in the centre of each of the serving plates, set the trifles on top of this and pipe some of the cream on top of the trifles. Decorate with the wild or small strawberries.

Summer Pudding

12 thin slices of white bread
675 g / 1½ lb mixed red and black
fruit, such as raspberries,
strawberries, redcurrants, black-
currants, stoned cherries
175 g / 6 oz sugar
15 g / ½ oz gelatine

TO SERVE:
English custard sauce
more summer fruit
clotted cream

1 The day before you want to serve: cut 4 small circles of greaseproof paper to line the bottom of each of 4 individual dariole moulds.
2 Remove the crusts from the bread and roll the slices out more thinly with a rolling pin. From the slices of bread, first cut out 4 circles roughly the size of the bottoms of the dariole moulds (use a suitable cup or glass) and 4 to match the tops (use a dariole mould as the cutter for these). Cut the other slices into rectangles.
3 Put the fruit and sugar in a saucepan and bring to the boil. Simmer for about 5 minutes. Dissolve the gelatine in a little water. Pass the fruit through a sieve. Stir the dissolved gelatine into the strained liquid and stir until well mixed.
4 Dip the base circles of bread into the liquid and use them to line the bottoms of the moulds. In the same way, line the sides of the moulds, overlapping the pieces slightly and allowing a little of the bread to overhang the tops.
5 Pack the moulds with the fruit and pour a little of the juice over the top. Dip the top circles in the liquid and place on the fruit. Fold over the overhanging pieces of bread to secure the tops. Chill for 24 hours before serving.
6 Serve the puddings on top of some English custard dotted with summer fruit, setting a quenelle (moulded with 2 spoons) of clotted cream on top of the pudding.

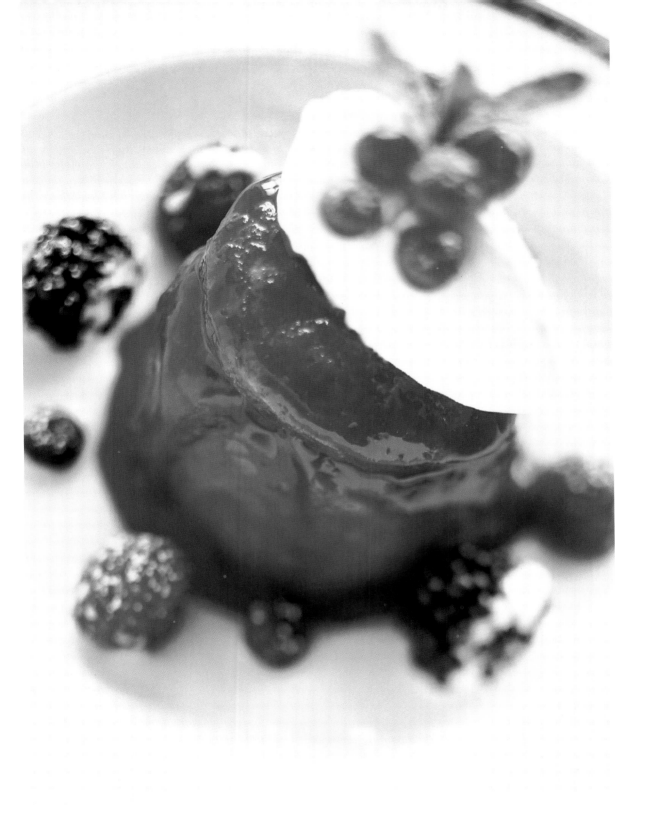

Poached Peaches with Almond Parfait and Raspberries

250 g / 9 oz caster sugar
1 cinnamon stick
1 vanilla pod
4 peaches
raspberries, to decorate

FOR THE ALMOND PARFAIT
250 ml / 9 fl oz milk
1 vanilla pod
6 egg yolks
225 g / 8 oz caster sugar
4 drops of almond essence
375 ml / 13 fl oz whipping cream,
whipped to ribbon stage

FOR THE RASPBERRY COULIS:
450 g / 1 lb raspberries
about 150 g / 5 oz caster sugar

1 Well ahead, make the Almond Parfait: put the milk and vanilla pod in a pan and bring to just below the boil. Whisk the egg yolks and sugar together in a heatproof bowl until light. Pour the milk over the egg mixture, then return to the pan and cook, stirring continuously, until the custard coats the back of a spoon. Remove from the heat. Pass through a fine sieve, stir in the almond essence and allow to cool. When cool, mix in the cream. Churn in an ice-cream maker until frozen.

2 Prepare the peaches: put the sugar in a pan with 500 ml / 18 fl oz of water and the cinnamon stick. Scrape out the seeds from the vanilla pod and add them with the scraped pod as well. Bring the syrup to the boil, then reduce the heat to a simmer.

3 Poach the peaches in the syrup until cooked but not too soft (so the skin can easily be removed), about 15–20 minutes (although, if the peaches are very ripe, as little as only 2 or 3 minutes may be needed).

4 Transfer the parfait from the freezer to the fridge about 20 minutes before you want to serve.

5 Make the raspberry coulis: put the raspberries and sugar in pan with a drop of water and bring to the boil. Cook until a syrup has formed that is thick enough to coat the back of a spoon. Purée in a blender or food processor, then strain through a sieve to remove seeds. Adjust the sweetness with a little more sugar, if necessary.

6 Spread a layer of the raspberry coulis in a circle on the bottom of each serving plate and place a slice of parfait on top, then top that with a peach. Decorate with some raspberries.

Deep-fried Stilton Fritters

THE PREPARATION OF THE
FRITTER BATTER IS SIMILAR
TO THAT FOR CHOUX PASTRY,
BUT ALLOW THE MIXTURE TO
COOL A LITTLE BEFORE
ADDING THE CHEESE.

115 g / 4 oz butter
150 g / 5 oz sifted plain flour
4 eggs
150 g / 5 oz grated Stilton cheese
115 g / 4 oz grated Gruyère cheese
salt and freshly ground black pepper
oil, for deep-frying

FOR THE SALAD:
colourful assortment of salad leaves
sprigs of chervil
sprigs of tarragon
dill fronds
chive stalks

FOR THE VINAIGRETTE
1 tsp white wine vinegar
1 tsp sugar
3 tbsp extra-virgin olive oil
2 tbsp water

1 Bring 300 ml / ½ pint of water and the butter to the boil in a large pan. Add the sifted flour and beat in with a wooden spoon until the mixture leaves the side of the pan. Remove from the heat.
2 Beat the eggs together and add to the mixture in three stages, beating well each time. When the mixture is cooler but still warm, add the cheeses with some salt and pepper.
3 Mix the salad, then make the vinaigrette by mixing all the ingredients and toss the salad in it to coat the leaves and herbs well. Arrange a pile in the centre of each of 4 serving plates.
4 In hot oil, deep-fry the fritter mixture in spoonfuls (or mould it into quenelles using two spoons) until well coloured but still just runny in the middle. Remove with a slotted spoon and drain on kitchen paper.
5 Immediately place the fritters in the centre of the salad and serve.

Autumn

The day becomes more solemn and serene

When noon is passed – there is a harmony

In autumn, and a lustre in its sky,

Which through the summer is not heard or seen,

As if it could not be, as if it had not been!

HYMN TO INTELLECTUAL BEAUTY, Percy Bysshe Shelley

Getting It Right
A Day in the Kitchen at Heathcote's

It's 9 a.m. and foggy. The buildings of Longridge bloom like strange structures, monochrome coral reefs in milky waters, their shapes softened, colours muted. The still raw cold seems to strip away a layer of skin, sitting damply about the town.

The kitchen is serene. It's square, about forty feet by forty feet, with larders and washing-up areas off one end, and windows looking out to the front, to the road and the houses on the far side. In the centre of the room is the vast, purposeful mass of the Bonnet range, dormant and inert. There's a tray of orchids in floral china pots sitting on the end of it.

The floor and the stainless-steel surfaces are gleaming clean, unsullied as yet by raw or cooked materials. There's a regular pulsating buzz from the several fridges, a low hum from the air-conditioning unit, the intermittent rush of traffic on the road.

A cool subaqueous light from the windows falls on a stack of cardboard and polystyrene boxes, with a large salmon resting on top. Around to the right are two cases of Mumm Cordon Vert champagne. Around to the left, a long, boned saddle of lamb, slightly compressed and looking oddly fluid inside a vacuum pack.

Above or under the work surfaces there is a jumble, of pots, pans, whisks, boxes of knives, cutting boards, ladles, sieves, spoons, weighing machines, vacuuming machines.

By and large, professional kitchens are not picturesque places. There may be picturesque elements – the sky blue and copper and stainless steal on the range, the rows of oils and wines, the glittering silver chain-mail skin of the salmon on the fish section – but these are isolated images. The overall impression is one of industry. A kitchen is a factory. This one produces food as once the mills of Lancashire produced cotton.

Therefore a kitchen is utilitarian and practical. It has to work under extreme conditions. If you need to feed sixty people not less than three courses each between, say, 7.30 p.m. and 9.30 p.m., this room has to produce 180 separate dishes – not to mention *amuse gueules*, petits fours and a few other odds and sods. The pressure is extreme. So this is a place of work, graft, slog, grit, stamina, professionalism, determination and craftsmanship, not of romance, artistry, refinement and pretension.

Paul won't be in the kitchen, displaying his brand of graft, slog, grit and what-not, until this evening. The business of cooking, of devising new dishes, of getting them together, takes up relatively little of his time. He no longer has to put in the hours peeling, dicing, skinning, skimming, stirring, filleting, chopping, searing, boiling, stripping, getting ready for the moment the first customer rolls in through the door. That's what the brigade of eight are now doing under the mild but watchful eye of Andy Barnes.

You see, in this kitchen – in any modern kitchen – there is the name of the chap over the door. He is 'Chef'. Then there is the head chef, his or her right-hand man or woman. He or she actually runs the kitchen, is physically present in it at all times, doling out the responsibilities, making sure that things are got on with, in the right order and to the right standard. No top-class kitchen can function without an Andy Barnes.

Then, below that is a series of junior ranks, the number depending on the size of the kitchen. There may be a chef du partie, a kind of section head, although this is usually only in hotels, where the total brigade may run to several dozen. There are no chefs du partie at Heathcote's, although there are sous-chefs, each of whom are responsible for one of the sections – meat, fish, hot starters and *amuse gueules*, cold starters and veg, desserts and pastry. Each section looks after its own sauces.

Below sous-chefs are chefs de partie, and below chefs de partie, commis-chefs, the apprentices, boys and maids of all work, the bottom rung in the hierarchy, save for the washers-up; except that, this being Heathcote's, the visible manifestations of this hierarchy are quite hard to spot. They are all young. The average age, if you don't count Andy, who has seen a bit of the outside world before he became a chef, is about twenty. That still means that some of them have known the curious, exclusive tempo of the restaurant kitchen, and been imbued with its relentless disciplines, for almost a quarter of their lives.

Paul has been through all this, has done it, could do it again, does do it from time to time, but there are other parts of his business that demand his attention. According to him, there are three sides to running a restaurant: cooking, management and marketing. Nowadays the second two take up as much of his energies as the first, what with the brasserie in Preston and Manchester.

Preston didn't have such a place until a few years ago, when Paul opened Heathcote's Brasserie in fashionable, solicitor- and tree-lined Winkley Square.

It cost £300,000 to get it right, to rip out the old fittings of what had been a pub, restructure the inside, put in polished wooden floors, a mural and mirrors, and a *Gone-With-the-Wind* staircase linking the self-contained brasserie on the ground floor with the bar and rôtisserie serving simpler dishes in the basement.

Smart chefs are making a habit of using their star status to open up cheaper, more accessible joints. It started in France, but it's caught on here. It's not that they get tired of churning out all that elaborate high-faluting, fine-dining stuff every day of the week. It's just sensible marketing. That cheaper brasserie can be doing very nice business when the flagship establishment is buffeted by the winds of macro-economic circumstance.

But £300,000 is a big investment, whichever way you look at it. It's a huge investment in a town in which gastronomy is something you go abroad to enjoy. However, Paul thought brasseries were something we can do just as well in this country. He promoted one of his staff from Heathcote's, Max Gnoyke, to supervise the kitchen and help set up the menu, which runs the gamut of fashionable European fare and includes some simpler versions of the new British dishes on which Paul's reputation is based.

As a first shot, Heathcote's Brasserie has been a bit of a success, after some initial fine-tuning. Emily Green, then restaurant critic of the *Independent* promptly

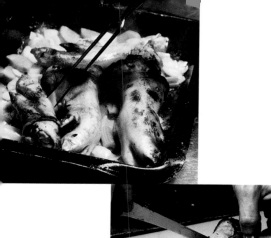
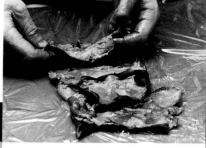
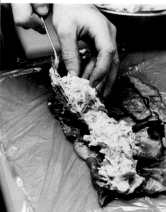

named it her brasserie of the year. Much more importantly, it did good business.

Such good business that Paul decided to open a second brasserie in a glorious, riotously scrolled, curlicued and pedimented, red-brick Edwardian, ex-DHSS building on the corner of Deansgate and Jackson's Row in Manchester.

That meant upping the ante quite a bit, £600,000 to find this time, and a year of meetings, meetings and battles – with the Manchester Buildings Department, Fire Department, Health and Safety Department, Environmental Health Department, not to mention builders – to be fought and won.

The £600,000 was found and spent, and the brasserie doors opened in time to catch the Christmas trade. Now Manchester is doing good business, very good business indeed.

Having the brasserie also means that Paul can offer more varied career opportunities to his staff. Restaurant staff tend to be a pretty peripatetic lot. Two years here, a year there, sometimes less if they don't fit in. You have to accept a certain level of turnover, but the less it happens, the more economical the business remains. It takes time to train staff, to find out their strengths and weaknesses, and shift your own working patterns to accommodate them. If you can find them, that is. Most young chefs and waiters, come to that, want to work in the big, famous establishments, preferably in London. These are the places that look good on the CV.

Heathcote's looks good on the CV. It has a Michelin star, the standard within the industry. It has a good reputation, but it's in Longridge, for heaven's sake... whoever has heard of Longridge? So you have to work that much harder at getting the right level of staff. You can't afford duffers in a Michelin-starred establishment. And once you've got them, you want to hold on to them. After all, by training chefs and waiters, you're investing in them. By setting them up in another of your restaurants, you can turn your investment into an asset as well as keeping a potential competitor off the street.

Come 10.15 a.m., the kitchen is getting into full swing. It's been picking up speed since 9.30, when several boxes arrived from Eddie Holmes, Heathcote's veg supplier – two boxes of button mushrooms, one box of soft tomatoes for soup, five pounds of carrots, two small containers of chervil, one iceberg lettuce, ten spring cabbages, six baby fennels, six large fennels, four globe artichokes, two packets of rocket – they're all there on the docket, written out in full, in clear, rounded handwriting.

Now it's 10.25 and Tony, Duncan, Mark, Lucy, Lawrence, Warwick and Lee, as well as Andy Barnes, have already got their heads down.

Tony is a local lad, from Preston on college release, tall, gangling, slightly bearded, getting in a bit of work experience. Mark is a calm, self-contained Aussie, here for a second stint, on pastry and puddings. Lucy is tiny and shy. She's also a trainee, working the fish section at present. Duncan has apprentice side-burns, fluff really. He is serious, taciturn and reserved, concentrating on the

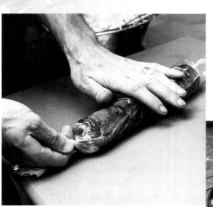

amuse gueules, petits fours and bread.

Lawrence and Warwick are brothers, locked in fraternal teasing. Warwick looks impossibly young, barely into his teens. Actually, he is about to go off to do a stint at Chez Nico in London, and Duncan has just returned from doing a stage at the Waterside Inn at Bray. And Lee, well, Lee has sideburns like Duncan's and an open, slightly quizzical expression, as if he finds it all a bit odd.

So it is, in reality. It's an odd way to spend your life, working when everyone else is having fun, working when they are working too, working fourteen hours a day on your feet, maybe more, five days a week. This may occur to them, but they are already locked into this profession,

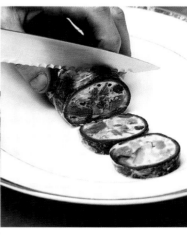

with an unfailing camaraderie and constant good humour, and a remarkable level of concentration, at least in this kitchen.

Everyone will work on a station for six months, until they've mastered all its intricacies, and then they will be changed around. This way they will learn about every aspect of their trade. They will be on their way to being fully rounded chefs, having learned, among other things, how not to be sloppy, how to maintain their concentration for several hours, how there are no shortcuts to good food.

They work with calm assurance. You can hear the snicker-snack of a blade on a sharpening steel, and the rhythmic wet slap as it hacks the head of a suckling pig into two neat sections. The ovens are already approaching their maximum heat. Lighting them is the first job of the day, whoever gets in. Mark comes surging in. 'Gotta get in the mood,' he says to no one in particular. Andy Barnes droops over Lucy's shoulder like a friendly giraffe as she scrapes the scales from a whole cod into a black plastic bag.

Everyone is wearing the classic blue-and-white check trousers, double-breasted white chefs' jackets, blue-and-white striped aprons, drying-up cloths tucked into the apron strings, heavy gear on the feet for protection against heavy equipment clattering down in the course of the working day.

The rhythm is steady and constant. Each is absorbed in their particular raft of chores, *mise-en-place* it's called in classic kitchen terminology, getting ready. There isn't a lot of chat. Lawrence picks over tomatoes ready for the chilled clear tomato juice, and breaks into a chorus of 'Cecilia' – 'Ce-ceelia, you're breaking my heart.' He can't have been born when that was a hit.

Lucy strains the water off three scarlet lobsters. Lee flips a brick of butter into a pan with fat round sections of potato. Warwick is trimming the fat and sinew off nuggets of ham, which will go into the pig's trotter. Mark scatters currants and raisins across the bottoms of the trays in which the bread and butter puddings will eventually be baked. Paul Heathcote come in, stands to one side, watching what's going on with thoughtful interest, but not involving himself. He's got another meeting with his bankers later today.

So it will continue for several hours, carrying out the labours of infinite patience – Duncan picking over and stripping leaves of emerald spinach; Lucy plucking the pin bones out of coral-pink fillets of salmon with tweezers; Mike trimming out the ribs of the pork cutlets; Andy Barnes boning out the trotters, patrolling the kitchen, keeping the brigade up to the mark.

'What about the sauce for the lamb for Wednesday?' he asks Mike. Mike looks blank. Andy gives him what you might call an old-fashioned look. Mike goes to the fridge to get a container of lamb stock and begins to make the sauce.

The whole surface of the range has now disappeared beneath a tattered regiment of battered pots, vapour trails rising up from them. At the end, towards the window, two massive stockpots are beginning to seethe, the magma of bones and vegetables clogging the surface. The air around them is filled with the wet dog-hair smell of chicken stock.

There is a rapid flutter of Warwick's hands, and a mound of neatly chopped ham mounts on his board. Lee has taken a large chopping knife to some carrots. It is almost miraculous to see a mass of tiny, neatly clipped strips and minute blocks flow from beneath the massive blade.

Andy Barnes adds handfuls of rosemary, thyme, onion and carrot to a roasting tray of oxtail before sliding it on to the hot plate to start braising. As the heat bruises the herbs, the penetrating wild smell of thyme wells up.

Move to another part of the kitchen, and you're enveloped by the warm, rich sweet musk of duck fat, in another sage, and another the reek of warm chocolate. There is always this sense of abundance and generosity in a professional kitchen. Ingredients are not measured out carefully by tablespoons, by millilitre and measuring jug. Even the ovens don't have variable temperatures.

So much is done by eye and experience. And when it comes to ingredients like herbs or wine or butter, quantities that are unimaginable to the domestic cook are routinely bunged in without any apparent concern. Andy Barnes put in bushes of thyme and rosemary with those oxtails. It will take two or three hours to draw out all their flavours.

By the same token, not much is wasted either. In order to get the tiny dice of shallot for a fish marinade, only half the bulb is actually chopped. The rest will go into making a sauce. The same with any peelings, meat clippings, bones. They'll all go into the stockpots. This practical and economical approach is denied the home cook.

The team work steadily, with palpable concentration, even if the overall atmosphere appears quite relaxed. There's the occasional abrupt clatter, the snap of cling-film over the top a container, the squeak of a felt-tipped pen scribbling the description of the contents on it, and the sudden sizzle as a fly is zapped by the electrical fly-killer high on the wall.

Duncan has been stripping the meat off ducks' legs which have been stewing in duck fat until they are reduced to soft fibre. His fingers are brown and shine with grease. This is the first stage of making duck rillettes, which will be used as a canapé this evening.

The cutlets of pork have been vacuum-sealed inside bags while they marinate. The delicate pale-pink meat appears to be suspended in yellow olive oil, with the contrasting greens of thyme, sage and tarragon, like different varieties of pond weed, as if in an aquarium.

Everywhere your eye catches the individual beauty of raw materials – the plump white elegance of chickens, with tips of clotted creaminess; the deep yellow of parsnips braising in amber duck fat; the vivid white flesh of turbot against the speckled tortoiseshell of its skin.

Mark pulls a pan of cream off the hot plate just as it foams over. There is a brief burst of dancing blue flame as the overspill burns off. Mike is carefully skimming the deep, toffee-brown stock. He slops a ladleful of cold water into it, which will lower the temperature fractionally and bring another cloud of impurities floating to the surface. Lee is stamping out potatoes like diminutive curling stones with manic energy, and then trimming them to smooth perfection.

So it will go on through the day, without even a pause for lunch. 'Lunch?' says Andy Barnes, 'There's only room for one meal in a day. If they're lucky, they might get a brew-up.' In the event they don't even get their brew-up today, and the one meal comes at 4.30 – pasta, sweet-and-sour pork and crushed potatoes, rustled up by Duncan, with tea or Coke to wash it down. It's warm enough today for them to sit on the steps and the wall at the back of the kitchen. They sprawl

together. The conversations ramble around the topics you'd expect – booze, football, sport, the inequalities and demands of work.

Now it's back into the kitchen, cleaning up, putting equipment away, wiping down surfaces, sweeping the floor. Warwick pours some water on the hot plate. Little bubbles dance over its surface like tiny balls of mercury and then vanish.

The first guests have booked their table for 7 p.m., which means they'll be expected at around 6.45. It's still only 5.30, but the tempo in the kitchen has already moved up a couple of gears. The hierarchy, who is responsible for what and to whom, which had been almost impossible to make out earlier, reasserts itself like a natural order. It's curious to watch very young men commanding complete authority over others no younger than themselves.

The sun is now streaming through the windows beyond Lucy and Duncan. The weather is settled. It is a beautiful soft autumn evening. Clara, the comely washer-up, arrives and walks smilingly through a blizzard of banter. With the utmost care, Mark dips a succession of Cape gooseberries in caramel. The glaze hardens to translucent amber on each.

There are four small copper pans on one side of the hot plate. They contain what appears to be identical dark, glossy liquid, the colour of molasses. On the handle of each is stuck a piece of paper with 'grouse', 'partridge', 'venison' and 'pork'. There's a sauté pan as well, containing the rounds of potato Lee cut earlier, resting placidly in a mass of butter. Lee tosses in some sprigs of thyme as well. There are two more pans with potatoes in varying stages of cooking for different dishes.

Warwick sniffs a chopping board suspiciously and returns it for washing. Andy Barnes moves about the kitchen almost self-effacingly, checking, tasting.

At 6.25 the sauces get their final tasting and are decanted into bottles and carefully labelled. The bottles will be placed in a pan of warm water and kept on the stove during service. It's a technique Paul Heathcote picked up somewhere along the line that helps maintain sauces at a consistent level throughout service, as well as facilitating the process of getting them on the plate.

At 6.35 the man himself arrives in the kitchen, immaculate in crisp, pristine white jacket with 'Paul Heathcote' embroidered on the right breast. He fills it comfortably. Beneath he has black trousers and black shoes which look like a modern modified version of the Chelsea boot.

'Are you going to be ready, Warwick?' His voice is pitched slightly lower than it is for normal conversation. Immediately it carries more authority.

'Yes, chef.'

'Mark?'

'Yes, chef.'

He goes round the kitchen, checking and appraising, especially the sauces. Little mistakes can make big differences. If you over-roast the duck bones which go into the stock, they will make the stock bitter, and that will find its way into the final sauce. It's all about maintaining the highest standards with the greatest consistency. If a sauce is even slightly over-reduced it will upset the whole balance of a dish. It all about unremitting attention to detail. It's his name on the front of the building, on the menus, on the bills. He'll be the one getting the flak if the evening's experience does not come up to expectations.

He explains that different stations will help each other out when the rush starts. Pastry (Mark) will help the larder (Duncan), and then vice versa, because their busy periods are at opposite ends of the evening. Actually, everybody ends up helping everybody else when push comes to shove, as it inevitably does when you've got a table of four, each with a different main course – say, one turbot, one pork cutlet, one venison and one partridge – each of which may have anything up to a dozen different elements to be assembled on a plate, and all of which have to go out within a minute of each other. It makes you realize what a co-operative exercise working in the kitchen is, just how dependent on each other the people working in it are.

No wonder, if you ask Andy Barnes what are the primary qualities that go into making a chef he'll reply, 'Common sense, dedication, self-sacrifice, team-work.' And the greatest of these is teamwork, you suspect.

At one end of the Bonnet range is a stack of large silver-plate trays. On each is a fresh starched pink cloth. When the dishes are assembled to Paul Heathcote's satisfaction, the plates will be loaded on these trays and then carried through the electrical door into the dining room.

The room is already moving with a brisk purpose when Paul Heathcote claps his hands at 6.52 p.m. 'OK,' he calls. 'People arriving.' The air is filled with the smell of cooking sugar. Lawrence is vigorously washing down the walls. Warwick mills some pepper over the crushed potatoes.

6.55 p.m. ... Andrew Lee, the maître d'hôtel, comes in to fetch two glasses of champagne from the bar at the back of the kitchen. 'Canapés for two,' Paul Heathcote calls. This evening the canapés are little tarts filled with duck rillettes with a dab of chutney, small rolls of coulibiac, and a tiny tart of cream cheese with diced tomato and olives. This will keep Mr and Mrs Wallasey busy as they make their choice from the menu. *Amuse gueules* are part of the carefully ordered series of warning signals to the kitchen to be on stand-by. You can feel the shift in the level of adrenalin. The sun has gone down. It's dark outside. Inside Duncan's face is almost self-illuminated in its fierce concentration as he places feathery fronds of chervil on top of the rillettes tartlets.

Over on the pastry section, Mark is arranging fat thimbles of diminutive creamed rice puddings. Beside Warwick are trays of deep-fried basil, parsley, chervil; amber torpedoes of apple; striated beads of braised shallots.

7.10 p.m. ... Andrew Lee comes in and hands Paul Heathcote a slip of paper. He glances at it. 'Two covers, one gourmet, one game tea, one skate, two turbot, sorbet, one venison, one pork.'

'Yes, chef.' The response is called by each of the responsible section heads. Once called out, the order is stuck beneath a metal strip so that the chefs can check their dishes against it if need be. Once a dish has gone to the table, it is crossed off with a thick yellow felt-tip.

Lucy is already busy. A salmon fillet hits a hot pan, skin-side down, with a sputtering hiss. They are salted in the pan, the salt tossed over them with a delicate throwing movement.

7.20 p.m. ... In Warwick's section there is an array of little metal ramekins, each filled with a different garnish of glittering colour like stones in a jeweller's – carrot, chervil, tomato, chive, parsley, basil, mushroom, garlic, capers and butter.

Warwick himself is not yet engaged in the evening's performance. He's leaning against a wall, chatting to his brother. Only the kitchen is getting warmer.

7.30 p.m. … Angela, one of the team working the dining room, comes in and hands Andy Barnes the second order. 'Two gourmets,' he calls. There are three menus to choose from: 'A la carte', which is the full Monty, choose from six sections, twenty-eight dishes; 'signature', which consists of ten courses of the dishes for which Heathcote's has become famous; and 'gourmet', which is a selection of five courses of past and present classics, with the odd experimental dish popped in from time to time.

Gourmet dinners are easy. They're set meals, made up of dishes the team all know well. Tonight the gourmet consists of ballotine of foie gras with spiced chicken livers; salmon with lemon pickle; risotto of wild mushrooms; breast of grouse with celeriac purée, roast potatoes and port sauce; and hot chocolate fondant. It gets difficult if you're full and everyone wants to eat off the A la carte. Then you can go down big time. That's what Paul Heathcote says. Andy Barnes agrees. Like last Saturday, it was hellish. Seventy covers and no gourmets.

7.38 p.m. … Andy Barnes checks the skate dish on the pass, at the end of the Bonnet range nearest the door to the dining room. The soft corduroy-furrowed wing is smudgy brown. Brilliant glossy emerald spinach peeks out from underneath it at odd points. Plump mussels repose like languid sentries at regular intervals, in sauce yellow with butter and studded with scintillating garnets of tomato. The plate is lifted on to the first of the heavy silver trays with the napkins and borne away by Angela. The orders begin to come in faster now:

'One foie gras, one broth, one trotter.'

'Yes, chef.'

'Canapés for three, away.'

'Yes, chef.'

'One foie gras, one black pudding.'

Pause. No one responds.

'Hello,' calls Andy Barnes.

'*Oui*, chef.'

Oui, chef? The first language of the kitchen is still traditionally French, even if in places like Heathcote's it doesn't get quite the look-in it once did. A little later, when the pace really hots up and Paul takes over running the pass – that is, calling the orders and checking the dishes as they go out – from Andy Barnes, he uses French more frequently.

'*Envoyez* one duck, one lamb,' he calls.

'Canapés for three, away. *Envoyez* table seven. Get three lobster on the go.'

8.37 p.m. … The orders are coming in at the rate of one every couple of minutes. The kitchen is in constant movement, a whirling blur of moving bodies, hands, pans, dishes, trays. Tony places a partridge in a pan on the hot plate. It sizzles in a shower of hot fat. He turns it over, whips it off the plate and slides it into an oven. Andy Barnes is rolling diced courgettes over and over in a small sauté pan with a flick of his wrist. Paul bends over a plate, wiping a minute speck of something from the rim with a cloth. Warwick has taken a blow torch to a disc of apple and the edges are just beginning to blacken. Lucy pours olive oil into a frying pan. Immediately the oil glides to the edges.

There is an extraordinary choreography being enacted now, with figures swirling about each other, moving back and forth between station and stove, through the steam and smoke. Tony waltzes around Mark. Lawrence threads his way between Warwick and Tony. Tony whirls from the stove back to his station. Concentration is palpable. No one has time for chat now, except Lawrence, who still manages to crack a joke. Sizzle goes the fly-killer.

Duncan is under pressure. He left a can of Coke in the freezer and it's exploded over the contents. Everybody looks at the offending piece of equipment. Glad it wasn't me, you can almost hear them thinking. You don't need this in the middle of service. There isn't time to bollock him. Mark, on pastry – and so not yet seriously involved in the battle – goes over and offers to help Duncan.

'Three skate signatures here, table two. Extra bread, table three, away. Won't be long for one venison, one turbot.'

'*Oui*, chef,' shouts Lucy.

'One gourmet, one black pudding, two no starters. Looks like you're having an easy night of it, Mr Dodds,' Paul says to Lawrence.

8.55 p.m. ... The top of the range is a mass of pans. Warwick is chewing on a stalk of tarragon. The meat and fish sections are in a frenzy of activity. Lawrence and Andrew have gone over to help out. There are four chefs now working on these two sections alone. Lumps of meat are sizzling away beneath clouds of smoke. Each piece of meat and fish is lightly seasoned three times – before cooking, during cooking and just before plating up.

Lucy shouts 'Back' as she scuttles down the corridor between the range and the preparation stations with a smoking hot pan, towards the washing-up area.

Paul Heathcote calls, 'I want three racks of lamb on the pass NOW. Too much sauce. It's all over the place. Plate it up again, without sauce. Extra veg for two.'

'*Oui*, chef.'

Tony squints through the smoke at a puck of beef. All pretence of nonchalance or casualness has been blown away in the absorption of the moment. The attention to detail is absolute, even at this stage and under this pressure. It is a feat of co-ordination and co-operation.

'A couple of slices of cheese bread *now*, Duncan. I've got the starters here and the bread hasn't gone yet.'

A cutlet of pork dish is being assembled on the pass. First a low hummock of cabbage is carefully positioned, then the caramelized half-apple. Two shallots follow, placed with equal care, followed by the round of cider potato and a tower of black pudding. The cutlet is lowered gingerly on top of the cabbage and finally the dish sauced from the bottle. It's taken three pairs of hands one minute and thirty-five seconds to put it together. Now it's loaded on to a tray and it's gone.

There is a brief spat between Lawrence and Duncan. It flares like the flame on the hob as some hot fat spills over and is gone as quickly.

9.21 p.m. ... The kitchen has settled to a steady rhythm. There is five minutes between a dish being called and being ready to go. Paul patrols restlessly between the orders clipped beneath the metal strip on the wall and the pass. 'Give me one foie gras, one lobster, one brioche, Two signature. Let's go.' He is moving all the time. He is in command of everything. 'Warwick, can we have this pass wiped down.' He is involved in everything. Like a conductor in one of the

more vigorous movements of a symphony, he dictates tempo, controls the detail.

'Two brill, Lucy. And it won't be long before four partridges after that. Black pudding. How long?'

'One minute, chef,' says Warwick.

'Lobster, how long?'

'Two minutes, chef.'

'Make that two minutes on the black pudding, Warwick.'

'Yes, chef.'

And in this way a sequence of immensely beautiful, sophisticated dishes requiring great precision is produced in immaculate order by a group of sweaty, scruffy, very young men and women with burn marks on their arms and cut scars on their hands.

At 9.44 p.m. the kitchen is still running at very high revs.

'I'm waiting on two venison. I'm waiting on two more foie gras.'

'*Oui*, chef.'

'*Envoyez* two duckling and one pork. Sauceforthesalmon. Sauceforthesalmon.' Paul drives his team along. Urgency surges through his voice. It's like listening to Peter O'Sullivan commentating on the final stages of a classic race.

No one stops for a single second. It is almost impossible to hear anything above the crash, rattle and resonating bangs of pans being whipped into action, above the hiss, roar and crackle of cooking food.

The level of energy has the force of an electrical charge. Everyone doubles up, helps out when needed. Duncan and Lawrence motor through the washing-up alongside Clara. Andy Barnes moves quietly among them, turning some spinach in a pan, checking some beef fillet, flaming some lobster pieces. He is a model of economy, but the work he gets through is formidable. And he smiles, enjoying it all.

Just as the succession of dishes on trays and orders seemed endless, the tempo drops. Suddenly it's 10.17 p.m. The main rush is over for *hors d'oeuvre*, fish, meat and vegetables, although for Mark, business is just starting.

While he toils over the bread and butter puddings and furls of chocolate, the others start clearing up. So Lawrence sets to mopping the floor, and Duncan to scrubbing down the surfaces on the range with vinegar until he is called away to help on the petits fours. Tony and Lee wrap up their containers with those ingredients which will keep for another day and slip them into their respective fridges. Lucy is busy scrubbing down the grill.

11.05 p.m. ... Mark pops the last four apple crumble soufflés into the oven, and has a mild panic attack as he discovers that it has been turned off. Luckily one of the other ovens is still blasting away.

The team continue to move with pace and spring, but somehow their actions are slightly less focused, the air is less charged. Banter and small talk have crept back in. The floor is done. The walls are being wiped down. The preparation surfaces are clear for the most part. The whir of the fridges and air-conditioning gradually reassert themselves as the team disperse amid the jokes and chatter.

11.43 p.m. ... The kitchen is clean and deserted. The lights are still on for the front-of-house staff to finish clearing away when the last customer has gone. Andrew Lee will lock up. It's just under fifteen hours since Paul Heathcote opened the place up. In just under ten hours' time he will be opening up again.

Frank Thurlow
Knowing Your Territory

'There's only one way to do it,' says Frank Thurlow, 'and that's the right way.' Frank is a stickler for the right way. He shoots – 'culls' is the word he uses – the deer, and butchers them, for Heathcote's. Paul says Frank can give you the life history of each deer he brings in. Modestly, Frank says he just keeps records.

On this still, clear, cool autumn evening, Frank is dressed to kill, you might say. Everything he wears is serviceable and has seen a good deal of service, and has been chosen to make him as invisible as possible as he patrols the woods beyond the perimeter of the Longridge Golf Club and Cycling Association course – heather-green trousers, shirt, jacket, waterproof, cap, heavy boots, mittens. He wears the mittens to minimize he flash of his hand as he raises his binoculars to scan glades in the wood, or the open escarpment at their edge that marks the end of his domain.

His gun, a Finnish Osaka Winchester .270 model – 'a very, very good model' – subdued gleaming gunmetal, walnut stock polished to a high gloss with use, he slings upside-down under his right arm for ease, speed and smoothness of access. Ammunition he keeps in an old, well-worn crocodile-skin cigar case in his inside pocket. In his left hand he carries two straight branches about five and a half feet long, joined by a thong of rubber near the top. If he sees a deer, he will use this as a rifle rest to make sure of an absolutely steady shot. He took to using this device after his accident.

The accident was a good few years ago now, but it brought his career as a forester to an end. He had always wanted to be a forester, had Frank. Not that he had been born to the outdoor life. No, early days were spent fishing the Thames for roach, perch, chub and pike on the weir at Sunbury, Middlesex. But he chose forestry as a career, trained in the great Kielder forests in Northumberland, and later went down south, to Exmoor and the Brendon Hills, and worked there until one evening, he was knocked down by an elderly woman driver – actually 'scooped up' is the term Frank uses – while in Edgware, dragged fifty yards and left with twelve major fractures.

That was the end of the outdoor life as far as the Forestry Commission was concerned, although Frank disagreed. He went to work for the MOD in Bristol and there he met his wife, Jean, who had a house in Longridge. They moved up here a few years ago when he retired. Or didn't retire, depending on how you look at it, because in the last six years that he has been working for the Longridge Golf Club and Cycling Association he has planted 18,000 trees; him, personally. Dug the holes, stuck them in – Corsican pine, alder, sycamore, Scotch pine – and filled in the earth around them.

He is as proud of the way he has changed, clothed the raw-boned profile of Jeffrey Hill and the Long Ridge as he is of anything he has achieved, but it is constant hard work to keep the trees, particularly the saplings, healthy and

OPPOSITE:

FRANK THURLOW, SUPPLIER

OF GAME

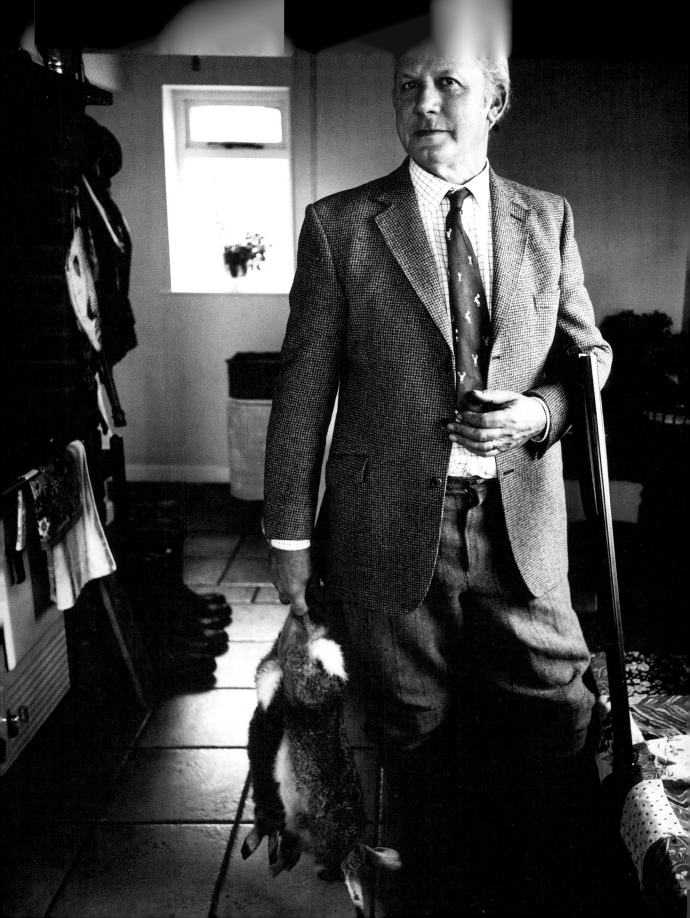

growing. That's why it's necessary to keep the deer under control, and the hares and rabbits, come to that.

Deer are territorial animals, and they mark out their territory by rubbing the bark off trees. Rubbing the bark off a sapling will kill it, as will nibbling the young green leaves or shoots, which deer are also prone to do. So, come November, Frank begins his solitary patrols around the golf course.

This isn't the only place he is employed as a professional hunter. In fact, his main range is down south in Hampshire, where he patrols a 2,000-acre block of land and will take out anything up to seventy does and stags, roe and fallow, a year. It's mostly roe does, about forty to thirty of the other, but the final count depends on the current deer population and how it's made up.

Professional culling, he says, is all about knowing your territory; what's in it, where the deer feed, how they react to the weather, basic country craft, really. Frank knows, for example, that if the sun comes out after rain, the deer are most likely to make their way to a favoured glade, and so he can make his way there, and ambush them, as he puts it, last thing before sunset, when they emerge from the sheltering woods to feed, or at first light, when they are making their way back to the sanctuary of cover. Usually he gets one at each spot, maybe two if he's lucky. The most he has ever shot in a morning is five, but that's exceptional.

There are two seasons. He shoots bucks from 1 April until the start of the doe season at the beginning of November. The doe season then lasts through to the end of February. Essentially it is about population control. You have to keep the numbers of deer steady, not just for the sake of the land but also for the sake of the deer. If you let the population get too large, then the health of the deer declines as the pressure on food grows.

Aside from that, he's very keen on eating it. Frank has a missionary zeal for the meat he provides. Roes are the nicest, he says, between eighteen months and three years old, but he loves it all and eats it all, even the heart and liver. The liver is almost the best bit, he says.

The classic shot is through the heart, although even an animal shot clean through the heart will not drop immediately. Such a rush of adrenalin is released that it can run quite some way before falling. So he prefers the shoulder shot, which puts them down and out right away. Then he grallochs – eviscerates – them on the spot, keeping the heart and liver and the carcass, and lugs them back to his truck. It's heavy work.

Some of the deer he culls go to game dealers, but the saddles and haunches of the pick of the cull go to the landowners or to Paul Heathcote. He skins these and cuts them up himself. Wouldn't trust anyone else to do it. Well, Paul's as much of a stickler as Frank is himself. 'I wouldn't dare give him anything that wasn't perfect,' says Frank.

He always hangs the carcasses, just for twenty-four hours if it's a really warm period in summer, but more usually for two, three or even four days if it's chilly in November. It all depends who its for. You have to be careful at every stage.

He does meet people who say they don't like venison, but he thinks that's like saying you don't like meat. The quality and flavour of an animal will depend on time of year, species, sex, how it's been handled, how it's been cooked.

It's not all supply and demand. He could go out after deer for a week,

especially up here, on Jeffrey Hill, and not get a single animal. He won't shoot just for the hell of it. As he says, there's only one way to do it, and that's the right way: 'Any fool can pull the trigger.'

He doesn't really shoot anything else now. He keeps the hares and rabbits off the greens at the golf club, and once a year or so he goes after pink-footed geese on the Fylde estuary, with a mate who is a goose-caller. He could, says Frank, call the geese down on the road outside his house, he's that good.

Frank's sixty-nine, although he doesn't look it, particularly as he crosses the greens between his own plantations at an easy lope, points out how old those trees are and where he has plans for further plantings. Here's a sapling that's been marked by a deer, but he reckons that it's still a bit early for serious shooting. Still, you never know your luck, do you?

There's a great chattering cacophony of pheasants perched companionably on top of the dry stone wall that marks the boundary between the golf-club land and that of the farm beyond. Frank makes his way along the length of the wall, underneath the dancing curtains of tiny late olives, to a point where it's easy to climb over, and there he slips into the wood, walking with a delicate, high-stepping motion, not unlike that of a deer itself, to minimize the noise of feet brushing through the grass and undergrowth, or the chance of cracking an old twig underfoot.

The point of entry and the direction of the circuit are dictated by the wind. There's hardly any wind tonight, just the lightest feather on the cheek. As you get among the trees, you can't feel the wind any more. Frank walks steadily, carefully, keeping trees between himself and likely open areas. Minimize the silhouette, that's the next lesson. Nothing will spook deer as quickly as an unfamiliar shape breaking a familiar line.

He makes his way down through the trees, steadying himself with the rifle-support sticks. He's like a solid shadow. A few freshly fallen leaves lie on the ground in haphazard kaleidoscopic patterns, and once in a while a single leaf sidles down through the still air, but for the most part the hardwoods are still carrying a full complement. You realize how difficult it would be to spot an animal with almost identical markings to the trees in this mixed woodland. Perhaps it is as difficult for them to spot Frank. He's as much a part of the pattern of the wood as they are.

The sun has gone off this part of the hill and it is now very cool. His breath has become visible, and hangs on the air for a second or to before dispersing. There are none of the badgers, foxes, mink or Montague's harriers he sometimes disturbs, although, where the wood ends at a field, there are plenty of rabbits, a hare or two, and pheasants by the brigade.

As he follows the line of the wood round and back up Jeffrey Hill again, he stops to watch a family of twelve magpies. It's not often you see that many all at once. But he is right about the deer. Maybe it is still too early. He's made his rounds, though, checked the ground, familiarized himself again with the area. Local knowledge, that's the real secret of successful stalking, knowing the land as well as the deer do themselves, and then, when you make mistakes, not making them again.

It's 6.40 when he hits the top of Jeffrey Hill again. It's too dark to shoot accu-

rately. You can see the lights of Fleetwood blazing and twitching away far out in the gathering darkness. It's time to head back to the small modern house he and Jean have on the edge of a Barratt's development in one corner of Longridge, back to the Rayburn, the dog, the stone-flagged floor, the wellies in the hall, the walking sticks and waterproofs, and all the other paraphernalia of a countryman's home. Tonight it's lamb for dinner for a change.

Frank Thurlow's Roe Doe Steak

4 venison steaks, each about
175 g / 6 oz, cut about
1.5 cm / ⅔ inch thick
pepper
2 tbsp olive oil
2 garlic cloves

1 Season the steaks with pepper, but no salt.
2 Heat the oil in a frying pan with the garlic until smoking. Remove the garlic from the oil and slam in the steaks. Sear them on one side for 3 minutes. Turn them over, lower the heat and cook for a further 3 minutes.
3 Serve and eat immediately.

Jean Thurlow's Baked Shoulder of Venison

1 shoulder of venison, about
1.5 kg / 3½ lb
4 tbsp olive oil
2 garlic cloves, chopped
1 tsp oregano
150 ml / ¼ pint dry cider
salt and pepper

Ideally, the shoulder should be frozen and then allowed only to partly defrost before cooking. This will increase retention of the blood and water (which will otherwise seep out during cooking), keeping the shoulder moist and creating a lot of very good gravy.

1 Preheat the oven to 180°C/350°F/gas 4. In a large heavy pan or flameproof casserole, heat the oil to smoking and brown the shoulder all over.
2 Transfer the shoulder to a piece of foil large enough to wrap it up. Sprinkle the garlic and oregano over the shoulder. Anoint with cider and wrap the whole thing up in the foil.
3 Bake in the oven for 1¼ hours.
4 About 20 minutes before you want to serve, open up the foil and pour the juices into a saucepan. Put the shoulder back into the oven, uncovered, to brown.
5 Meanwhile, reduce the gravy to the desired intensity.

John Hancock

The Secretive Hunter

The woods are quiet with sunlight. It filters down through the turning leaves, giving the yellows and ambers and browns and reds and oranges of the beech, oak, larch and ash leaves the brilliance of an illustrated missal.

Where the ground is not disguised by coils of bramble and the dying stalks of nettles and foxgloves, it is covered in leaves, layer upon layer of them, like strata of tortoiseshell. The surface veneer is already beginning to moulder, to take on the deep brown of the leaves' decayed predecessors.

A man with a basket on his arm moves among the trees with slow, easy paces. He is tall, as thin as a pipe cleaner. His face is crab-apple russet with wind and sun. His eyes are a very pale, patient blue. Above his mouth droops a Zapata moustache. He walks with long effortless strides.

He wears heavy-duty brown walking boots, black jeans tucked into blue socks, a waterproof vest over a check shirt over a rugby shirt. He is in no hurry. He stops to watch a grey squirrel scuffing among the leaves. It picks up a piece of beech mast, sits examining it for a moment and then skims away in looping bounds with it. The man adjusts the basket on his arm.

He crosses a patch of sunlight, pauses on the edge of a reef of shade, bends down and cuts the fat stem of a glistening brown-capped cep and puts it into the basket. He bends again and cuts another, and other. The little cluster is gone and he moves on into the shadow again.

This is Hank; John Hancock on his passport, but Hank to anyone other than officialdom. Hank is a happy man. You don't often meet them like him. He does what he wants. He does it when he wants it, which is most of the time. He collects mushrooms in season, which he sells to Paul Heathcote. He sells them only to Paul Heathcote.

Paul Heathcote doesn't actually depend on what Hank brings him in. He couldn't afford to. These days chefs can be getting ceps from South Africa, North Africa, Poland, Bulgaria, France, all over, all the year round. But Paul will use whatever Hank brings in, with extra care.

Hank met Paul through Reg Johnson, and he met Reg Johnson through Chipping Cricket Club. Not that he plays much cricket now. Bad back, you see. He was a useful quick bowler at one time, until his back went, and his back went as a result of his job as a psychiatric nurse.

He used to work at the Whittingham Hospital (incidentally, an institution boasting a very fine cricket ground), which specialized in people with varying degrees of social and mental problems. Hank had an idea that some of the inmates might respond to a different kind of treatment. His idea was to get in some chickens, sheep, maybe a cow or two, and make the patients responsible for them.

It seems almost absurdly idealistic now – and, of course, it worked. After a bit of opposition from the hospital administrators – 'That's not in your job

description. What do you want to do that for?' – he persuaded them to give him a bungalow in which to house the patients and a bit of land to go with it.

'We used to have some real bad lads, and I mean bad lads, with serious problems, violence and such. You'd get 'em started by rebuilding a cabin to get 'em involved, like. Then you'd get in some hens, and after a while you'd say, these are yours. It's amazin'. They might not talk to you or look after themselves or make their beds, but you could guarantee they'd always feed those hens. It's a funny thing, in't it. It becomes, like, a catalyst, common ground between you.'

The project became self-financing, making enough money to buy its own minibus, which allowed Hank and his patients to travel, to get out. It wasn't without its problems. 'I used to say we're into confrontational psychiatry. Many's the time things'd get confrontational. There'd be somebody with a spade, like, wavin' it about. But at the end of the day you've got to confront them. There's still right and wrong, in't there?'

In the end he couldn't confront the changes in the NHS. The hospital became a trust and looked at Hank's project as if it were a garden centre and a potential source of profit. That finished it right off. They replaced the nurses with gardeners and the therapeutic aspect went right out of the window. 'It was knackered. It still seems a shame. The lads are back on the streets. You make them so many false promises...'

And his back went, and his job. He took redundancy, and took to doing what he did as a child, wandering the countryside, snigging eels, gathering berries, doing the odd bit of fishing, but no shooting now, or setting snares. He went right off that a few years back when he caught someone's cat. 'I'd rather watch things these days.'

And pick mushrooms. It's not really commercial drive that draws him out to the woods around the edge of the Trough of Bowland, and along the Ribble, Hodder and Calder valleys, it's the pure pleasure of being out in the country.

'Anyway, mushroomin's changed now. There's professional pickers and a Mycological Society and stuff like this. And they say they can cultivate mushrooms, all kinds, now. This bloke says he'll provide the spores, you provide the right conditions and there should be no reasons why you can't grow 'em. They've been able to do it with some kinds. They do yer shiitakes and oyster mushrooms, like, but I can't see mushrooms grown on papier mâché are going to taste as good as wild ones on a tree.'

There are something like 3,000 larger fungi to be found in the British Isles. Seven of these should be avoided at all costs. The list of seriously edible mushrooms is correspondingly short: hedgehog, giant puffball, blewits, chicken-in-the-woods, St George's, horn of plenty, chanterelle, fairy ring champignons. The vast majority are relatively harmless but just not very interesting.

When he first started, he'd go out looking for oyster mushrooms, because that was what he knew. 'Now I never look for oysters. There's more oysters than anything. You can find them without lookin' for 'em.' These days it's morels, the curious brown, intricately marked fungal helmets which grow in the sandy earth around the roots of alders along the Hodder in spring. Paul Heathcote is very keen on morels to go in the wild mushroom soup, or as an extra garnish with the chicken.

OPPOSITE:

JOHN HANCOCK, FUNGI FORAGER

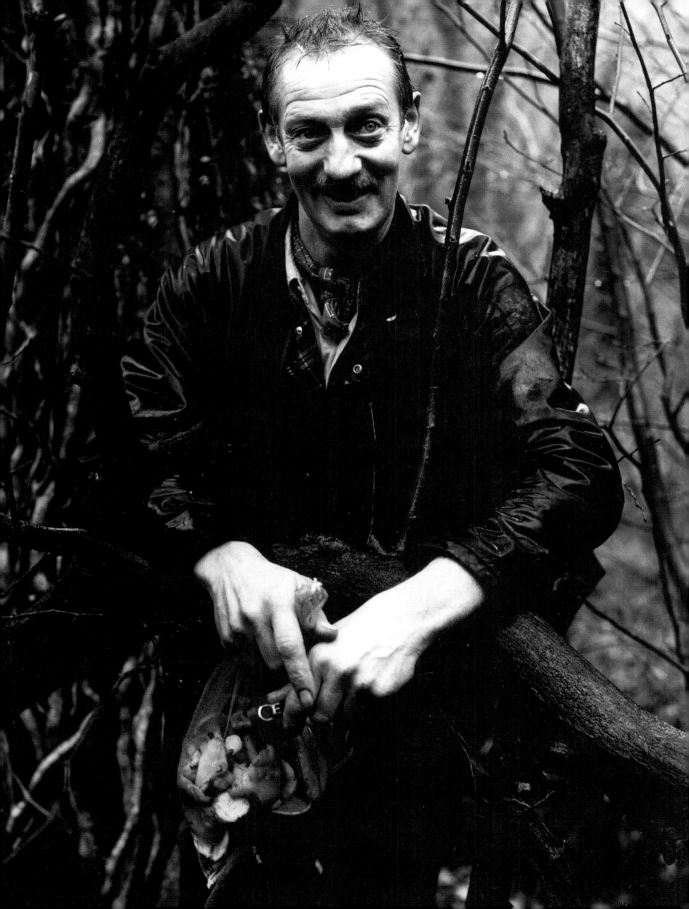

Then, in summer, parasol mushrooms, a.k.a. shaggy caps or lawyers' wigs; and in autumn the pieds de moutons, and ceps – penny buns they used to be called, but now everyone calls them by the anglicized version of their French name – are the big money-spinners, which Paul matches with brill; and field mushrooms, 'me own favourite, to be honest, like, fried up in a bit of butter or bacon fat, 'specially if you get a big one with plenty of gravy in it'.

You can have too much of a good thing. He once found a massive cep weighing three and a half pounds. He ate it. He practised various ways of cooking it, just cutting a few slices off at a time, until he decided that he's just about eaten himself sick on cep.

Hank will be keeping an eye open throughout the summer as he goes about his rural ramblings, but come September he'll be giving close attention to the first stirrings of the caps breaking through the leaf mould. Mind you, there's really no telling. Mushrooming is a pretty random affair. Mysterious things, mushrooms. No one has quite sorted out their comings and goings, why one year you can fill up the boot of your car with them, and the next you can scratch around for a few miserable specimens. It's something to do with rain – mushrooms need water to flourish – and heat, and heaven knows what else. Warm, wet weather, that's what mushrooms like, to give of their best, usually. But you never can tell. What you can be sure of, though, is that, come the first frost, there won't be any more. Frost is the one sure killer for the mushroom. But then winter is a good time to go pike fishing.

So there's always something to get Hank away from the household chores – his wife still works as a nurse and his children are coming up for O levels and A levels respectively – and from the dahlia and the gherkins he's growing with the help of mink manure. 'You know what they say, what's best for the garden? Shit off a Derby winner, because they're fed on the best. Well, mink shit's better 'n that. They're fed on fresh fish and chicken, are mink.'

He knows every corner of the countryside about, every hill, every wood and what you can find in them, every river and lake and what you can catch, although he'll not share the knowledge easily. Mushroom hunters are, necessarily, a

secretive lot. Productive spots are easily picked out.

It started when he was a lad. His father was a joiner who loved to cycle, to 'go for a spin', as he said, so they'd cycle, him and his dad, every Sunday, anything up to a hundred miles, over to Hallam and the Yorkshire Dales and back. It was a good way to travel, to get to know the area with an intimacy few people ever manage. 'You can see over the hedges from a bike,' says Hank.

His dad was a fisherman too, like his grandad, and if they were a bike short, as they sometimes were when his grandma's sister came visiting from Liverpool on her tandem, she used to drop one of them off and go back for the other, 'and think nothing of it'. And think nothing of it... That kind of community and way of life have all but vanished from the Ribble valley, Hank notes sadly.

His dad and his two brothers lived together in one house with twenty acres which they farmed. It might have been subsistence farming by today's standards, but they didn't go hungry. These days, he says, that kind of arrangement can't work, and it's a pity. People' expect more from life. They need to put money into the bank as well.'

His whole relationship with the countryside carries with it a wistful affection based on a sense of its unchanging pattern. Yet it has changed, as he also recognizes. There are more people living in the countryside now than there were, but they are visitors, tourists, even in their own homes. They don't take part in local life, go into local pubs or patronize local shops. And if they wandered along the banks of the river, would they see the electrifying flicker of the kingfisher, and the helmetted morels? Would they know how to cut a swathe of wild watercress from the runnel running clear along by the hedge? Would they inspect the dead heron on the side of the gravel pit? 'It 'ad choked trying to swallow a moorhen. You could see the moorhen's feet sticking out of its mouth.' He laughs and shakes his head.

You wonder too if they would share another deep-lying strand of Ribble valley life, represented by his mother's side, its nonconformity. His mother's family were – are – staunch Methodists. 'Me great grandad was a lay preacher, like the Bishop of India, or summat. And me grandad was, too.' It made for a slightly strained occasion when his mother married his father, who was distinctly non-Methodist and non-teetotal.

Hank may have taken after his father rather than his mother in the matter of drink, but the non-conformity seems to run pretty strongly in his veins, even if the way it is manifested is more pagan than Christian.

No, there isn't much he'd change about his life, and nothing he would swap it for. He leans on the bridge over the clear waters of Dean Brook. The mushroom basket is at his feet. The autumn sun is still warm, although a slight chill is beginning to seep in.

'Someone said what would you do if you won the lottery. I said, I'd be disappointed. Really, I would.'

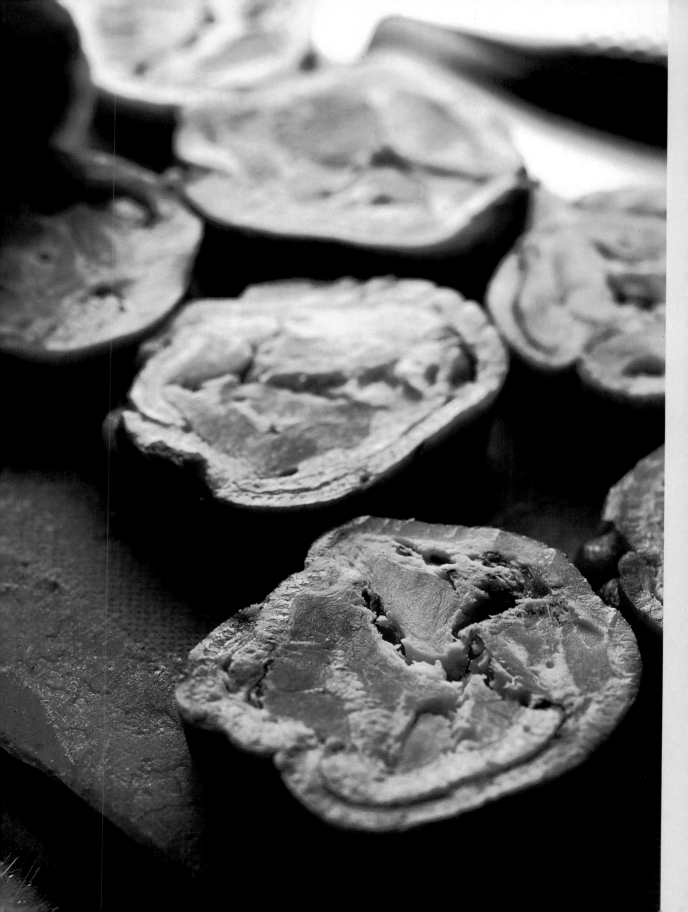

Autumn Menu

First Courses

Pig's Trotter Filled with Ham Hock and Sage, Tartlet of Pea Purée and Shallot Sauce

Tea of Game with Herb Dumplings

Jellied Eel Terrine with a Caper Dressing

Hot and Cold Salad of Smoked Salmon and Scallops with Basil Dressing

Main Courses

Skate Wing with Spinach and a Tartare of Mussels and Parsley

Braised Fillet of Turbot with Jerusalem Artichokes, Baby Leeks and Wild Mushrooms

Cutlet of Pork with Cider Potatoes, Gâteau of Black Pudding, Onions and Cabbage, and Juices Scented with Sage

Braised Haunch of Venison with Celeriac Purée, Roast Root Vegetables and Kümmel Cream

Roasted Partridge with Walnut Mashed Potatoes, Chicory, Candied Onions and Its Own Juices

Desserts

Creamed Rice Pudding Scented with Hazelnut, Served with Honey Ice-cream

Apple Crumble Soufflé and Apple Crumble Sorbet

Apple Charlotte with English Custard, Caramelized Fruit and Caramel Ice-cream

Apple Tarts with Gingerbread Ice-cream and Cider Butter

Warm Salad of Welsh Goats' Cheese with Roasted Walnuts, Deep-fried Herbs and Nut Dressing

Baked Coconut Cream with Caramelized Fruits and Rum Sabayon

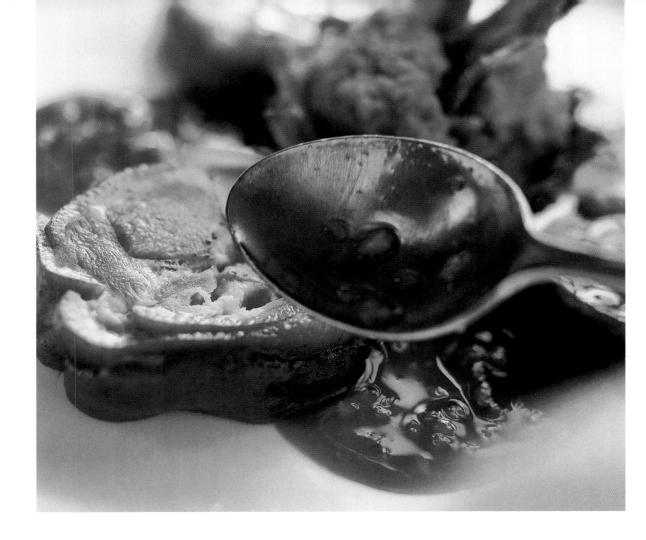

Pig's Trotter Filled with Ham Hock and Sage, Tartlet of Pea Purée and Shallot Sauce

4 pigs' trotters
olive oil
1 onion, coarsely chopped
1 carrot, coarsely chopped
1 celery stalk, coarsely chopped
600 ml / 1 pint chicken stock
200 g / 7 oz diced cooked ham
8 fresh sage leaves, chopped

1 At least 2^1/$_2$ hours before you want to serve: scrub the trotters well and remove any hairs over a gas flame or using a disposable razor. Brown the trotters all over in a little olive oil, add half of the onion, the carrot and the celery. Cover with chicken stock and braise for about 1^1/$_2$ hours, until the trotters are tender but not split.

2 Towards the end of the trotters' cooking time, make the chicken mousse (as with making mayonnaise, it helps if all the ingredients and utensils — including the processor — are well chilled): in a blender or food processor, purée the chicken with the salt until smooth, about 3 seconds, then scrape the mixture down the sides and process for

FOR THE CHICKEN MOUSSE:
225 g / 8 oz skinless chicken breast, coarsely chopped
1 level tsp salt
white of 1 egg
300 ml / $\frac{1}{2}$ pint whipping cream

FOR THE POTATO BASKETS:
1 large potato
salt and freshly ground black pepper
125 g / $4\frac{1}{2}$ oz clarified butter

FOR THE SHALLOT SAUCE:
6 shallots, finely chopped
100 ml / $3\frac{1}{2}$ fl oz port
pinch of sugar
100 ml / $3\frac{1}{2}$ fl oz chicken stock
100 ml / $3\frac{1}{2}$ fl oz veal stock

FOR THE PEA PUREE:
300 g / $10\frac{1}{2}$ oz shelled peas

15 seconds more to make sure no meat is left unprocessed.

3 Add the egg white and process for another 15 seconds, scrape down and add about 2 tablespoons of the cream. Process for a further 10 seconds, then scrape down again.

4 With the machine running, slowly pour in the rest of the cream to produce a smooth mixture. This should take 20–30 seconds. Don't take too long or the machine will heat the mixture up. In the professional kitchen this mixture would now be forced through a sieve, but you can use it just as it is; it won't make much difference to the finished result.

5 When the trotters are braised, allow to cool slightly, then remove the flesh from the bone (see pages 130-31) and scrape the fat away.

6 On a flat work surface, roll out a 30-cm / 12-inch-long piece of cling-film and place the trotters on it lengthwise.

7 Chop the remaining onion finely and boil until soft, about 1 minute. Refresh in cold water, then drain and pat dry. Mix into 200 g / 7 oz of the chicken mousse, together with the ham and sage. (You can use the rest of the mousse to stuff mushrooms: cover them with breadcrumbs and bake with garlic butter for a wonderful first course.)

8 Spoon the mousse mixture on top of the trotters, line them up and roll them up together to make a sausage. Roll up the cling-film around them, then roll the package in foil.

9 Steam the packages for 20 minutes.

10 While the trotters are steaming, make the Potato Baskets: preheat the oven to 190°C/375°/gas 5. Peel the potato and cut it into very fine matchstick strips or grate it finely. Season with salt and pepper and leave for a few minutes to allow the salt to draw out the moisture from the potato. Squeeze it out in a clean tea towel. Add the clarified butter and mix in well.

11 Press the mixture into 4 individual brioche moulds to line them and then press another similar mould inside each to hold it in place. Bake in the oven until the potato is golden, about 7–10 minutes. Allow to cool and then turn the baskets out of the mould.

12 At the same time, make the Shallot Sauce: put the shallots in a pan, pour in the port and add 100 ml / $3\frac{1}{2}$ fl oz water. Add the sugar and cook until almost all the liquid has evaporated.

13 At the same time in another pan, boil the mixed stocks down until they have a good sauce-like consistency. Mix into the pan of shallots and adjust the seasoning if necessary. Reserve.

14 Make the Pea Purée: cook the peas in a pan of boiling salted water until just tender, about 1 minute. Refresh in iced water and drain in a colander. Purée in a blender or food processor and pass through a fine sieve. Reheat to serve.

15 Allow the trotters to cool slightly, then cut them into slices. Put a potato basket in the middle of each plate, then place a spoonful of pea purée in each basket. Arrange 3 slices of trotter around each basket and 3 spoonfuls of the shallot sauce in between the medallions of trotter.

Tea of Game with Herb Dumplings

1/4 onion, finely chopped
1 carrot, finely chopped
1 celery stalk, finely chopped
1 garlic clove, finely chopped
100 g / 3^1/$_2$ oz game trimmings, finely chopped
4 juniper berries, finely chopped
whites of 3 eggs
2 litres / 3^1/$_2$ pints game stock (make it like that for the venison on page 160, using any game trimmings or carcasses)
salt and freshly ground black pepper

FOR THE HERB DUMPLINGS:
40 g / 1^1/$_2$ oz game meat, chopped
a little oil
125 g / 4^1/$_2$ oz self-raising flour
60 g / 2^1/$_4$ oz beef suet
10 g / 1/$_2$ oz finely chopped herbs, ideally a mixture of thyme, tarragon, chervil and chives
more game stock or water, for poaching

1 First make the Herb Dumplings: seal the chopped game meat briefly in a very little oil over a high heat. Let it cool slightly. Mix the flour and suet together, add the herbs and game meat and bind together with about 5 tablespoons of water. Season the mixture and roll into 3-cm / 1^1/$_4$-inch dumplings. Cook the dumplings in game stock or water for about 7–10 minutes, until they are fluffy.

2 Make the tea of game: in a large bowl, mix all the vegetables, game trimmings and juniper berries. Add the egg whites and mix in well.

3 Stir the vegetable mixture into a pan containing the cool game stock and put over a high heat. Stir regularly, until almost at boiling point a thick crust forms on top. When a crack appears in this crust, take a ladle and enlarge the hole with it so it is big enough for the ladle to fit through. As it simmers, keep pouring the liquid over the top of the crust to clarify it. Taste the stock, season it and, when it has a good strong flavour, pass it through a muslin-lined sieve.

4 Reheat the strained tea of game gently with the dumplings in it and serve immediately.

Jellied Eel Terrine with a Caper Dressing

4 large eels, skinned, filleted and cut into long strips
2 large potatoes, cut into 5-mm / 1/4-inch slices
1 large leek, thinly sliced
7^1/$_2$ leaves of gelatine
600 ml / 1 pint clear tomato juice
bunch of tarragon, chopped
bunch of chervil, chopped
salt and freshly ground white pepper
lemon juice
mixed salad leaves, to serve

1 Several hours ahead, make the court-bouillon: put all the ingredients into a large pan with 500 ml / 18 fl oz water. Bring to the boil and then lower the heat and simmer for about 20 minutes. Remove from the heat and allow to cool, then pass through a fine sieve.

2 Bring the sieved court-bouillon back to a simmer and poach the eel in it until just cooked through and firm, about 5 minutes.

3 Cook the potatoes in boiling salted water until tender. Cook the leeks in boiling salted water until tender.

4 Soak the gelatine in some cold water. When soft, drain off the water and dissolve the gelatine in a little warmed tomato juice, then add this to the rest of the juice. Stir well and then stir in the herbs and some of the cooked leeks.

FOR THE COURT-BOUILLON:
300 ml / $\frac{1}{2}$ pint white wine
60 g / 2$\frac{1}{4}$ oz onion, sliced
60 g / 2$\frac{1}{4}$ oz carrots, sliced
1 stalk of celery, roughly chopped
2 garlic cloves
1 bay leaf
1 sprig of thyme
8 black peppercorns
generous pinch of salt
$\frac{1}{2}$ lemon

FOR THE CAPER DRESSING:
2 shallots, finely chopped
1 tsp grainy mustard
pinch of sugar
2 tbsp caper vinegar
250 ml / 9 fl oz olive oil
25 g / 1 oz capers
1 tbsp chopped parsley

FOR THE BOILED ONION RINGS:
2 onions, sliced

5 Pour a layer of this about 1 cm / $\frac{1}{2}$ inch deep in the bottom of a terrine and chill to set.

6 Add a layer of the eel, season with salt and lemon juice, then add more jelly (reheated if necessary) and allow to set again.

7 Add a layer of potato and continue in this way until the terrine is full. Then chill for several hours until quite firm.

8 Make the Boiled Onion Rings: boil the onion slices until tender, then drain well.

9 Make the Caper Dressing: in a bowl, mix the shallots, mustard, sugar and vinegar. Whisk in the oil and add the chopped capers. Season to taste. Add the parsley just before serving, to avoid losing its colour.

10 To serve, cut the terrine into slices about 2 cm / $\frac{3}{4}$ inch thick. Set each terrine slice on a bed of mixed leaves, scatter the boiled onion rings on it and pour some caper dressing over the top.

Hot and Cold Salad of Smoked Salmon and Scallops
with Basil Dressing

225 g / 8 oz smoked salmon, thinly
sliced
mixed salad leaves
a little oil
8 scallops
juice of 1 lemon

FOR THE BASIL DRESSING:
4 tbsp extra-virgin olive oil
50 g / 2 oz basil
salt and freshly ground white pepper

**FOR THE VEGETABLE
GARNISH:**
50 g / 2 oz onion, diced
50 g / 2 oz courgettes, diced
50 g / 2 oz aubergines, diced
115 g / 4 oz red peppers, peeled and
diced
a little oil
50 g / 2 oz blanched, skinned,
deseeded and diced tomato flesh

1 First, make the Basil Dressing: warm the oil, add the picked basil leaves and season. Blend to a purée in a blender or food processor. Allow to cool.

2 Prepare the vegetable garnish: lightly sauté all the fresh vegetables separately in a little oil until tender. When all are cooked, mix them together and add the tomato. Keep warm.

3 Roll up the slices of smoked salmon, with one end of the roll more open to make 'roses'. Arrange the salmon on 4 plates on top of a bed of mixed leaves.

4 Put a little oil in a hot frying pan. When that is hot, add the scallops and cook on one side for about 2 minutes to get them golden-brown and caramelized.

5 While the scallops are cooking, arrange 5 piles of the warm vegetables around each smoked salmon salad.

6 Turn the scallops over and cook for a further 20 seconds on that side. Season with salt and lemon juice.

7 Arrange the scallops on a couple of the warm piles of vegetables and pour the basil dressing around.

Skate Wing with Spinach and a Tartare of Mussels and Parsley

1 large skate wing, flesh removed
from the bone
200 ml / 7 fl oz nage (page 112)
1 tsp cream
150 g / 5 oz butter
salt and freshly ground white pepper
lemon juice
a little oil
1 garlic clove
200 g / 7 oz spinach

FOR THE GARNISH:
20 mussels, prepared and cooked as
described on page 112
30 g / 1¼ oz capers
20 g / ¾ oz finely diced onions,
briefly blanched in boiling water,
refreshed and well drained
30 g / 1¼ oz diced gherkins
1 plum tomato, blanched, skinned,
seeds removed and diced
1 tbsp chopped parsley

1 Cut the skate into 4 equal portions and chill in the fridge until ready to cook.

2 Reduce the nage down by one-half, then add the cream and whisk in 125 g / 4½ oz of the cold butter, a little at a time. Season with salt, pepper and a little lemon juice.

3 Get a frying pan good and hot, add a little oil and, when that is hot, fry the skate for about 3–4 minutes until golden brown. Turn and cook the other side for a further 20 seconds.

4 While the fish is frying, heat the remaining butter in another pan with the garlic and cook the spinach with some seasoning until just wilted.

5 Divide the spinach between 4 warmed bowls and put a piece of skate on top. Season with salt and a little lemon juice. Keep warm.

6 Add the garnish to the nage and warm through, but do not allow to boil.

7 Spoon the garnish and sauce around the skate and serve.

Braised Fillet of Turbot with Jerusalem Artichokes, Baby Leeks and Wild Mushrooms

4 fillets of turbot, each about 150 g / 5 oz, skinned

about 125 g / 4½ oz Jerusalem artichokes

8 baby leeks

50 g / 2 oz butter

salt and freshly ground white pepper

1 shallot, thinly sliced

4 tbsp white wine or dry vermouth

lemon juice

175 g / 6 oz wild mushrooms, picked over and cleaned

1 tsp cream

about 115 g / 4 oz spinach

1 garlic clove

1 Remove any pin bones from the turbot. Set aside.

2 Peel the Jerusalem artichokes and then cook them whole in boiling salted water, putting the larger ones in first, until they are just tender. Refresh in cold water and drain well.

3 Rinse the leeks and blanch them briefly in boiling salted water, then refresh in cold water and drain well.

4 Preheat the oven to 190°C/375°F/gas 5. Heat 15 g / ½ oz of the butter in an ovenproof pan and lightly sweat the shallot in it until softened.

5 Place the seasoned fish in the pan and add the wine or vermouth and 6 tablespoons of water. Bring to a simmer, then cover and place in the oven for 3–4 minutes. Remove from the oven, remove the fish from the pan, sprinkle with a little lemon juice and keep warm.

6 Sieve the cooking liquid into a frying pan. Add the wild mushrooms and cooked artichokes to the pan. Add the cream and whisk in two-thirds of the remaining butter, in small pieces, then season to taste.

7 Sweat the spinach in pan with last of the butter, some seasoning and the whole garlic clove for about 1 minute. (When cooking spinach like this it is essential that you season as soon as it goes into the pan, otherwise the leaves tend to form a solid mass and the seasoning does not get evenly distributed). Keep warm.

8 Warm the leeks through in the sauce and then reheat the fish in the sauce.

9 To serve: pile some spinach in the centre of each of the plates and put the fish on top. Spoon over the sauce, mushrooms and vegetables.

Cutlet of Pork with Cider Potatoes, Gâteau of Black Pudding, Onions and Cabbage, and Juices Scented with Sage

1 rib-end loin of pork, weighing about 2 kg / 4½ lb
salt and freshly ground black pepper

FOR THE JUICES SCENTED WITH SAGE:
Herb Juices (page 116, made without the tarragon)

FOR THE CIDER POTATOES:
6 large baking potatoes
1 litre / 1¾ pints sweet cider or apple juice
50 g / 2 oz butter
pinch of salt

FOR THE GÂTEAU OF BLACK PUDDING, ONIONS AND CABBAGE:
a little oil
1 onion, thinly sliced
leaves picked from 1 sprig of sage, chopped
8 leaves from a Savoy cabbage
25 g / 1 oz butter
60 g / 2¼ oz smoked bacon, thinly sliced
1 shallot, diced
4 slices of black pudding (see page 202)

1 First, well ahead, make the Herb Juices as described on page 202.
2 Make the Cider Potatoes: peel the potatoes and cut them into 2.5-cm / 1-inch-thick slices. Using a 5-cm / 2-inch circular cutter, cut the potato slices into rounds. If you like, peel around the edges of the potato for a neater appearance.
3 Put the potato slices in a large pan and cover with cider or apple juice. Add the butter and salt. Place the pan over a high heat and bring to the boil. Gently reduce the liquid, until it is syrupy and caramelization has begun. Turn the potatoes and gently colour them until nicely golden on both sides. If the potatoes are coloured but not cooked, add a little water and repeat the process. Remove and keep warm.
4 While the potatoes are cooking, prepare the pork: preheat the oven to 220°C/425°F/gas 7. Chine the pork, remove the skin from the loin and reserve to one side. Use a sharp knife to remove the silver skin from the pork flesh. Clean down the rib bones and portion the pork. Remove the excess fat, cut it into strips the size of each pork cutlet and wrap these around the pork. Tie up so that they will hold their shape.
5 In a hot ovenproof frying pan, seal the seasoned meat on both the sides which are not covered by the fat.
6 Put the pan in the oven, with the pork skin on the bottom of the pan (to protect the meat and keep it moist). Cook for about 15 minutes.
7 While the pork is roasting, make the Gâteau of Black Pudding, Onions and Cabbage: put a little oil in a hot pan, add the onions and sweat them until all the moisture has gone. Season, add the chopped sage leaves and set side.
8 Remove the large vein from the cabbage leaves and discard. Blanch the leaves in boiling salted water, then refresh in iced water.
9 Meanwhile, sweat the bacon in the butter until cooked, then add the shallot and cook until softened but not coloured. Add the blanched cabbage leaves, season with pepper and stir to warm through.
10 Put the slices of black pudding inside a metal cutter about 7.5 cm / 3 inches across and 10 cm / 4 inches high. Add a layer of onion and heat through in the oven for about 10 minutes. Put the cabbage on top of the onion.
11 Turn the gâteaux out on to one side of the centre of (preferably oval) serving plates, with the cabbage on the bottom. Put the pork in the middle of the plates and the potatoes on the other side, in a line. Spoon the sauce over all three.

Braised Haunch of Venison with Celeriac Purée, Roast Root Vegetables and Kümmel Cream

800 g / 1³/₄ lb haunch of venison

FOR THE SAUCE:

1 kg / 2¹/₄ lb venison bones
1 carrot
2 celery stalks
¹/₂ onion
2 garlic cloves
a little oil
2 ripe plum tomatoes
200 ml / 7 fl oz port
1 sprig of thyme
6 juniper berries
1.5 litres / 2¹/₄ pints chicken stock
500 ml / 18 fl oz veal stock

FOR THE ROAST ROOT VEGETABLES:

2 carrots
1 small swede
1 small celeriac root
2 black salsify roots
about 450 g / 1 lb duck fat

FOR THE CELERIAC PUREE:

1 small celeriac root
300 ml / ¹/₂ pint milk
100 ml / 3¹/₂ fl oz whipping cream
salt and freshly ground black pepper

FOR THE KÜMMEL CREAM:

1 shallot, thinly sliced
4 juniper berries, crushed
3 tbsp Kümmel
250 ml / 9 fl oz whipping cream

1 Several hours ahead, make the sauce: preheat the oven to 190°C/375°F/gas 5 and brown the bones in the oven for about 1 hour. Roughly chop up all the vegetables and the garlic, keeping the tomatoes separate. Put the chopped vegetables into a pan with a little oil and cook until brown. Add the chopped tomatoes and cook a little longer, until some of the moisture has evaporated from the tomatoes. Add the port and reduce by half.

2 Put this with the browned bones into the pan, together with the thyme and juniper. Pour in the chicken stock, bring to the boil and simmer for about 3 hours. Pass the stock through a fine sieve, discarding the solids.

3 Add the veal stock and reduce down until the sauce has a good strong flavour and pouring sauce-like consistency.

4 Preheat the oven again to 190°C/375°/gas 5.

5 Prepare the roast root vegetables: peel all the vegetables and cut them into diamond shapes. Poach in the duck fat for about 25 minutes, until soft but not overcooked.

6 Meanwhile, make the Celeriac Purée: trim the celeriac and dice it. Boil it in the milk until tender, about 25 minutes. Purée the drained celeriac in a blender or food processor.

7 In another pan, boil the whipping cream until thick, add the purée and season with salt and pepper. Keep warm.

8 Make the Kümmel Cream: put the shallot and juniper berries into a heavy-based pan, add the Kümmel and boil to reduce by half. Add the cream, and continue to reduce to achieve a consistency slightly thicker than the sauce (so the two won't mix). Sieve, season and keep warm.

9 Cook the venison: remove all the sinew from the haunch and cut the meat into 3-cm / 1¹/₄-inch cubes. Season, then seal in a hot pan with a little oil until well browned on all sides. Braise in the oven with about 200 ml / 7 fl oz of the sauce for about 15 minutes.

10 At the same time, finish the roast root vegetables: drain off the duck fat, then fry the vegetables briefly in a heavy-based ovenproof pan to colour and dry them slightly. Finish by cooking them in the oven for about 5–10 minutes, until the vegetables are golden.

11 To serve: arrange the roast root vegetables on the plates with the celeriac purée in the centre. Place the venison on top of the celeriac purée. Spoon a small cordon of the kümmel cream over the vegetables and some of the venison sauce around them.

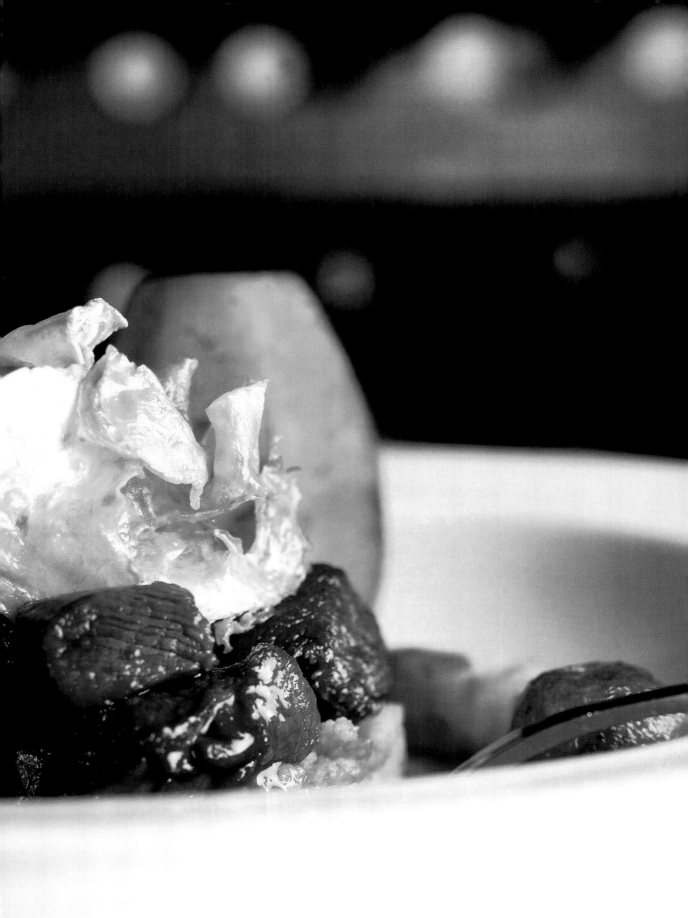

Roasted Partridge with Walnut Mashed Potatoes, Chicory, Candied Onions and Its Own Juices

3 tbsp walnut oil
2 brace of partridge, wings trimmed
and wishbone removed, trussed
salt and freshly ground black pepper

FOR THE SAUCE:
3 tbsp walnut oil
150 ml / ¼ pint port
8 shallots, chopped
2 garlic cloves
1 sprig of thyme
10 walnuts
600 ml / 1 pint chicken stock
150 ml / ¼ pint veal glaze (optional)

FOR THE WALNUT MASHED POTATOES:
450 g / 1 lb baking potatoes in their skins
200 ml / 7 fl oz whipping cream
125 g / 4½ oz butter
3 tbsp walnut oil

FOR THE PEELED WALNUTS:
20 walnut halves
milk to cover
pinch of salt

FOR THE CHICORY:
4 heads of chicory
1 lemon
a little oil
1 tbsp caster sugar
knob of butter

1 Preheat the oven to 230°C/425°F/gas 7. Heat an ovenproof frying pan or casserole, add the oil and, when that is hot, seal each of the birds on both breasts. Place in the oven for about 10 minutes, turning the birds over half-way through. Make sure the entire leg is flat on the bottom of the pan so that they cook more quickly and the breasts more slowly.

2 Remove from the oven and allow to rest for about 5 minutes. Remove the leg ends and trim the drumsticks for presentation, scraping away fat and sinew about 1 cm / ½ inch back from the top of the leg to make a nice clean bone. Remove the breasts from the bone, cover them with butter paper or foil and set aside in a warm place.

3 Make the sauce: chop up the bones as small as possible. Place them, including the wing-tips and wishbones removed earlier, in a hot pan with a little walnut oil and cook until golden brown.

4 While the bones are browning, blanch the walnuts for about 30 seconds in boiling milk and then, when they are cool enough to handle, peel them.

5 Add the port to the pan of bones and reduce by half. Add the shallots, garlic, thyme and walnuts. Cover with chicken stock, bring to the boil and simmer, skimming off all of the fat and scum that come to the surface, for about 1½ hours. Add the veal glaze and reduce to a pouring-sauce consistency, then pass through a fine sieve.

6 At the same time, make the Walnut Mashed Potatoes: simmer the potatoes in salted water until cooked. Drain and, when cool enough to handle, peel them.

7 In a pan, bring the cream and butter to the boil. Reduce the heat and simmer until thickened, about 2 minutes. Add to the potatoes and pass through a coarse sieve. Add the walnut oil and season to taste.

8 Prepare the peeled walnuts: place all ingredients in a pan, bring to the boil and simmer for 5 minutes. Remove from the milk with a slotted spoon. When cool, use a small knife to remove the bitter skin. Place the walnuts back in the milk to keep them white.

9 Prepare the chicory: cut them in half lengthwise and remove most of the core. Blanch in a pan of boiling water with the juice of half the lemon to stop the chicory from discolouring, then refresh in iced water. Put a small amount of oil in a hot frying pan, add the chicory and fry until golden. Add the sugar and caramelize. Add the butter, season with salt and pepper and finish with a little lemon juice.

10 Make the Candied Onions: heat a heavy-based pan, add a little oil,

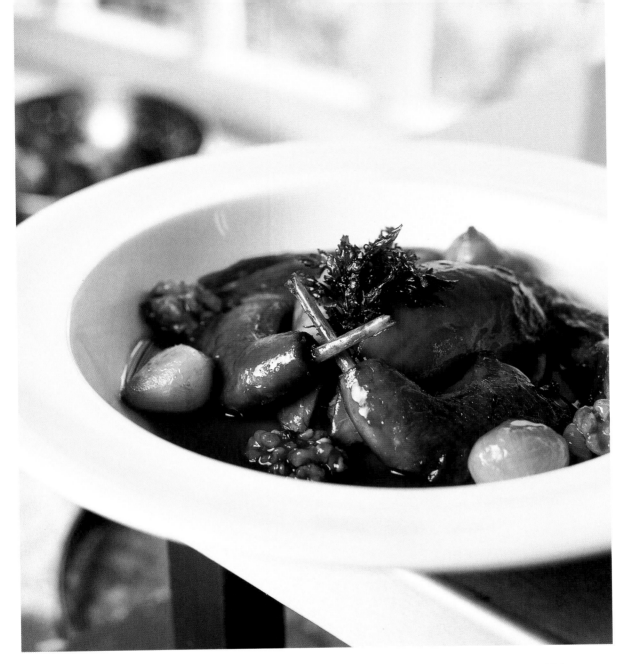

FOR THE CANDIED ONIONS:
a little oil
50 g / 2 oz caster sugar
20 button onions, peeled

followed by the sugar and heat until a caramel is formed. Add the onions, cover with water and boil to drive off all the water, leaving a syrup in the bottom of the pan. Season the onions and remove them from the pan.

11 To serve: place a quenelle or heaped spoonful of the potato in the middle of each plate. Push a partridge breast in on either side of the potato. Lean the legs against the breasts, almost as if reconstructing the shape of the bird. Place some chicory at the top of each plate, arrange the onions and walnuts around and spoon some sauce over the bird.

Creamed Rice Pudding Scented with Hazelnut, Served with Honey Ice-cream

150 g / 5 oz Carolina pudding rice
1 litre / 1³/₄ pints milk
1 vanilla pod
5 tbsp hazelnut oil
4 eggs
125 g / 4¹/₂ oz caster sugar

FOR THE HONEY ICE-CREAM:
300 ml / ¹/₂ pint whipping cream
600 ml / 1 pint milk
1 vanilla pod
10 egg yolks
85 g / 3 oz caster sugar
175 g / 6 oz runny honey

1 Well ahead of time, make the Honey Ice-cream: put the cream and milk together in a pan with the vanilla pod and bring to just below the boil. Cream the egg yolks and sugar together until pale and frothy. Pour the boiling cream and milk over the creamed mixture, whisking continuously. Pour the mixture back into the pan and cook until it coats the back of a spoon. Pass through a fine sieve, then whisk in the honey until it is well combined.

2 Place in an ice-cream machine and churn until frozen. Freeze for at least 4 hours.

3 Soak the rice in cold water for about 1 hour.

4 Drain the rice and put it in a heavy pan with the milk, vanilla pod and oil. Bring to a simmer and cook until the rice is tender, about 20 minutes.

5 Cream the eggs and sugar together until light.

6 Bring the rice to a rolling boil and stir in the egg and sugar mixture. Leave to cool. Remove the vanilla pod.

7 Preheat a hot grill. Put the rice pudding mixture in ramekin dishes and grill briefly to colour the tops and warm through.

8 Serve with a side dish of the ice-cream.

Apple Crumble Soufflé and Apple Crumble Sorbet

SERVES 2

2 Bramley apples
1 tbsp cornflour mixed with a little water
whites of 4 eggs
100 g / 3$\frac{1}{2}$ oz caster sugar

FOR THE APPLE CRUMBLE:

45 g / 1$\frac{3}{4}$ oz butter
90 g / 3$\frac{1}{4}$ oz flour
90 g / 3$\frac{1}{4}$ oz brown sugar
90 g / 3$\frac{1}{4}$ oz ground almonds

FOR THE APPLE CRUMBLE SORBET:

450 g / 1 lb Bramley apples, peeled, cored and roughly chopped
450 g / 1 lb caster sugar
45 g / 1$\frac{3}{4}$ oz butter
90 g / 3$\frac{1}{4}$ oz flour
90 g / 3$\frac{1}{4}$ oz brown sugar
90 g / 3$\frac{1}{4}$ oz ground almonds

1 At least 8 hours ahead, preferably the day before, make the apple crumble: preheat the oven to 150°C/300°F/gas 2. Rub the butter into the flour until the mixture resembles fine breadcrumbs. Mix in the other ingredients, place on a tray in a layer about 1 cm / $\frac{1}{2}$ inch deep and bake in the oven until golden brown, 10–15 minutes.

2 Make the sorbet: put the apple and caster sugar in a pan with 500 ml / 18 fl oz water, bring to the boil and simmer gently for about 15 minutes until the apple has collapsed to a purée. Pass through a fine sieve, allow to cool and then churn in a sorbetière until frozen.

3 Preheat the oven to 150°C/300°F/gas 2. In a mixing bowl, rub the butter into the flour until the mixture has the consistency of coarse breadcrumbs. Stir in 175 g / 6 oz of the crumble, together with the brown sugar and ground almonds. Spread out on a baking sheet like the crumble and bake until crisp, about 10-15 minutes. Leave to cool.

4 Fold the cooled mixture into the sorbet and refreeze briefly.

5 An hour or two before you want to serve: cut the apples across in half, just above halfway up, and scoop out all the flesh, leaving about $\frac{1}{2}$ cm / $\frac{1}{4}$ inch of apple flesh on the skin, to form 'dishes' for the soufflés.

6 Place the flesh in a pan with a little water and cook until all the apple has collapsed into a fine pulp. Thicken with the cornflour and set aside.

7 Make the soufflés: preheat the oven to 190°C/375°F/gas 5. Whisk the egg whites with the sugar until they form a meringue.

8 Make a paste with the apple coulis and about 4 spoonfuls of the meringue, then lightly fold in the rest.

9 Mix in a heaped tablespoon of the crumble mix. Spoon this mixture into the scooped-out apples, sprinkle the top with more crumble and bake until fully risen, 10–12 minutes.

10 Serve the soufflé on plates alongside a serving of the sorbet.

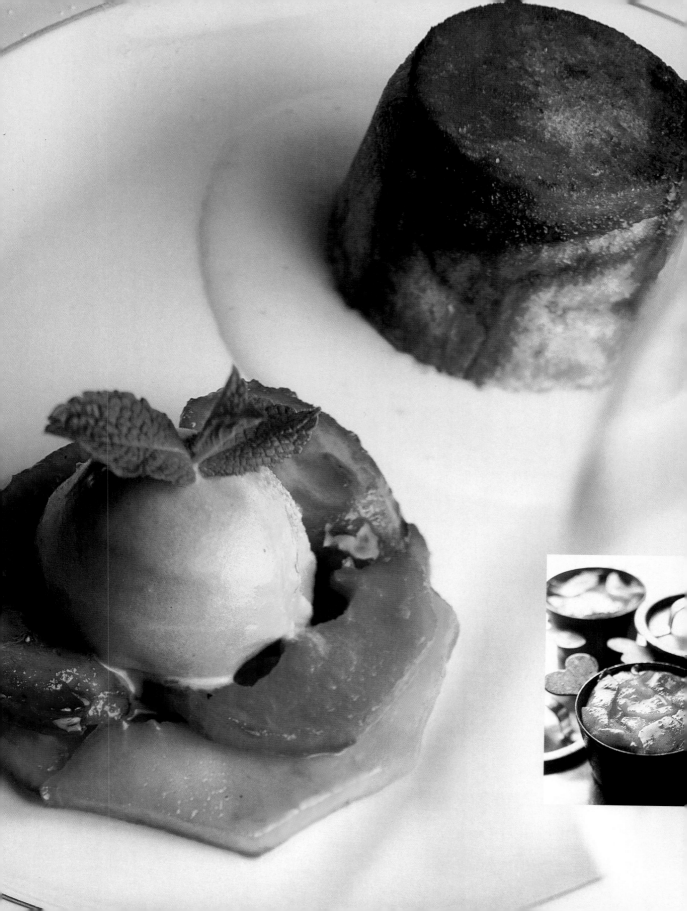

Apple Charlotte with English Custard, Caramelized Fruit and Caramel Ice-cream

6 Granny Smith apples
2 tsp ground cinnamon
3 tbsp brandy
125 g / 4^1/$_2$ oz soft brown sugar
12 thin slices of bread
125 g / 4^1/$_2$ oz butter, melted

FOR THE CARAMEL ICE-CREAM:
500 ml / 18 fl oz milk
250 ml / 9 fl oz whipping cream
1 vanilla pod
350 g / 12 oz caster sugar
10 egg yolks

FOR THE ENGLISH CUSTARD:
4 egg yolks
125 g / 4^1/$_2$ oz caster sugar
1 vanilla pod
300 ml / 1/$_2$ pint milk
150 ml / 1/$_4$ pint whipping cream

FOR THE CARAMELIZED FRUITS:
about 7.5 g / 1/$_4$ oz icing sugar
50 g / 2 oz pear, peeled and sliced
50 g / 2 oz apple, peeled and sliced
50 g / 2 oz banana, peeled and sliced
50 g / 2 oz mango, peeled and sliced
50 g / 2 oz papaya, peeled and sliced
a little vegetable oil

1 Well ahead, make the Caramel Ice-cream: put the milk and cream in a pan with the vanilla pod and bring to the boil.

2 In a large bowl, cream 100 g / 3^1/$_2$ oz of the sugar with the egg yolks, then pour the boiled milk and cream mixture on the yolk mixture. Pour back into the pan and cook, stirring continuously, until the custard is thick enough to coat the back of a spoon.

3 In a heavy-based pan, dissolve the remaining sugar in 3 tablespoons of water. Bring to the boil and cook to a dark caramel. Add another 150 ml / 1/$_4$ pint of cold water to stop the sugar from cooking any further and make a syrup.

4 Add the cooled caramel syrup to the custard and churn in an ice-cream machine until frozen.

5 Make the English Custard: in a bowl, cream the egg yolks and sugar together until light.

6 Split the vanilla pod lengthwise and scrape the seeds into a pan. Add the milk and cream and bring to the boil. When the mixture has boiled, add a little of it to the eggs and whisk in. Return all the mixture to the pan and gently heat, stirring continuously, with a wooden spoon, until it has a good sauce-like consistency (if the mixture curdles or splits, simply liquidize it until smooth). Pour through a sieve and allow to cool, covered with cling-film (punctured with a few holes) to prevent a skin forming.

7 Prepare the Caramelized Fruits: heat a pan, put in a drop of oil and add the icing sugar. When it starts to froth, add the sliced fruits and toss in the pan (you may have to do this in batches). When they are soft and golden, remove from the heat and allow to cool.

8 Preheat the oven to 190°C/375°F/gas 5. Peel the apples, core them and cut the flesh into 1-cm / 1/$_2$-inch dice. Place in a very hot dry pan and sauté for about 30 seconds. Add the cinnamon and brandy, then add the sugar and cook for a further 10 minutes.

9 Cut the bread into 8 circles the same diameter as the ramekins to be used as charlotte moulds and strips the height of the sides of the ramekins. Dip them into the melted butter and use to line the ramekins.

10 Fill the lined moulds with the apple mixture, seal with a final round of bread and bake in the oven until crisp and golden, about 20–25 minutes. Allow to cool slightly and then turn out of their moulds.

11 To serve: arrange some caramelized fruit on each plate with some of the ice-cream on top. Place a charlotte to the side of each plate, set on top of a pool of the custard.

Apple Tarts with Gingerbread Ice-cream and Cider Butter

4 Granny Smith apples
4 discs of puff pastry, about 15 cm / 6
6 inches across and 4 mm / $^1/_{16}$
inch thick
icing sugar, to glaze

FOR THE GINGERBREAD:
90 g / 3$^1/_4$ oz butter, plus more for greasing the pan
125 / 4$^1/_2$ oz golden syrup
250 g / 9 oz flour, plus more for dusting
2 tsp baking powder
1 tsp ground ginger
125 g / 4$^1/_2$ oz granulated sugar
pinch of salt

FOR THE GINGERBREAD ICE-CREAM:
400 ml / 14 fl oz milk
5 egg yolks
35 g / 1$^1/_4$ oz caster sugar

FOR THE CIDER BUTTER:
3 Bramley apples
300 ml / $^1/_2$ pint sweet cider
about 50 g / 2 oz caster sugar
(depending on the acidity of the apples)
200 g / 7 oz unsalted butter

FOR THE SYRUP:
100 g / 3$^1/_2$ oz caster sugar
1 vanilla pod
1 cinnamon stick
juice and zest of 1 lime

1 Well ahead, ideally the day before, make the Gingerbread: preheat the oven to 190°C/375°F/gas 5 and grease a 23-cm / 9-inch cake tin with butter, then dust the insides with flour. In a small pan, melt the butter with the syrup. In a large bowl, mix the remaining ingredients together and then stir the melted butter mixture into that. Spoon the mixture into the prepared cake tin and allow to rest for about 20 minutes.

2 Bake the gingerbread for about 20 minutes, until golden on top. Allow to cool.

3 Make the Gingerbread Ice-cream: break up 75 g / 2$^3/_4$ oz of the cooked gingerbread into a mixing bowl. Bring the milk to the boil in a pan and pour it over the gingerbread. Leave for 1 hour to allow the gingerbread to dissolve in the milk.

4 Put the milk back on to heat to boiling. In a mixing bowl, whisk the egg yolks and sugar together until light. Pour the boiling milk mixture over the egg mixture and mix well. Return to the pan and simmer until smooth, about 5 minutes. Pass through a sieve and allow to cool.

5 When cool, churn in an ice-cream maker until just firm, then stir in 25 g / 1 oz more crumbled gingerbread and freeze for at least 1 hour more.

6 About 45 minutes before you want to serve, preheat the oven to 190°C/375°F/gas 5.

7 Make the Cider Butter: peel and core the apples, then chop the flesh roughly. Cook in the cider with the sugar until tender. Liquidize until smooth, then pass through a sieve and whisk in the butter while it is still warm. Adjust the sweetness with more sugar if necessary.

8 While the apples are cooking, make the syrup: heat the sugar in 200 ml / 7 fl oz water with the remaining ingredients. When all the sugar has dissolved, bring to the boil and boil rapidly for about 10 minutes. Keep warm.

9 Make the tarts: peel and core the apples, then slice them thinly. Arrange the slices overlapping over the centre of pastry discs, leaving a clear edge of pastry about 5 mm / $^1/_4$ inch wide. Spoon the syrup over the apples.

10 Dust with icing sugar and bake for about 15 minutes, until golden.

11 To serve: place a warm tart in the centre of each of the serving plates, then spoon a cordon of the cider butter around it. Place some ice-cream on top of each tart and serve immediately.

Warm Salad of Welsh Goats' Cheese
with Roasted Walnuts, Deep-fried Herbs and Nut Dressing

12 small slices of bread roll
knob of butter
2 Gedi goats' cheese logs, each cut
into 12
about 20 walnut halves
several good sprigs each of tarragon,
basil, celery leaves and flat-leaved
parsley, as much of the stalks
removed as possible
vegetable oil, for deep-frying
200 g / 7 oz salad leaves

FOR THE NUT DRESSING:
1$\frac{1}{2}$ tbsp white wine vinegar
125 ml / 4 fl oz extra-virgin olive oil or
mixture of nut oils
$\frac{1}{2}$ garlic clove, finely crushed
$\frac{1}{2}$ tsp sugar
$\frac{1}{2}$ shallot, very finely chopped
$\frac{1}{4}$ tsp grainy mustard
$\frac{1}{2}$–$\frac{3}{4}$ tsp salt
50 g / 2 oz chopped roasted nuts,
ideally hazelnuts

1 Preheat the oven to 190°C/375°F/gas 5 and preheat oil for deep-frying to 140°C/285°F.

2 In another pan, fry the croutons in a little butter until golden.

3 Place a piece of cheese on each crouton and bake in the oven for about 5 minutes until melted and bubbling.

4 At the same time, roast the walnuts in the oven for about 5 minutes to increase their flavour.

5 Make the Nut Dressing: mix all the ingredients together well until emulsified. (These quantities will make more than you need, but the dressing keeps well in a screw-top jar in the fridge and can be used on a wide range of salads.)

6 Prepare the herbs for the garnish: carefully drop them into the hot oil (be careful, they are full of moisture, so they will cause spattering and lots of foaming). Cook for 20 seconds only, then remove with a slotted spoon and drain on kitchen paper.

7 Dress the salad leaves with about 4 tablespoons of the dressing and arrange these in the centre of each plate. Arrange the nuts and deep-fried herbs around it. Place the baked cheese on top and pour on a little more nut dressing.

Baked Coconut Cream with Caramelized Fruits and Rum Sabayon

175 g / 6 oz caster sugar
2 eggs, plus 2 extra yolks
500 ml / 18 fl oz coconut milk or
purée
1 vanilla pod

Caramelized Fruits (see page 169)

FOR THE RUM SABAYON:
2 egg yolks
2 tbsp rum
1 tsp caster sugar
1 tsp whipping cream

1 Make a caramel by stirring 100 g / 3$^{1}/_{2}$ oz of the sugar with 2 tablespoons of water in a heavy-based pan, bring to the boil and cook until it becomes a golden caramel. Pour into the bottoms of 4 dariole moulds and leave to set.

2 Preheat the oven to 130°C/275°F/gas 1. In a large bowl, cream the eggs and remaining sugar together until light.

3 Put the coconut milk or purée in a pan with the vanilla pod and bring to just below the boil. Pour on to the egg mixture, stir well and then pass the mixture through a fine sieve. Skim off the foam and pour the mixture into the moulds.

4 Place them in a bain-marie half-filled with hot water. Cover with foil and cook in the oven for about 25–30 minutes.

5 While the coconut creams are cooking, prepare the Caramelized Fruits as described on page 169. When the coconut creams are cooked, allow them to cool slightly before turning out of their moulds.

6 While the creams are cooling, make the Rum Sabayon: place all the ingredients in a metal mixing bowl with 2 tablespoons of water and set it over a bain-marie filled with hot water. Whisk together until the egg yolk is cooked and the mix has almost doubled in size.

7 Preheat a hot grill. Spoon the sabayon over the caramelized fruits and glaze under the hot grill for about 30 seconds until lightly coloured.

8 To serve: arrange the caramelized fruits in a circle around each plate and spoon the rum sabayon over them. Set a coconut cream in the centre.

Winter

I watch as people go in
looking starved and as they come
out full of energy. Once a woman
went in as thin as a stick, then
an hour later she came out as
fat as an elephant.

written by ROBYN CHAMBERS, aged seven
(niece of Paul Heathcote)

Christmas in Longridge
God Rest Ye Merry, Gentlemen (and women)

12.45 a.m. The night is clear and bitterly cold.

'Good night, madam. Good night, sir. Merry Christmas.' Andrew Lee's voice still manages to sound cheerful and infinitely courteous even though the cold seems to add a slight metallic resonance to it.

Madam pulls her coat more tightly around her, and tucks her arm inside that of sir. They make their way over to their Rover, its maroon shape lit by the flood-lighting reflecting off the creamy white front of the restaurant.

Andrew Lee doesn't wait for them to drive away. He still has to total up the evening's takings, make sure the team of Colin Shepherd, Michael Curry, James Garth and Chris Oliver, and Paul Wilshire, the sommelier, have laid up the tables for the next day, check the security, switch the lights off, and finally lock up. He won't be getting away much before 1.30 a.m. Still, that's what he's there for, isn't it?

The restaurant did forty-eight covers tonight, not bad at all. At £60 a head on average – that works out at a shade under £3,000 for the night's takings. On checking, Andrew finds that it's £3,164.75. It being this time of year, people are spending a touch more on wine, and a couple of bottles of Roederer Cristal at £130 a throw have helped bump things up.

Of course, Andrew reminds himself, that £130 probably represents a gross margin of only about 40 per cent, rather than the usual 62 per cent Paul tries to get them to work on. Still, it's not unsatisfactory, and part of a pattern that has been building nicely over the last few weeks. Yes, very satisfactory.

It's tough, this Christmas period, tough on them all, but the front-of-house staff really have to put in the hours. The last of the kitchen crew were able to go off hours ago, but now everyone else is into the festive season, he and the waiting staff will be working all the hours God gives them. The last of the lunchtime revellers only pushed off at 5.40, a group of five ladies, civil servants, who save up to come twice a year.

'This has been our fifth visit, and it's been really lovely. It's the best, isn't it?'

'Always the last to leave, that's our tradition.'

'Have you seen Marlene?'

'Where did you get those shoes?'

'Designer label, these shoes.'

'Get along with you. Which designer? Was it Bally?'

'Never.'

'Has anyone seen Marlene?'

'Well, where was it, then?'

'M & S. Very exclusive. You do have to ask the right questions, don't you?'
Gales of laughter.

'Marlene, where've you been?'

'Guess.'

'Not again.' Hoots of laughter. 'Did you see Dot?'

'Did someone call my name?'

'Have you got the car keys, Dot?'

'Have I got the car keys? Of course, I've got them. Look, here.'

'Miracle. Dot's got the car keys.' Hurricanes of laughter.

Andrew Lee holds the door open for them.

'We'll be back same time next year, unfortunately for you.' Typhoons of laughter.

They bustle and jostle out into the dark, faces lit with good living and shared pleasure.

That's what waiting on people is all about, really, making sure that they, the customers, have a good time, make sure they feel happy parting with sixty or so quid of their hard-earned money. Of course the food and drink have something to do with it too, but if the service isn't right, if you don't feel comfortable and content and cosseted, the hautest cuisine and the grandest of crus will be no more than ashes in the mouth.

The trouble is that the business of running a dining room doesn't get the recognition it deserves these days. It's the chefs who grab the headlines, do the TV appearances, write the books.

The art of waiting on people lacks the drama of the kitchen. There's none of the heat or noise or magic of transforming a piece of meat, a few veg and a bit of liquid into a creation that works its own magic on eye and mouth. No, it is in the very lack of all these things that the essence of good service lies. The more skilful the service, the more invisible it becomes. In a sense you should not notice good service. You should never have to ask for bread, wine or water. You should never wonder when your food is going to arrive. You should never feel you are being rushed from one course to the next.

For a short while between lunch and dinner there is tranquillity in the dining rooms. Something of that crepuscular inertness of a nightclub in daytime settles on them. They become empty, hollow, shadowy. There are faint smells, of the earlier celebrations and celebrants, a whiff of the Cornas, a hint of the baked coconut cream, a shading of Arpège, all overlaid by air freshener.

The tables are all laid ready for the evening crowd. The cutlery gleams in squared-up order, napkins rampant in elaborate ruffle formations, glasses in clusters of three, the light tracing a faint curved line down the outside of each, an unlit candle on every table, and an arrangement of orchids, ivy and fir.

The quiet – it is not quite silence – is broken by sounds from the kitchen, which is already revving up, and by the trilling diddle-diddle of the phone. It should never ring more than twice before being answered. 'Good evening. Paul Heathcote's restaurant.' Andrew Lee's tones are even and pleasant. It's someone wanting instructions on how to find the restaurant.

The restful quiet descends again. The blue/green and pink of the wallpaper and the sunflower yellow tablecloths glow.

ABOVE AND RIGHT:
STAGES IN THE
PREPARATION OF
BLACK PUDDING,
PAGES 202-3

On a good night the restaurant will seat sixty, divided between four rooms which run off one another, like the folia of a four-leaf clover. The arrival of the sixty will be carefully staggered so that there are no more than four new bookings every half-hour. In fact, on a really good night, Heathcote's will feed more than that because, by taking the first booking at 7.00, they can turn the tables round more than once by the time the last bookings are taken at 9.30.

Tonight, however, will not be a mad clatter like that. Tonight will be orderly. The guests will be greeted at the door, pass into the warmth of the porch, hung with the memorabilia of past triumphs – Chef of the Year 1994 plate, Booker Prize for Excellence 1992, a certificate noting three rosettes from the AA, the menu for the Grand Prix of Gastronomy dinner 1994, a menu signed by his colleagues at the Connaught Hotel when he left in 1985 – guided on into the reception area.

They will make their way to one of two levels, divided from each other by a half-wall of stone, and settle down into an armchair or sofa covered in strongly patterned natural colours, blue-green, pinks, browns. They will have a moment or two to admire the cream walls, and note where bulges of stone and the beams burst through. They may even have time to register the discrete cult of the personality, the photographs of Paul Heathcote with Raymond Blanc, with Anton Edelmann, with the late Francis Coulson, and a copy of *Great British Chefs* by Kit Chapman open at the section devoted to Paul Heathcote.

In truth, though, there is far less of the ego-flattering aggrandizement than you will find in most chef/patron restaurants, and many of the touches are hidden

away among the Christmas cards and the seasonal decoration, the bursts and arrangements of gilded and silvered fruits, hips, haws, ribbons and fir.

Guests will be flattered by the discreet and gentle lighting, from overhead spotlights, lamps on the side tables and upturned-cup wall fittings. The whole effect is to invite relaxation, to envelop the visitor in a sense of being looked after. 'Trust us,' the room whispers. 'We will look after you. Nothing can happen to you here.'

Then, suddenly, it's not all in the future. On the dot of 7 p.m. the first guests arrive. They are so punctual you feel they must have been waiting in their car outside, seen Andrew turn on the floodlighting on the front, counted to ten and come in. As they do so, the automatic door between the kitchen and the dining rooms swings open. 'Congratulations,' someone is saying. 'What's it like to've just won arsehole of the evening award.' Only it's unlikely that the couple who came in heard it above 'Have yourself a merry little Christmas' cooing over the sound system.

Andrew checks the names on the reservations list, takes the coats, guides them gently through to the first of the two reception areas.

'Would you care for a drink?'

A g&t and a mineral water, and we're up and away. Are they first-timers or regulars?

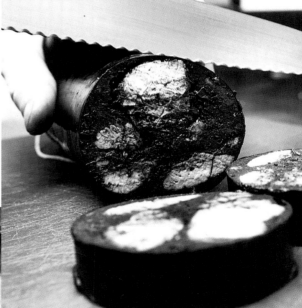

Are they habitués of restaurants or is this their big treat of the year? Have they ever been to this kind of place before? Do they know what to expect of it? Do they know what is expected of them? Are they nervous? Do they feel at home? All these imponderable will be pondered on, and depending on what their experience tells them, Andrew and his team will adjust their manner in a dozen unobtrusive ways, soothing, settling, reassuring where necessary, providing additional information on the menu descriptions, explaining, advising, guiding them through the wine list, making sure they feel relaxed and happy, because relaxed and happy guests have no trouble paying bills, relaxed and happy customers come back again, relaxed and happy customers tell their friends what a relaxed and happy time they had.

'It's perfect weather for a sleigh ride with you,' warbles the sound system.

She is talking to him. He is talking to her, but you can't hear anything other than a low murmur. They have automatically adopted the defensive colouring most people do on finding themselves alone in a restaurant or a church. They lower their voices. They form a kind of two-person laager.

Not for long, because a second couple have come in...

'Good evening, madam, sir. And the name is? Oh yes, will you come this way and would you care for a drink?'

Would you care for a drink? Not, would you like a drink? Do you want a drink? Can I get you a drink? No, it's would you *care* for a drink? And in an instant a pattern of courtesy and consideration are established.

Of course they'd care for a drink, two tonic waters, one with ice and lemon and one without the ice. Well, some people aren't taking many chances this evening. Sir has a blazer and grey flannels, white shirt and a dashing corporate tie. Madam is rather splendid in a full-length dark maroon suit with a black velvet collar. They aren't in the least intimidated by being in a public place.

'Did he touch that clock?' he demands. 'If he has I'll kill him.'

'He's normally very good,' she says, undisturbed by his vehemence.

The first couple get their drinks and canapés – 'A little cottage pie, duck in puff pastry and fromage frais with olives, tomatoes and chives on a puff pastry base,' explains Michael, who brought them – and they look grateful for being talked to. That's six minutes after they arrive. Their menus arrive eight or nine minutes after that, complete with explanation of the difference between the gourmet, the signature and the à la carte, and they sink into silent contemplation of their mysteries.

The second couple get their drinks.

'Oh well,' he says, 'happy birthday', and they clink glasses.

'If there's a moment when I'm freezing'

'A little squeezin' would be mighty pleasin', chunters the sound system.

The chap in the blazer and madam in the maroon suit are having some trouble coming to a decision. It would seem that although there are some dishes she would like, she does not necessarily go for all the elements of each dish. He, on the other hand, could quite easily work his way through from top left to bottom right. Oh dear. What to do?

Before they can come to a decision, the numbers are swelled by three young women, and the room is filled with the frilly smells of perfume. And would they

care for a drink? asks Andrew Lee, voice nicely balanced between deference and authority. It's a lemonade, this time, and a soda water, and a white wine. Hurrah. Someone who isn't driving.

Soon they're arriving thick and fast. And not all everybody seems to be sticking to Andrew Lee's masterplan of only four bookings every half an hour. But there are ways and means of keeping the flow of eager eaters from the reception area through the short corridor to the dining rooms. A minute or so added to the time it takes to deliver a drink, serve the canapés, deliver the menus and the wine list, take the food order, take the wine order, and then summon people to their table acts as a smooth brake without causing offence or making people unduly aware that they are waiting just a little longer than normal.

'The cutlet of pork sounds nice.'

'What's a bay leaf?'

'I'm going to decide what I want for dessert first.'

'What do you want?'

'Duckling, pork *and* beef.'

'Have you decided on the wine, sir?' asks Paul Wilshire, the sommelier.

'58, please.'

'The Macon Lugny.'

'Sounds nice.'

'And a partridge in a pear tree.' The voice on the sound system is a fruity as a Christmas pudding.

Through they go in their twos and threes, to be divided up among the four rooms according to a plan worked out between Andrew and his colleagues earlier. The big tables are allocated first, those with six or eight to them. There are also a few regulars who have stated preferences, and then the rest are distributed evenly between the rooms.

Each room has a dedicated waiter, Colin, Michael, James or Chris, with Andrew and Paul covering all four, making six full-time staff in total, with a couple of casuals to help out when things are really busy. Only tonight one of the full-timers called in earlier to say that that he wouldn't be in as his car had broken down on the motorway. Andrew regrouped his troops with his usual disciplined forbearance.

Tiddle-tiddle trills the phone. Mr and Mrs Watkins are going to be a little late. Not to worry, sir. No problem. And it's off to unravel the mysteries of the menu for the three young women.

'Ooooo, it's so hard to make up your mind.'

'Georgina guessed what I was going to have before I asked.'

'Well, I haven't guessed yet, madam,' says Andrew politely.

Soon two black puddings, one tea of game, one beef cutlet, one sole and one quail have been inscribed on the order pad, and Andrew has vanished into the kitchen, where he hands the order to Andy Barnes.

'Two black puddings, one tea, one beef cutlet, one Dover sole, one quail,' he calls out. He doesn't shout. Andy Barnes rarely shouts.

'Yes, chef,' comes back the chorus, and the cooking is underway with a rattle and a crash and the crackle of meat making contact with a super-heated pan. Andrew Lee has already gone, back into the ordered calm of the dining room.

There are already two more couples to attend to, dressed to kill, or the women are at any rate, in black sparkly jackets, cream silk shirts, and black skirts, worn quite short. The men are what you might call more circumspect, except in the tie department. Tonight is the night of the fantasy tie. Tonight ties flash and sparkle like the jewels in Aladdin's cave.

Andrew Lee discusses wine with two ladies in black. They know they want something white and something Australian. Andrew listens with his head cocked to one side. He is careful never to talk down to his customers. He goes off and comes back with a bottle of Chardonnay from Tasmania, not too expensive. Carefully he explains the provenance and the qualities of the wine. The two ladies in black look happy. Andrew smiles, pats the bottle, bobs his head, and takes it off. By the time everyone has got through into the dining room, all questions over food and wine should be resolved. Nothing should interfere with the smooth progression of courses and glasses, nothing disturb the sense of pleasure.

Then in comes an elderly party; spry, mind you, very spry. In fact, you wonder what exactly the nature of their relationship might be. She's wearing a floor-length otter- or seal-skin coat. You don't see many of those these days. And when she slides out of it, there underneath is a zebra-skin waistcoat, and you don't see many of those either. The hair has been hennaed and fluffed into a pleasing aurora, and the make-up has been artfully layered.

He is the very image of an elderly Lothario, trim, slim moustache, hair sleekly brushed back hard against the scalp, dark suit, black shoes as polished as the hair, white-shirted, and the flash and sparkle about his eyes and his tie.

'Would you like a glass of champagne?' says he.

'Oh, do you know, I just might, if you twist my arm,' says she.

'A couple of glasses of bubbles,' he says to Colin Shepherd.

'I always thought it was "bubbly". We always said "bubbly",' she says. 'It's twice the price it normally is.'

'It is the real McCoy. The real thing. You can always tell the real thing.'

'That's true.'

So they settle into the easy, chatty intimacy of people who know each other pretty well but don't see each other all the time.

'Are we going to see your family tomorrow?'

'I don't think so. It seems they don't want us now.'

'God rest ye, merry gentlemen,

Let nothing you dismay.' belts out the sound system. I'll say not.

'Ready to order, Mr Fort?' Andrew Lee bends over, pad in hand.

'Do you know, I think I am. I'd like tea of game, the jellied eel terrine, the cutlet of beef with oxtail and a baked coconut cream

with caramelized fruits and rum sabayon. Yes, that's what I'd like.' It's a lot, I know, but what the heck, it's Christmas, isn't it. The tea and the eel and the baked coconut cream are all old friends, survivors from the autumn menu, and I suspect the beef will be a new one.

'Very good, Mr Fort, Thank you.' Off he goes.

Over comes Paul Wilshire, sommelier, master of the wine list, student of human nature. You have to be a keen student of the human race if you're going to be a good sommelier. Within these few moments of contact you have to able to sum up (a) whether this person knows anything about wine; (b) what kind of wine are they likely to want; (c) how much you can reasonably expect them to spend; (d) how to adjust your manner between, say, leave-it-all-to-me and do-you-know-I-would-have-chosen-that-myself by way of that's-a-very-good-suggestion-but-if-I-might-suggest. It's a subtle business, being a sommelier.

'I was thinking I might have a half of the Cornas.'

'The '91. That should go very nicely with the beef. And what about a glass to start with?'

'With the tea and the terrine?'

'Hmm. Difficult one that. What about the Chablis? Premier Cru. It's quite fruity, so it'll stand up to the tea, but it's quite subtle, so it won't kill the terrine.'

'I'm in your hands,' I say. He smiles and departs.

Over on the far side of the room there's a busy debate going on between the two women in black.

'I'm going to have the black pudding to start.'

'I was thinking about the terrine.'

'What! The jellied eels?'

'No, no, the foie gras.'

They seem to be selling a lot of black pudding tonight. Of course, it is a classic, one of the signature dishes, but you don't really think of black pudding as *haute cuisine*, of people paying £7 for black pudding. Here it goes down a storm, unlike the jellied eel terrine. Why is it people with chomp their way through black pudding, made with pig's blood, and a terrine made with duck livers, but shudder at eel?

Now it's my turn to go through. 'Your table is ready, Mr Fort.' Oh, hurrah. It's just a matter of looking cool as everybody gives you the quick once-over when you walk into a room. This I manage, more or less, and slide the legs underneath the table, allow young Chris to shake out the napkin and settle it gently on my lap.

Then it's through the water rigmarole – 'Sparkling or still?' 'Still, please' – which makes you wonder what they did in the days when water came only from the tap. You realize how the water marketing industry has added immeasurably to the rituals of the table.

Now let's adjust the knives and forks a fraction, settle the three bell-shaped glasses in a slightly different order, check the arrangement of orchids, heather, gilded walnuts and yew, smooth any slight wrinkle in the yellow linen top-cloth over the sea-green/grey undercloth. These little actions have a ritual significance, taking possession of the table, putting your mark on it.

Right opposite is the large party of eight who have already settled into relaxed

affability. The conversation flicks back and forth easily between them.

'We had a disaster with our Christmas dinner last year.'

'That was only because you wanted to eat the goose three-quarters of an hour before it was ready.'

There's a necklace of lights above the defunct fireplace, woven in and out of more clusters of silvered and gilded twigs, ribbons and fir branches. Just to the right of that is a long narrow window on to the brilliantly lit kitchen the other side. You can see columns of vapour rising up from pots on the range, and headless figures passing and repassing with restless energy. Every now and then the automatic door opens to let a waiter go in or out, and you catch the clamour of cooking and Andy Barnes's steady voice – 'One salmon, one black pudding, one tea, two –' and the door closes, cutting off the rest of the order.

In there they are going mad. In here all is order, decorum and the discipline of civilized behaviour, even if warmth and alcohol and the spirit of the occasion are already having their effects. The level of conversation has reached a fluid burble, a constant of noise in which individual words, or even voices, become indistinguishable. Then, suddenly, there is a distinctive voice beside the table.

'Bread, sir?'

There are four breads: two little perfectly spherical milk rolls like snowballs, a slice or two of black pudding and poppyseed, two wholesome wholemeal date and rosemary rolls, and slices of cheese, sage and onion.

Let's have one each of the little white numbers, and break them open and smell the sweet, yeasty steam that puffs up and out. Then there are more exquisite smells as Michael Curry passes carrying a tray, plates of other people's food on it. The smells are rich, allusive, slightly mysterious. The whole mouth contracts in anticipation.

The tea of game arrives. It is in a bowl of adamantine white, with a narrow marbled border around the edge. It is set on a saucer and the saucer set on a plate, both of the same dazzling whiteness, with the same narrow border around their rims. The whole composition is redolent of order and control. How curious to associate these exquisitely formed, proportioned and flavoured dishes with the maelstrom of a kitchen.

I am not in a hurry. Pause, study, breath once, twice, three times, sniff the little trails of vapour rising up from its deep, glossy, peat-brown surface. The odours of this quiddity of meat seem to gather at the top of the sinus, suffusing everything with rich softness. There are little onions, carrots and French beans floating on the surface like debris in a flood. And what's this?

This is a poached quail's egg, soft and bursting in the mouth, just coating the tongue and the back of the throat, bland richness of egg eliding with potent concentration of consommé, the flavours of which are as deep and dark and smooth as its colour. It goes to the edge of stickiness but does not topple over. There is a breath of vegetable in each mouthful and the soft nuttiness of barley. It is very fine.

'My mother loves old films,' says one of the parties across the way. 'She says "He's dead, she's dead," every time some deceased old-timer appears on the screen.'

Over in the corner, the first young couple are deep in silence. Conversation

flickers only intermittently, and then suddenly catches, and crackles along as they discover the subject that unlocks their tongues, at least for a few minutes.

In front of me, the batteries of cutlery are replenished. A new knife and fork wink up from the table. I adjust them minutely and feel familiar, just in time for the jellied eel terrine.

Around the edge of the plate is a frieze of blanched onion rings in figures of eight. The slab of almost translucent jelly sits within it. It has the quality of light refracting in a rock pool, narrow layers of eel and flecks of parsley suspended in it. Just coating the plate between the onion ring frieze and the terrine block is the caper sauce, delicate and discreet.

That's how it tastes too. The sensation of the jelly just hangs in the mouth for a moment or two, a faint trace of white wine and fish stock, mixing with the gentle acidity of the capers, and then both dissolve, leaving the fat delicacy of eel resting in the mouth. There is a sequence of gentle textures and sensations that may or may not constitute flavour.

So this is what fine eating is all about, I think to myself. As Michael removes my plate, I don't lift my eyes from the table. I sip the Chablis.

Food is not here to be worshipped; it is to be enjoyed. To sit in reverential silence contemplating the subtleties of the cooking is the denial of what eating is about. Great food never made a great meal. You can eat the greatest food in the world, washing it down with grand cru wines of magnificent vintages, but if the company is dross, then it will be ashes in the mouth. By the same token, you can eat a dish of shepherd's pie and drink Bulgarian Merlot in the privacy of your own kitchen, and remember the occasion with a lift of the heart because the company is wholly desirable.

If you eat on your own, however, then you can only keep company with the food and participate in the *tableaux vivants* of the other tables by proxy. So I watch the waiters pass and repass, catching whispers from the dishes carried on the trays, seeing the smeared and shattered remains of each finished plate being taken away. Light gleams off glasses, cutlery, bald heads, spectacles. The conversation from eighteen tables washes around the room. There is a sudden cough of laughter, the tink of cutlery on plate, an echoing boi-ing where one of the glasses had been accidentally struck. There is no muzak in here, no 'Have yourself a jolly little Christmas,' because everyone is.

It's not a knees-up. There's nothing disturbingly frenetic or over the top or in any one else's face about the celebrations at Heathcote's. The restaurant imposes its own discipline. You don't spend a lot of money to behave like a load of yahoos, or have to put up with anyone else behaving like one.

No, you come to a restaurant like this for civilized exchange, to enjoy a sense of the pleasure that is concomitant with consumption, the agreeable tension that is created between the formality of the occasion and the energy released by the food and drink, an assertion of self within this cosy theatre.

The waiters are the guardians of the authority of the restaurant. Properly trained and with a deep understanding of their profession, they establish equality with those they are waiting on just as much as a doctor or a solicitor. It has to be said that it is rare to find British waiters capable of this. The British easily confuse service with servility, and, bridling within the mesh of the class system, fail to

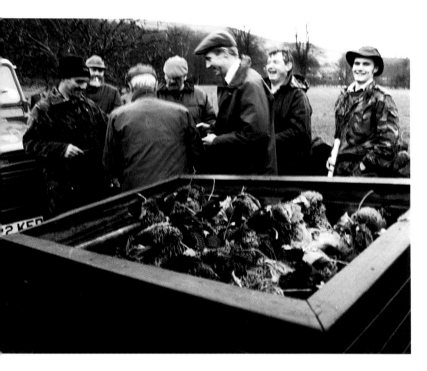

understand that a good waiter is a highly skilled figure.

The sad truth is that the status of the waiter has suffered a monumental decline since the days when the *patron* chose the front of the house as his visible empire. Now *patrons* are more likely to be chefs, and with the rise of the chef the lords of the dining room have become eclipsed. Gone are the theatrical flourishes which epitomized their pre-eminence, the flamboyant showmanship of flambéing or dissecting an entire duck's carcass with a few assured sweeps of the carving knife. Dishes are plated up in the kitchen.

Still, the waiters aren't merely carriers of messages and porters for food. They do have their power. Bad or malicious waiters can ruin a good dish by delaying just a minute or two before delivering it so that it is cold by the time it is eaten. They can always put it down is such a way that the artful arrangement looks as if it had been thrown together.

By the same token, good waiters keep the dishes flowing from kitchen to table, making that very fine judgement between haste and thereby hustling the eater, and sloth, which creates anxiety and then anger. Dishes should come in a seamless flow so that you are scarcely aware of the gap between them, but, at the same time, you never feel as if you have barely had time to digest the preceding course.

Then there are other subtle arts: judging the right balance between familiarity and diffidence, between over-zealous intrusion and ignoring people altogether. Waiters are in the business of crowd control, even if the crowds are quite small.

They have to keep their wits and their eyes constantly about them, to anticipate needs and problems. If a partridge eater decides to rend the legs off by hand in order to nibble them delicately, a finger bowl should be provided before it is asked for, as happened with that lady at the table in the corner.

Or, take the table over there. The chap's just knocked over a glass of red wine, but not to worry, sir. With the minimum of fuss, a couple of clean napkins are placed over the offending patch, the table rearranged as before, the voluptuous ease of the evening re-established

And there's Paul Wilshire, in black apron and bum-freezer jacket, with the insignia of his calling in the lapel, leaning slightly forward, right hand at the small of his back, palm outwards, refilling the glass, with a few reassuring words.

'As if we hadn't had enough,' she's saying.

As if I hadn't had enough, I think, contemplating a dish of cutlet of beef with oxtail in a beer sauce with potatoes roasted in dripping, salsify, mash and cabbage and bacon. This is the apotheosis of Sunday lunch. Its magnificence is daunting. Everything on the plate glistens – the meats, the sauces, the vegetables, everything. It has a glossy good humour about it, a cheerful, arms folded, eh-up, lad, get stuck in. Can this really be *haute cuisine*?

With a sigh of pleasure, I left a small forkful of cabbage and bacon. The sweet freshness of the cabbage is overlaid with a warm glow of pork. Cabbage is rehabilitated as a superior vegetable.

The sauce has the lambent Vandyke brown of polished mahogany, but a subtle, allusive flavour so that it strikes a harmony with the beef. The beef, itself – and so on and so on. I eat slowly and carefully. If the quality of food is in relation to the pleasure it gives on a number of levels, then there is no question that this is smart cooking. *Haute cuisine* I suppose it must be, because there is no equivalent in English for the phrase.

Within the conventional framework of an English – English, not British – dish, a series of serious judgements has been made and executed so that the initial combination has been thoroughly reinvented, and out of it something new and infinitely pleasing has come.

'How's the Cornas, Mr Fort?' says Paul Wilshire, appearing at my elbow, and topping up the glass.

'The Cornas is all right.'

'All right?' he says. He knows.

'It's opening up in the glass,' I say. 'It's getting better the more I drink.'

'It is a lovely wine, but it's still quite young,' he says. 'It needs a little more time to breathe,' which is a tactful way of saying that I chose a wine that, in his opinion, may not have been the best choice available and that he would have guided me elsewhere, but as I had been so definite about it, it wasn't his place to tell me I was an ignorant plonker.

Suddenly it's 10.25, and Andrew Lee is guiding the last party, two couples, to their table. The two women come in holding hands in commanding solidarity and friendship. The two men behind them make a similar statement through their identical blazers. 10.25 p.m. You've got to hand it to people; they've got stamina. I mean, these folk aren't in the first flush of youth, and you know they're not going to leave here much before 12.30, that they're going to put away the regulation three courses of, let's face it, not insubstantial food, whatever its subtleties and sophistication. I hope I can muster the vim and vigour when I'm their age.

Good God, there's an elderly party at the table to my right. He must be seventy-five if he's a day, grey hair, gold-rim specs, and trim with it. Having finished off his own plate of suckling pig, he's sampling his daughter's fillet of halibut with every sign of pleasure. You can't help be awe-struck by that.

'The sauce is nice,' he says.

'Do you know there are two Casablancas on Christmas Day?' someone is saying across the way. 'Two. It's batty.'

'I told Terry to video it.'

'Oh, but it's not the same.'

Through, round, past all of this, the waiters pad in ceaseless sequence. Oh, there's sea bass, skin brown, flesh white, spinach deep emerald-green, tomato flashing with jewel-like brilliance. Do you know, I could almost – but no, the baked coconut cream with caramelized fruits and rum sabayon has arrived.

It is about as perfect a pudding for a crisp winter's night just before Christmas as you can get. The baked cream bit has that soft, unctuous richness that is fabulously soothing, with a hint of coral strand and palm trees wafting in gently with the coconut. Waves of pleasure shimmer down the throat. The fruits and rum bring sweetness and the breath of alcohol into play.

I think by the end of a meal you are ready only for simple pleasures. The more refined organs of judgement and analysis have become saturated, not to say sated. You can no longer distinguish subtle complexities, even if you want to, and I am long past that point.

I am long past any point, so I retire to the reception area again for coffee and all those nibbly things they bring you at the end of the meal: the chocolates, caramelized orange peel, tuiles...

The sound system's back in the swing again, with a fruity, warbly rendition of 'God rest ye, merry gentlemen, Let nothing you dismay.' I'll say not.

'We've spent a whole evening just eating', she says. She is beautiful, blonde and in black.

'What's wrong with that?' he says, his hand stroking her thigh. She doesn't seem very responsive. Ferreting around inside her bag, there's an almost obstinate refusal to fall in with his mood. Presently he gives up and calls for the bill.

Andrew Lee nips into his cubbyhole between the reception area and the restaurant to clear the payment, and then out again to get the coats.

'Everything all right, sir, madam? Enjoy your evening?' asks Andrew Lee with a Jeeves-like suavity.

'Yeah, lovely, thanks,' he says. 'No complaints.'

'It was superb,' she says.

Andrew acknowledges the compliment with a smile and a dip of the head.

11.30. Work in the kitchen is almost finished. The great clean-up is underway, the range a mass of suds and scouring pads and hissing water. Andrew, Paul, Chris, Michael, Colin and James will be here for some time to come. The plumping of the cushions, the clearing away of coffee cups and trays, the adjustments to photos and stacks of mini-brochures promoting the special offers of the next year go on automatically. The place never looks anything but orderly, comfortable, expectant.

It's time to go. 'It's a winter wonderland,' sings out the sound system. So it is.

'Good night, Mr Fort,' says Andrew Lee.

'It has been,' I say.

Chris Neve

The Pick of the Catch

C. & G. Neve, Seafood Specialists: you find them half-way down Siding Road, Fleetwood, a long and unprepossessing gulch of small two-storey industrial units, warehouses and workshops on the fringes of Fleetwood. It's just after midnight. The street and the front of the buildings are orange from the streetlights. A rime of frost begins to settle on the car as soon as you turn off the engine. You can feel a deadening chill rising up through the soles of your shoes as you step out on to the tarmac.

To the outsider, the working life of Chris Neve, and the forty-five people who work for him, seems odd. They work when the rest of the world sleeps, when all round them is dead.

Chris sits in a long, heat-blasted office on the first floor of an unremarkable building across the road from the main fish-processing area for C. & G. Neve. There's a bank of answerphones in front of him on which are recorded the orders from his customers. He depresses the play-back buttons, decodes the raucous messages, notes the orders and fills out the dockets needed for processing them. He works steadily and methodically, never seeming pressed or hurried.

He has a lean compactness. His hair is shaved quite close to his scalp. His face is alert, mobile, clever. He never seems to break out of his relaxed, equable rhythm, but the way he talks carries the certainty and clarity of easy authority.

He has been steadily dealing with the orders since midnight, and, like the rest of his workforce, will be at it until 9 or 10 a.m.

'I've always done odd hours, so it's not as if it's forced on 'er. She'll ring up and say "What time will you be coming 'ome like," and if I say I'll be early, like, she'll stick around like, but if I say I'm going to be stuck most of the morning, she'll go and meet her friends in Bolton. It works really well.'

'Fleetwood, at one time, had the highest divorce rate per capita of the population of anywhere in the country, and that was purely because all the boats were at sea.' He pauses. 'It was a great period to live through.' His voice has a humourous, nostalgic ring to it.

That was when Fleetwood was the premier port on the west coast of England. It was the closure of the Icelandic waters that did for Fleetwood. Now there are only a few boats, this night maybe five or six moored along the deserted quays. The water is smooth, black, like oilskin. On the quay are stacked boxes – solid, plastic – piled up to the top with glistening cod, whiting, mackerel, ready to be picked up on fork-lift trucks and ferried directly to the chilled lorries for transport elsewhere, or into the simple cavernous market where they will be auctioned later in the morning.

In the vast, dark region around it, the market is brilliant with light, figures moving about among the neatly laid-out boxes – halibut, monkfish, container after container of cod, others of sole, plaice, dogfish, the familiar and the

OPPOSITE:

CHRIS NEVE, SEAFOOD SPECIALIST

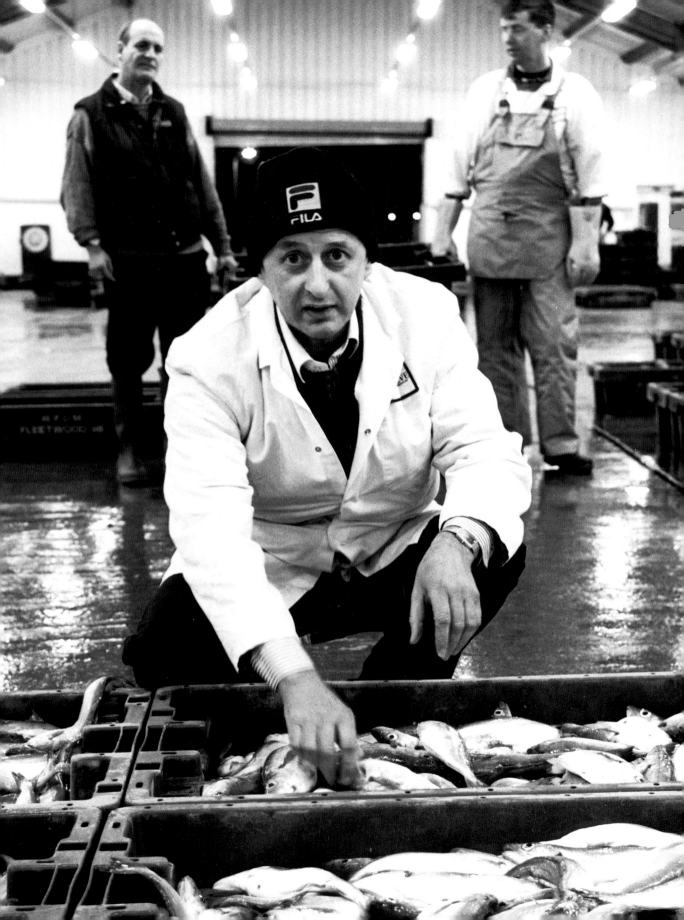

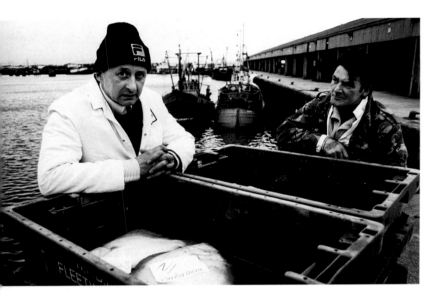

unfamiliar. All fish are placed belly upwards so that the skin and flesh will not become discoloured by any blood.

It represents a substantial body of marine life, whatever way you look at it, but it is fraction of what was there, as the dead buildings, long-gone processing plants, refrigeration companies and the like bear mute witness.

However, if Fleetwood is not what it was, it would be even less were it not for the likes of Chris Neve. Business is flourishing for him. The company has recently bought three boats, and takes the entire catch from each. That is by way of an experiment. The boats will have two years before they qualify for decommissioning, and if they pay their way, then Chris will hang on to them. So far things have been looking pretty encouraging, and it's one way of guaranteeing the quality of the fish he wants.

That's what he's interested in, quality. 'We're committed to building long-term customer relationships by giving a consistent, reliable and friendly service while offering competitive prices,' as the mission statement on the wall of his office reads. He pays top dollar for the best fish. 'We're known as good payers,' he says.

He's always been in fish, after some time in the army to get away from a spot of paternity bother and general rumbustiousness, and a short term as a taxi driver. His father had been a ship's runner, taking supplies out to the trawlers in the Irish Sea, so they had good contacts with the boats, and when they came into Fleetwood to land their catches, Chris's father would buy the share that each member of the crew was allowed to take off with him, prime fish, the pick of the catch.

They load what they have bought into the back of a van and went off to sell door-to-door in Southport. That was twenty-eight years ago. 'We used to get massive queues. We did it for ten years, it was great. But when we got kicked out of Iceland, all the ships went, and it was never as good. I wasn't getting the price. Or the quality. But we've always had these contacts with the fishermen. And it's gone on from there.'

Now he has a turnover of £4 million a year, owns four boats, employs forty-five people, is opening up a profitable Continental trade and still works through the night.

Across on the other side of the road is the preparation, packing and refrigeration area. It is more or less open to the elements. It's bloody cold. The walls are antiseptic white. Water glistens in puddles on the concrete floor. Water, there's always water – water for washing the floor, for washing the knife blades and handles, washing the hands, dipping the fillets, rinsing, sloshing, splashing.

Steve, Phil, Geordie, Jim, Billy and Fred wear thick jerseys, shirts, vests, plastic aprons, rubber tips over the fingers and tattoos up their arms. They are the

embodiment of masculinity. They exude raw physical power, almost brutality, and yet, when you watch them removing bones from salmon fillets with deft precision, or sweeping the fillets off the bones of a sole or a herring with a couple of elegant movements of the thin filleting blades, their movements have all the grace and control of an Olympic gymnast.

They work one of two shifts, from midnight to 8 a.m., and 5 a.m. to 1 p.m, hellish hours for most people, but they wouldn't have it any other way. It's so much quieter now, at 2.30 a.m., less bother. It makes for a cosy camaraderie, a curious clubbability.

By 3 a.m. the boxes of treated fish begin to stack up. Into huge waste boxes go the bones and skins, the guileless staring heads, glop and guts. In others, glistening trim fillets of cod, slack and relaxed as elbow-length women's kid gloves; mackerel with their Celtic rune markings; herrings of elegant symmetry, with their browny-pink flesh and shimmering silver and grey skins. There are banks of fleshy white scallops, Arctic char pale as white gold, meaty chunks of salmon, the raw orange flesh marked with the regular herringbone of intramuscular fat typical of the farmed fish.

The men work with a rhythm as steady as their banter. Their breath rises like steam. Their hands are bare but for the rubber fingertips to help grip the fish as they sluice them in tanks of cold water, dip their knives, rinse their hands, water slipping and slopping all the time. It's so cold you can only just catch the sweet, slightly cloying smell of fresh fish.

Filleters could be an endangered species. 'There's a shortage now,' says Chris. 'We've been quite lucky this year. We've taken on four youngsters. They always used to train at Ross and Farmer's, big firms. But really, these days, there's no one training them. Ten, fifteen years down the line – I'll be retired and I won't care.'

But not yet, there's still the fish. The fish come from all over – Newlyn, Brixham, Peterhead, Aberdeen, local – some of it landed by foreign trawlers, about which Chris Neve has mixed views. He dismisses the doom-laden pronouncements about the state of British fisheries. He points to good landings of cod made from the Irish sea by his boats. 'What happens is, you can fish it out so far, and then it becomes uneconomic to fish, and then the fish will recover.'

However, we do have to get out of this EU Common Fisheries Policy. 'Now some of the MPs are realizing what a load of bollocks it is. It's all one-way traffic. They've fished out their grounds and now they want to fish out ours. Do you think they would sit back and let us fish their grounds?' Chris's voice rises with irritation and incredulity.

On the one hand he admires the skill with which the Continental fishermen catch the fish and – even more importantly for his business – handle them once they are caught. 'They're years ahead of us, really.'

He presses a switch on the answerphone. An anonymous voice barks out an order for turbot. There's a discussion as to whether there's enough turbot of the right quality. 'If we were to send 'im brill as a substitute for 'is turbot, 'e'd send it back, but if we were to skin the brill and send it out as turbot, 'e'd keep it.'

He doesn't do that kind of thing, naturally, but he says that it can be quite difficult to tell one fish from another, sometimes. 'Paul's done it to me. He kept on sending out little dishes and I had to guess what it was. And I knew he'd

bought turbot that day. But 'e'd frozen a piece of brill up the week before. And I kept saying, 'This 'as got to be turbot, this one.'

He laughs. Outside the sky is just beginning to lighten. It's time to head for the market.

The daily auction is held in a vast modern structure like an aircraft hangar, only with a lower ceiling. The sturdy white plastic boxes of fish are arranged in three or four blocks. They look lost, almost insignificant, on the wet glistening concrete floor under the strip fluorescent lighting.

'There's a lot of crappy fish about,' mutters Chris Neve, giving each lot no more than a glance. He buys about 20 per cent of the fish he needs here. There is a dark, mottled black monkfish complete with head and gaping mouth. There are pink and silver haddock, frowning gurnard, soles, place, silvery grey hake, mouth bursting with pin teeth, cod green/grey as the sea, a misplaced spider crab, a couple of dogfish, some black and brown brill.

Chris joins a group of, maybe, forty white-coated figures as they move at a leisurely pace from block of boxes to block of boxes, some picking up the occasional fish to squint at them and flop them back down. They converse in a shorthand incomprehensible to any outsider, with a good deal of banter, voices echoing in the cavernous interior. The stone weight of each box is written in pencil on a piece of paper and left on top, stuck to a fish by its natural slime.

Chris Neve bids with a fractional nod of the head, three boxes of cod and two boxes of hake. He slaps the Neve family label on each, and writes down each purchase in a battered pocketbook. This fish is for a customer in Birmingham.

'He said, "I don't care what it costs. I just want the quality." I could do with a few more customers like that.'

He speaks briefly into his portable phone. One more call at the office and then it's off home. It's 10.15 a.m., and Siding Road is wide awake.

Chris Neve's Fish Cakes

MAKES 6–8

250 g / 9 oz skinless haddock
fillets
250 g / 9 oz skinless hake
fillets
1 onion, diced
1 tbsp vegetable oil, plus
more for frying the
fish cakes
$^{1}/_{2}$–$^{3}/_{4}$ cup of fine matzo meal
1 egg, beaten
salt and pepper

1 Steam the fish until just cooked through, allow to cool and then flake the flesh.
2 Sweat the onion in the oil until soft and silvery.
3 In a bowl, mix the fish flesh with the matzo meal and the onion. Stir in the egg, season and mix well. The mixture should be quite sticky.
4 Shape the mixture into individual fish cakes and fry until just golden on both sides .

Jurgen Haussels
A Proper Mismatch

You'd swear Jurgen Haussels was Eli Wallach, or the character that Eli Wallach played in *The Good, the Bad and the Ugly*. He has the same shrewd, laughing eyes, the same drooping moustache, the same engaging smile. He could be Eli Wallach, but for the fact that he speaks with a German accent of caressing sibilance, and that he is wearing a Lacoste shirt, fat Rolex watch with metal strap, and tasselled loafers. In other words, whatever similarity his face might have to that of a film star, he looks what he is: a successful and prosperous businessman.

He carries the talismans of his success rather than occupies them. His office is small, one of three tacked on to the back of a warehouse in an industrial estate in leafy Temperly, a suburb of Altrincham, itself a suburb of Manchester. The office is cluttered with wine magazines, lists, files, orders, and the walls are a gallery of elaborate scrolls or certificates proclaiming him to be a friend of the Beaujolais or a member of the *confrèrie* of Armagnac.

But it is what's on the other side of the wall that has put the designer labels on Jurgen Haussel's clothes: the cases of 1996 Merlot of Château Ricardelle in the Pays d'Oc, Vino Nobile di Montepulciano Riserva 1990 from Carpineto, 1994 Pinot Blanc of F. E. Trimbach, 1994 Blanc de Côte of Domaines Ott, several vintages of Châteauneuf-du-Pape, Clos de l'Oratoire, several offerings of Merryvale Vineyards in the Napa Valley, California, stacked like child's bricks in uneven piles. Spain is there, and Chile and Portugal, South Africa and New Zealand, and the classic areas of France - '50,000, 60,000 bottles at any one time. We do close to £2 million, about 400,000 bottles a year. But no beers, no spirits, no water, purely wine. Once I get into water, I chapitalize my product.'

He runs an affectionate hand over the cases, picks up an odd bottle of Tavel, Domaine Lafond 1996, that seems to have popped out on top, comments on its qualities and puts it bac,k saying, 'I am a red wine man, and the wines of the Côtes-du-Rhône are my favourites.'

Jurgen Haussels has not been a wine merchant all his life. He was born in Heidelberg and went to school in Sollingen, the great centre of German knife-making. After school he joined the local paper, the *Sollingen Tagblatt*, where he learned about advertising, sales and marketing.

After his military service he moved to Mannheim, where he became circulation manager for the local newspaper there. All this provided early education in wine, although he wasn't aware of it at the time. Mannheim was in the wine-producing area of Bad Dürkheim and there were plenty of weekends when he would slip away to one of the innumerable wine festivals and drink Riesling by the pint mug, while women drank Sylvaner in smaller quantities. At this time, though, he had no idea of his future career.

Then he began bumping his head against the proprietorial ceiling, making further promotion within the newspaper industry impossible and 'I couldn't buy in

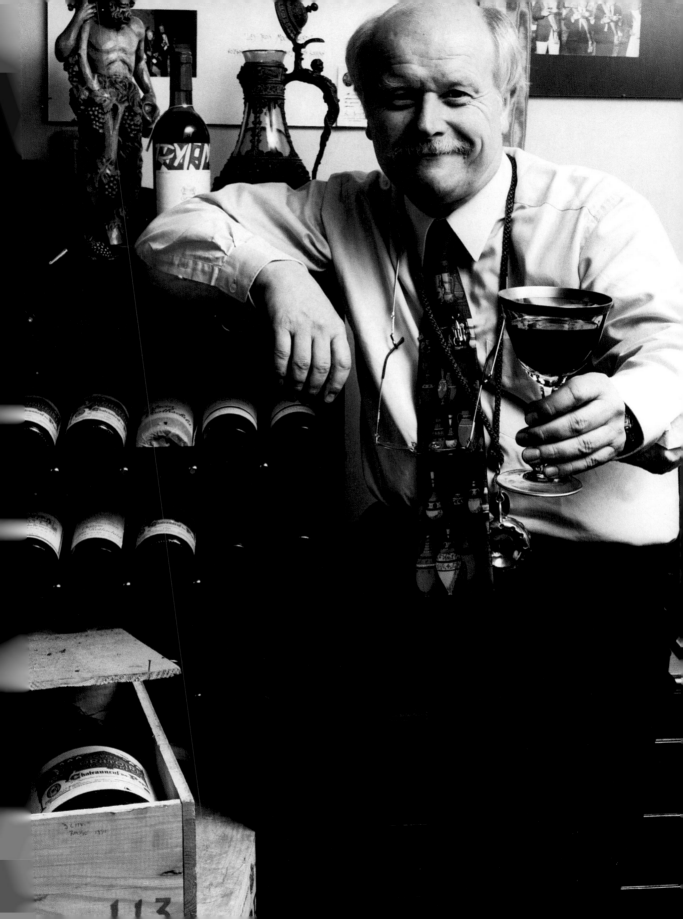

as I hadn't any money.' Also, he had married an Englishwoman. Sadly the marriage was not going well.

'The *esprit* had left the marriage somehow. I thought to rescue it I will have to go to England to understand her mentality. So I decided, do it or you'll never do it. Go. Try it. But still the marriage didn't work.

'I came to London in 1971 and your newspapers were completely unionized so I couldn't get a job. What did I do? I worked for a German wine company as a sales manager. For two years. Then I started my own business as a wine merchant, in Manchester.

'My second wife is Mancunian. Also I worked out I could set up a business here much easier than in London. I thought to myself, no, let Londoners kill each other, and this will make life a bit easier for me.'

'I started very late, under-capitalized, the usual story. Fortunately my old schooling at the newspapers taught me well – about hard work and very long hours and Saturday and Sunday work. I can calculate GPs [gross profits]. Half the restaurateurs we're dealing with can't do that.' He looks shocked.

He has focused his business, not just excluding spirits, beers, water, crisps and peanuts from the agenda, but limiting those places he sells to entirely to restaurants, giving him between 220 and 250 hard-core clients, and employing five salesmen to help him. He has no wish to go the mass-market route.

Through clenched teeth he acknowledges that the supermarkets have done 'a certain job educating the masses to drink wine, fair enough. But then they manipulate them to take a manufactured product. Sometimes I talk to a co-operative, and they say look at this wonderful skyscraper tank. It's all Sancerre for a supermarket. I think we have to preserve individualism.

'I know my survival is much easier if I stick to a specialized market. I'd rather be 100 per cent on one thing than 80 per cent everywhere. I am not a decathlon man, equally good in ten events. And there aren't many who are,' he adds as an afterthought.

'I work with about seventy wine growers in France, for example. They are all small. They never can supply supermarkets because they don't have the quantities. But I love that kind of involvement.'

He likes to buy the wine *en primeur*, assessing the quantity that he will need in four or five years' time, when the wine is ready to drink, so he doesn't need to search the markets. Or doesn't need to search them so much, for he still buys and sells a certain amount of wine at auction.

'If you go to an auction, you know if it comes from a private seller or, if it has an asterisk, you know it has VAT on it, and it comes from a merchant who needs some cash. Therefore you know it's been stored properly. It's good stuff, but they've just got too much. It happened to me. I had too many cases of Mouton Rothschild 1970. Paul will be lucky to sell a bottle year, so I got rid of my cases.'

He supplies about sixty-five wines out of the 250 or so on Paul Heathcote's list. 'The others can fight for the rest. I think that's important. I can supply everything. I have 700 regular lines, but I said that is not clever. It is a bit more work, but this way you keep us on our toes.'

There is also a sound pragmatism behind this judgement. Clearly it would lead to a massive mutual dependence, which would not be healthy. There are what

Jurgen Haussels calls 'techniques for survival' in the wine trade.

'I don't like someone who buys from me twenty cases of Chablis. It sounds like a one-off. So I know he won't pay me, not in four weeks, because there is plenty of stock left. He doesn't pay me in two months either, or three months. So he might hold me out for six months. I can't control his business. I have no feel for the pulse of his business. What I want is a minimum of twenty lines so that he comes weekly to me to restock. That gives me the opportunities I want, plus he owes me a regular amount, not one big one and then nothing.'

He met Paul at a gathering of the Northern Chefs Circle at Moss Nook in 1990. 'Moss Nook asked me to have a wine *spiel* to break things up before lunch. So I came and talked about the Côtes-du-Rhône and gave them some Gigondas, Châteauneuf, Tavel and so on. And then he come up to me after we were finished and asked to see me, and we fell in love.

'For me he is a guy I can trust. He is very controlled, very disciplined, but a touch laid-back, a touch on his heels. I can talk to him. I am proud he phones me first before anyone else. So when he has problems, I try my best to help him, you know, well beyond working hours.

'I try also to have in my team people who know something from the inside. They know how to serve. They know how to carry plates on their arm. So they understand the restaurant's problems from the inside.

'One Christmas he rang me and said he needed my help. He was very short of staff in the brasserie. He said, "Do you mind if I pay one of your guys to help me out." I said, "Look, we do that for nothing, but if it's on Sunday, give him something for Sunday." That's the kind of relationship we have.'

It helps, of course, that he likes Paul's cooking, too. 'It is very balanced. It would certainly have two stars in France. Look at the starters. They give you a quicker look at the handwriting of the chef than anything. You have to do something really exceptional with black pudding to get a Michelin star for it.

'I know one thing. It depends on your physical condition how you like the meal. If I am knackered and tired, I will not relish it in the same way I would if I was fresh and alert.'

You get the feeling that wine is only part of the picture with Jurgen Haussels, that food and people and conversation and all the adjuncts to his trade, play almost as important a part. The fact that he is selling wine is almost secondary to his energies.

This is frequently what happens to those whose hobby becomes their business. It ceases to be a means of escape from the daily pressures into the pleasures of your pastime. When those pleasures become part of your daily existence, they don't become any less pleasurable, but they lose their intensity. Nevertheless, he is clearly delighted that his son has expressed an unprompted wish to come into the business.

He reckons that Paul has himself learned a great deal more about wine than he knew when he started. He has taken him to France to introduce him to growers so that he can learn first-hand. He also gives regular wine-tasting workshops with chefs, sommeliers and other staff.

Being Jurgen, however, they are not exactly conventional tastings. 'We invite a client to go through a menu. We match three or four wines, different areas,

different grapes with one dish, and we go through and say which wine, A, B, or C, goes best with the dish, just to give food for thought, not to be clever, just to let the restaurateur or chef or whoever find out for himself what he feels. At the end of the day it's a matter of opinion.

'Anyway, I say, it's easier to match. The mismatch is more interesting. Do a proper mismatch and let's discuss that.'

He tells a story about going to see one of the growers he has worked with for years, in Bordeaux, in the area of Lalande de Pomerol, to a very good château. The owner took him to a local restaurant for dinner, and they drank the château's own wines with every course, with the foie gras, with the oysters even.

The red wine almost overpowered the foie gras, although it wasn't a complete mismatch. But it went really well with the oysters – 'There is a sweetness in the wines of Pomerol, and the oysters are salty. The sweetness and saltiness, they worked together. So be open-minded, be fresh. That's what it taught me. Basic rules are boring, red with red meat, white with white meat. It's boring keeping to those dumb rules.'

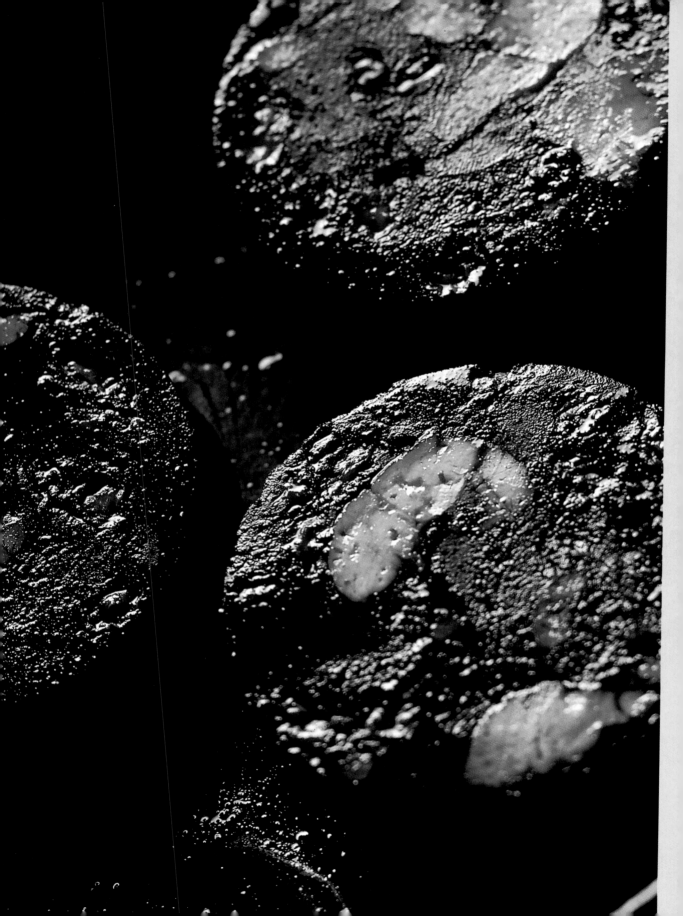

Winter Menu

First Courses

Black Pudding on Crushed Potatoes and Baked Beans with Bay Leaf Sauce

Oysters Set on Watercress in Tomato Jelly, Sour Cream, Cucumber and Chives

Roast Scallops with Cauliflower Cream, Sherry Caramel and Black Pepper Oil

Pressed Terrine of Spiced Pig's Cheek with White Beans and Caper Mayonnaise

Main Courses

Char-grilled Cutlet of Beef with a Braised Oxtail Casserole, Horseradish Potatoes, Mustard Cream and Ale Sauce

Braised Lamb Shoulder with Thyme Mashed Potatoes and Glazed Boiled Vegetables

Dover Sole with Parsley Mashed Potatoes, Nut Brown Butter and Lemon Pickle

Roast Turbot with Cauliflower Cream and Sage and Onion Mashed Potatoes

Broth of Quail, Wild Mushrooms, Baby Leeks and Artichokes

Desserts

Hot Banana Soufflé with Honey Ice-cream, Butterscotch Sauce and Caramelized Bananas

Spiced Apple Flan with Cider Butter

Welsh Rarebit Soufflé

Glazed Rice Pudding with Caramel Ice-cream and Butterscotch Sauce

Black Pudding on Crushed Potatoes and Baked Beans with Bay Leaf Sauce

60 g / 2¼ oz oat flakes
750 g / 1¾ lb dried pigs' blood
1 onion, chopped
250 g / 9 oz caster sugar
500 g / 1 lb 2 oz sultanas
250 g / 9 oz pork back-fat, cut into small dice
300 ml / ½ pint champagne vinegar
sprig of rosemary, chopped
sprig of thyme, chopped
4 bay leaves, chopped
salt and freshly ground black pepper
2 kg / 4½ lb lambs' sweetbreads, blanched and skinned
a little oil, for frying
1 large carrot, diced, for garnish

FOR THE BAKED BEANS:
1 kg / 2¼ lb haricot beans
1 onion, peeled
1 sprig of thyme
1 litre / 1¾ pints chicken stock

FOR THE BAY LEAF SAUCE:
8 shallots, finely chopped
1 garlic clove, finely chopped
knob of butter
100 ml / 3½ fl oz port
100 ml / 3½ fl oz Madeira
500 ml / 18 fl oz red wine
250 ml / 9 fl oz veal glaze

FOR THE CRUSHED POTATOES:
3 large baking potatoes
115 g / 4 oz butter

1 The day before, start preparing the Baked Beans: soak the dried haricot beans overnight in cold water.

2 Next day, drain the beans. Put them in a pan with the onion, thyme and chicken stock and bring to the boil. Reduce the heat to a simmer and cook for about 30 minutes, until tender. Drain.

3 In large bowl, mix the oats with the dried blood and mix into 1.25 litres / 2¼ pints of water at approximately 50°C/120°F. Allow to stand for 20 minutes. (Occasionally, some dehydrated blood can make a thicker mixture than you need – you are aiming for a thick tomato ketchup consistency – if so, add a little more water.)

4 Put the onion, sugar, sultanas, pork fat and vinegar into a heavy-based pan and cook over a moderate heat until the mixture becomes thick and syrupy.

5 Add to the blood mix, then add the chopped herbs and some seasoning.

6 Fry the sweetbreads in oil until golden and add to the blood mix.

7 Put the mixture into black pudding sleeves and poach in a large pan of simmering water for about 20 minutes.

8 Make the Bay Leaf Sauce: sweat the shallots and garlic in the butter in a pan over a gentle heat.

9 Add the port and Madeira and reduce by two-thirds. Add the red wine and reduce by a half. Add the veal glaze, bring to the boil, skim and cook until a thick sauce-like consistency is reached. Pass through a fine sieve and keep warm.

10 While the sauce is reducing, make the Crushed Potatoes: boil the potatoes in their skins until cooked. Drain and, when cool enough to handle, peel them.

11 In a bowl, crush the potatoes together with the butter, using the back of a fork. Season with salt and pepper.

12 Cook the carrot for garnish in boiling salted water until just tender, refresh in cold water and drain. Just before serving reheat gently in a little butter.

13 Preheat a hot grill. Cut the black pudding into 2-cm / ¾-inch-thick slices, brush the slices with butter and reheat briefly under the grill.

14 Put a pile of potato in the middle of each of 4 flat soup bowls, then place a slice of the black pudding on top. Scatter the beans and carrot around the plate and spoon over some sauce.

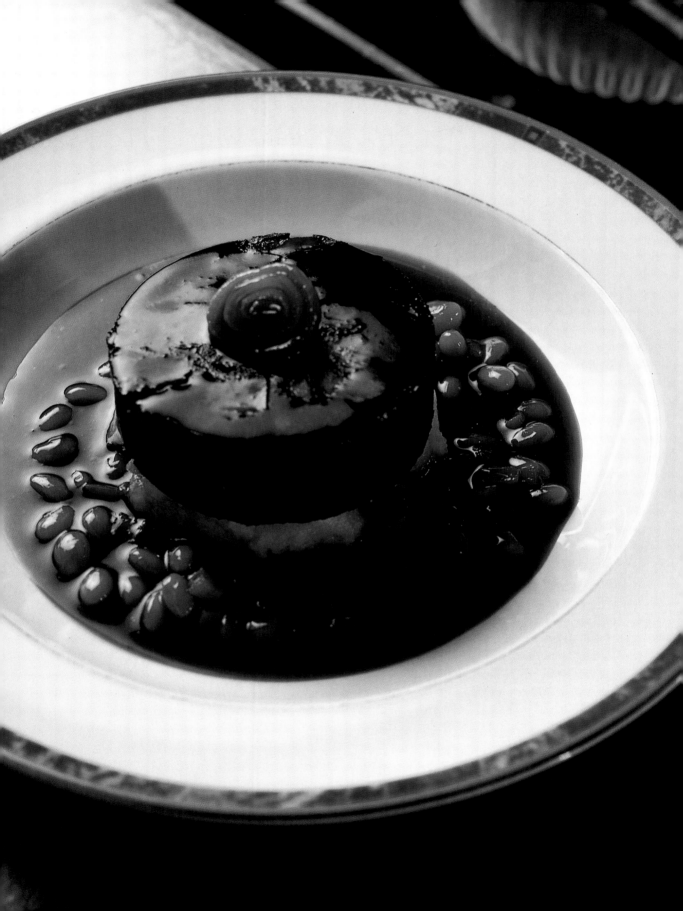

Oysters Set on Watercress in Tomato Jelly, Sour Cream, Cucumber and Chives

24 oysters
crushed ice, sea salt or blanched
seaweed as a bed for the oysters
bunch of large-leaf watercress
1½ leaves of gelatine, soaked in cold
water
250 ml / 9 fl oz Clear Chilled Tomato
Juice (page 104)
4 tbsp whipping cream
juice of ½ lemon
salt and freshly ground white pepper

FOR THE GARNISH:
¼ cucumber, deseeded and finely
diced
1 tbsp chopped chives
1 large tomato, blanched, skinned,
deseeded and finely diced

1 Open the oysters, remove them from their shells and drain in a sieve (the juices can be retained for a stock or sauce). Rinse gently in cold running water to remove any grit, then pat dry gently with a clean cloth. Scrape and clean the deep shells. Set them on plates nestling on beds of crushed ice, sea salt or blanched seaweed.

2 Pick over the watercress, leaving very little stem. Blanch in boiling salted water, then refresh in iced water. Drain and dry on kitchen paper.

3 Cover the inside of the cleaned deep oyster shells with the watercress and place an oyster on top of the cress.

4 Drain the gelatine and warm in a pan with a little of the tomato juice. When it has cooled, pour into the rest of the juice and then pour this over the oysters. Leave to set, about 1 hour.

5 Prepare the cucumber for garnish: lay the cucumber dice on a plate and put in the freezer.

6 Whip the cream to thick pouring consistency, add the lemon juice, season and add two-thirds of the chives.

7 To serve: put a little of the soured cream on top of each oysters and garnish with the rest of the chopped chives, the chopped tomato and the diced cucumber.

Roast Scallops with Cauliflower Cream, Sherry Caramel and Black Pepper Oil

a little olive oil
12 large scallops
salt and freshly ground white
pepper
lemon juice

**FOR THE CAULIFLOWER
CREAM:**

500 g / 1 lb 2 oz cauliflower
florets
100 ml / 3¹/₂ fl oz milk
100 ml / 3¹/₂ fl oz whipping
cream
salt and freshly ground white
pepper

**FOR THE BLACK PEPPER
OIL:**

100 ml / 3¹/₂ fl oz olive oil
10 black peppercorns, cracked
1 sprig of thyme

**FOR THE SHERRY
CARAMEL:**

250 g / 9 oz caster sugar
5 tbsp dry sherry vinegar
100 ml / 3¹/₂ fl oz dry sherry

1 Make the Cauliflower Cream: cook the cauliflower in the milk in a covered pan. When soft, drain through a colander and place in blender or food processor. Bring the cream to the boil, add to the cauliflower and blend to a purée. Pass through a fine sieve, season and refrigerate until needed.

2 Make the Black Pepper Oil: warm all the ingredients together gently in a pan for about 20 minutes.

3 Make the Sherry Caramel: in a heavy-based pan, boil the sugar and vinegar together until they form a caramel. Carefully stir in the sherry and allow to cool.

4 Cook the scallops: heat a frying pan until very hot, add the oil and, when that is hot, sear the scallops for 2–3 minutes on one side to get them golden-brown and caramelized. Turn the scallops over and cook for about 20 seconds more on that side. Remove from the heat, season and squeeze the lemon juice over.

5 Serve the scallops on top of a mound of the cauliflower cream. Trickle a cordon of oil around the cauliflower, then spoon a very little of the sherry caramel on top of the oil. This will split and hold in 'baubles' around the oil.

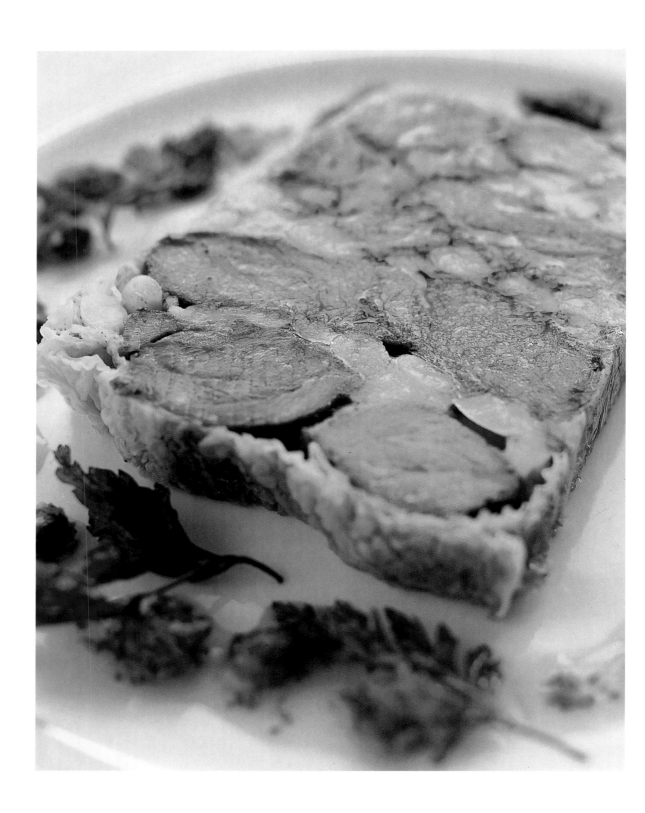

Pressed Terrine of Spiced Pig's Cheek
with White Beans and Caper Mayonnaise

1 kg / 2¼ lb pork cheek, trimmed of
all fat and sinew
a little oil
1 onion, coarsely chopped
1 carrot, coarsely chopped
1 celery stalk, coarsely chopped
sprig of thyme
½ tsp cayenne pepper
1 tsp freshly grated nutmeg
½ tsp allspice
½ tsp cumin
750 ml / 27 fl oz chicken stock
3 leaves of gelatine, soaked in cold
water

FOR THE HARICOT BEANS:
1 kg / 2¼ lb haricot beans
1 onion, peeled
1 sprig of thyme
1 litre / 1¾ pints chicken stock
salt and freshly ground white pepper

FOR THE CAPER MAYONNAISE:
2 egg yolks
1 tbsp English mustard
2 tbsp white wine vinegar
250 ml / 9 fl oz vegetable oil
30 g / 1¼ oz capers, rinsed, drained
and chopped, plus a few more
whole capers for garnish

TO SERVE:
salad leaves
Mustard Dressing (page 52)
slices of toasted baguette or
wholemeal bread

1 Ideally 2 days before, start preparing the beans: soak the dried haricot beans overnight in cold water.
2 Next day, preheat the oven to 190°C/375°F/gas 5. Seal the pork cheek in a pan with a little oil to colour. Add the vegetables, thyme and spices and cook for about 1 minute.
3 Pour in the stock, cover with a lid and place in the oven to braise for about 1½ hours.
4 While the cheek is braising, cook the beans: drain them, put them in a pan with the onion, thyme and chicken stock and bring to the boil. Reduce to a simmer and cook for about 30 minutes, until tender. Drain, remove the onion and thyme sprig, and season.
5 Remove the pork cheek from the oven and take it out of the pan. Reduce the cooking liquor down to 500 ml / 18 fl oz of stock. Pass through a fine sieve and discard the solids.
6 Drain the gelatine and mix with the stock. Put 250 g / 9 oz of the cooked haricot beans in a bowl and pour a little of the stock over them.
7 Line a 30 x 10 x 10-cm / 12 x 4 x 4-inch terrine with cling-film and fill the terrine with alternating layers of the pork cheek and the beans, seasoning each layer well and reserving 1 tablespoon of the beans for garnish. Pour in the rest of the stock and leave to set in the fridge for about 12 hours, preferably overnight.
8 On the day of serving, make the Caper Mayonnaise: in a bowl, whisk the egg yolks, mustard and vinegar together. Slowly whisk in the oil; if it starts to get too thick, add a little boiling water to let it down. Season with salt and pepper, then stir in the chopped capers.
9 Turn the terrine out, unwrap it and cut it into 1-cm / ½-inch slices.
10 Toss the salad leaves in the vinaigrette dressing with the reserved beans and whole capers and dress 4 plates with this. Set a slice of terrine in the centre and place a small quenelle of mayonnaise to one side. Serve with toasted slices of baguette or wholemeal bread.

Char-grilled Cutlet of Beef with a Braised Oxtail Casserole, Horseradish Potatoes, Mustard Cream and Ale Sauce

4 sirloin ribs of beef, cut through the bone, each about 350 g / 12 oz
large bunch of parsley, chopped

FOR THE OXTAILS IN ALE SAUCE:
2 whole oxtails
100 ml / 3½ fl oz vegetable oil
1 level tsp salt
3 garlic cloves, roughly chopped
2 carrots, roughly chopped
2 celery stalks, roughly chopped
1 onion, roughly chopped
1 bay leaf
1 sprig of thyme
150 ml / ¼ pint red wine vinegar
20 g / ¾ oz caster sugar
250 ml / 9 fl oz red wine
1 bottle of Guinness
1.5 litres / 2¾ pints chicken stock
1 litre / 1¾ pints beef stock
freshly ground black pepper
a little arrowroot

FOR THE ROOT VEGETABLES:
4 carrots, diced
1 small swede, diced
1 turnip, diced
about 600 ml / 1 pint chicken stock

1 Several hours ahead, make the Oxtails in Ale Sauce: preheat the oven to 190°C/375°F/gas 5. Trim the oxtails by removing the majority of outer fat and sinew from them, leaving a little to protect the meat. If the butcher has not already done so, cut into portions between the tail joints.

2 Sprinkle them with the oil and salt and roast them in the oven until brown all over, about 25 minutes.

3 Lift the oxtails out of the roasting pan, add the garlic, vegetables and herbs and cook in the oven until golden, about 30 minutes. Keep the oven on.

4 Leaving the vegetables in there, deglaze the roasting tray with the vinegar and sugar, and reduce by two-thirds. Add the red wine and three-quarters of the Guinness, then reduce by half.

5 Put the oxtails back in the tray and cover with the chicken and beef stock. Cover the pan with foil and cook in the oven for about 3 hours, until the meat is coming away from the bone.

6 When cooked, remove the oxtails and strain out the vegetables. Reduce the cooking liquor until coating the back of a spoon. Add the remaining Guinness and bring back to the boil. Taste, then adjust the seasoning, adding a little more sugar if it is slightly bitter. Add a little arrowroot to get a thickish sauce-like consistency.

7 Prepare the root vegetables: cook them in the simmering chicken stock until just tender.

8 Make the Horseradish Potatoes: boil the potatoes in their skins in simmering salted water until cooked. Avoid overcooking and splitting the skins. Drain in a colander and peel while still warm. Pass through a sieve or ricer into a bowl.

9 Bring the cream to the boil and beat it well into the potato, a little at a time. Stir in the butter and horseradish, and season.

FOR THE HORSERADISH POTATOES:

4 Maris Piper potatoes, about 900 g /
2 lb total weight
150 ml / ¼ pint whipping cream
60 g / 2¼ oz unsalted butter
2 tablespoons fresh grated
horseradish or horseradish relish
freshly ground salt and white pepper

FOR THE MUSTARD CREAM:

150 ml / ¼ pint whipping cream
1 tsp grainy mustard

10 Make the Mustard Cream: put the cream and mustard in a pan and bring to the boil. Continue to boil until thicker than the ale sauce, so the two won't mix.

11 Preheat a char-grill or heavy frying pan. Reheat the oxtail and root vegetables gently in some of the ale sauce.

12 Season the ribs and cook them on the char-grill or in the pan until done to taste: about 3 minutes each side for rare meat and 5 minutes for medium.

13 Just before serving, stir the chopped parsley into the oxtail. Pile some of the oxtail in the centre of each of the plates. Slice the rib and arrange around the oxtail. Using 2 large spoons, shape the horseradish mashed potatoes into quenelles and place these at the back of the plate. Dot the root vegetables here and there, pour on the ale sauce, sprinkle a little of the mustard cream over the beef and serve.

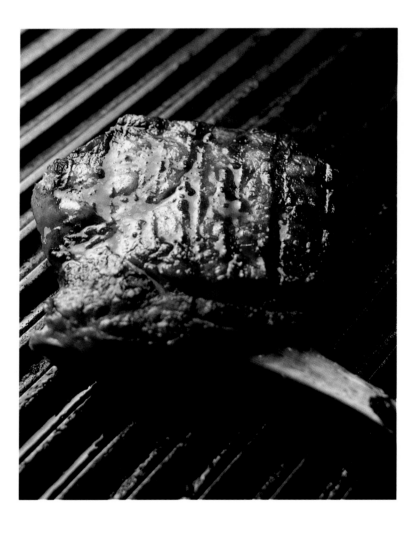

Braised Lamb Shoulder with Thyme Mashed Potatoes and Glazed Boiled Vegetables

SERVES 6

1 shoulder joint of lamb, weighing about 1 kg / 2¼ lb
a little oil
1 onion, roughly chopped
1 carrot, roughly chopped
2 celery stalks, roughly chopped
4 tomatoes, squeezed to remove the seeds
2 bay leaves
sprig of thyme
sprig of rosemary
½ head of garlic
1 tsp tomato purée
12 black peppercorns
1.75 litres / 3 pints lamb or chicken stock

FOR THE THYME MASHED POTATOES:

4 Maris Piper potatoes, about 900 g / 2 lb in total
150 ml / ¼ pint whipping cream
60 g / 2¼ oz unsalted butter
salt and freshly ground white pepper
1 tablespoon picked thyme leaves

FOR THE GLAZED BOILED VEGETABLES:

6 small carrots
6 small parsnips
450 g / 1 lb leeks
1 tsp sugar
50 g / 2 oz butter

1 Preheat the oven to 190°C/375°F/gas 5.

2 Place the lamb in large flameproof casserole dish with a little oil and brown all over.

3 Add the vegetables and tomatoes and continue to cook until coloured, about 15 minutes.

4 Add the herbs, garlic, tomato purée and peppercorns. Pour in the stock, cover and cook in the oven for about 2 hours.

5 Take out of the oven, remove the lamb from the casserole and allow to cool. Pass the cooking liquid through a sieve and reduce to a sauce-like consistency.

6 While the lamb is cooking, make the Thyme Mashed Potatoes: boil the potatoes in their skins in simmering salted water, until cooked. Avoid overcooking and splitting the skins. Drain in a colander and peel while still warm.

7 Pass through a sieve or ricer into a bowl. Bring the cream to the boil and beat into the potato, a little at a time, beating well. Beat in the butter and season with salt and pepper. Mix in the thyme.

8 At the same time, prepare the Glazed Boiled Vegetables: peel the parsnips and carrots, leave them whole and trim to a tidy shape. Cut the leeks at an angle into 7.5-cm / 3-inch lengths.

9 Put the parsnips and carrots in a pan, cover with water and season with salt. Bring to the boil and simmer for about 8 minutes. Add the leeks, sugar and butter and cook for a further 6 minutes.

10 Remove the vegetables from the pan and reduce the liquor down to a depth of about 2 cm / ¾ inch. Put the vegetables back in the pan and continue cooking, tossing from time to time, until they are nicely glazed, about 1–2 minutes.

11 When ready to serve, carve the lamb into slices about 2.5 cm / 1 inch thick, and reheat in the reduced braising liquid. Place a spoonful of potatoes in the centre of each plate and flatten it slightly. Arrange the glazed vegetables around, put a slice of lamb on top of the potatoes, pour a little of the lamb cooking liquor over and serve.

Dover Sole baked with Parsley Mashed Potatoes, Nut Brown Butter and Lemon Pickle

2 Dover soles, each weighing about 700 g / 1½ lb, skinned but left whole

sea salt

dried rind of 1 lemon

dried rind of 1 orange

1 garlic clove

1 star anise

1 sprig of thyme

1 bay leaf

350 ml / 12 fl oz olive oil

lemon juice

FOR THE LEMON PICKLE:

8 lemons

2 tablespoons salt

1 tsp grated ginger

300 ml / ½ pint vinegar

700 g / 1½ lb caster sugar

2 tsp freshly grated horseradish

FOR THE PARSLEY MASHED POTATOES:

4 Maris Piper potatoes, about 900 g / 2 lb total weight

150 ml / ¼ pint whipping cream

60 g / 2¼ oz unsalted butter

salt and freshly ground white pepper

115 g / 4 oz parsley, stalks removed and reserved and leaves very finely chopped

FOR THE NUT BROWN BUTTER:

50 g / 2 oz unsalted butter

good pinch of chopped parsley

1 Ideally a day ahead, make the Lemon Pickle: cut the lemons into thick slices, removing the pips, and mix with the salt. Leave for 8 hours.

2 Next day, mince, finely chop or pulse the lemons in a food processor (the result needs to be coarse, not smooth) and add the remaining ingredients.

3 Put the mixture in a pan and cook slowly until it goes thick and syrupy. Store in an airtight jar until required (you won't use it all in this dish, but it goes very well with terrines, like the Pressed Terrine of Ham Hock on page 50, and cold pâtés).

4 About 40 minutes before you want to serve, preheat the oven to 190°C/375°F/gas 5.

5 Make the Parsley Mashed Potatoes: boil the potatoes in their skins in simmering salted water, until cooked. Avoid overcooking and splitting the skins. Drain in a colander and peel while still warm.

6 Pass through a sieve or ricer into a bowl. Bring the cream to the boil and beat into the potato, a little at a time, beating well. Beat in the butter and season with salt and pepper. Mix in the parsley. Keep warm.

7 Trim the fins from the sole. Season the fish with sea salt and place in a baking tray with the orange and lemon rind. Add the garlic, star anise and herbs, cover with the oil and cook in the oven for 10–15 minutes, or until cooked (when pressed it comes away from bone readily).

8 Lift the fish out of the tray and remove the fillets with a serving fork and spoon. Transfer them to warmed plates and season with lemon juice. Keep warm.

9 Make the Nut Brown Butter: in a small pan heat the butter until it froths and bubbles. Allow the bubbles to die away and for the butter to turn a nice nut-brown colour. Mix in 1 heaped tablespoon of the lemon pickle and remove from the heat. Add a good pinch of chopped parsley.

10 Spoon or pipe the parsley mashed potatoes on the plates, set the fish on top and pour the nut brown butter over the fish to serve.

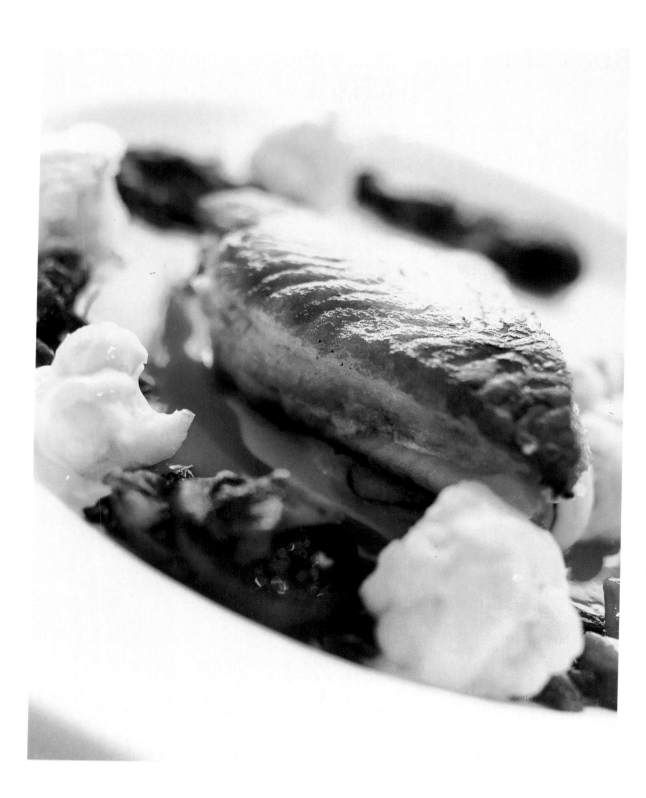

Roast Turbot with Cauliflower Cream and Sage and Onion Mashed Potatoes

1 whole turbot, weighing about 2 kg /
4¹/₂ lb
a little oil
lemon juice
1 small cauliflower, separated into
florets
25 g / 1 oz butter
150 g / 5 oz wild mushrooms, such as
shiitake, oyster and girolle
50 g / 2 oz spinach

FOR THE TURKEY JUICE:
2 turkey legs
5 garlic cloves
2 onions
4 celery stalks
2 carrots
a little oil
10 cracked black peppercorns
500 ml / 18 fl oz red wine
6 ripe tomatoes, squeezed to remove
the seeds

Cauliflower Cream (page 205)

**FOR THE SAGE AND ONION
MASHED POTATOES:**
4 Maris Piper potatoes, about 900 g /
2 lb in total
150 ml / ¹/₄ pint whipping cream
60 g / 2¹/₄ oz unsalted butter
salt and freshly ground white pepper
20 g / ³/₄ oz chopped fresh sage
100 g / 3¹/₂ oz onion, diced and
blanched

1 At least 4 hours ahead, make the Turkey Juice: preheat the oven to 190°C/375°F/gas 5. Chop up the turkey legs, including the bones, as small as possible and brown well in the oven, about 30 minutes.

2 Chop up the garlic and the vegetables, place in a heavy-based pan with a little oil and brown lightly.

3 Add the cracked peppercorns and red wine and reduce by half. Add the tomatoes and the browned turkey legs. Cover with water, bring to the boil and simmer for about 3 hours, skimming off the fat and scum continuously.

4 Pass the stock through a fine sieve into another pan and reduce until thick enough to coat the back of a spoon. Pass through a fine sieve again before serving.

5 Towards the end of the turkey juice cooking time, preheat the oven to 230°C/450°F/gas 8, make the Cauliflower Cream as described on page 205 and make the Sage and Onion Mashed Potatoes: boil the potatoes in their skins in simmering salted water until cooked. Avoid overcooking and splitting the skins. Drain in a colander and peel while still warm. Pass through a sieve or ricer into a bowl.

6 Bring the cream to the boil and beat it into the potato, a little at a time, beating well. Beat in the butter and season with salt and pepper. Mix in the sage and the onion, place in a piping bag and keep warm.

7 Trim the turbot, removing the fins and head. Cut down the centre of the fish through the bone, remove the skin and cut the fish into 4 portions each about 300 g / 10¹/₂ oz in weight. Season the fish with a little salt.

8 Heat a cast-iron pan or other ovenproof heavy pan on top of the stove and add some oil. When hot, add the fish and seal for about 1 minute on each side, until golden. Place in the oven and roast for about 8 minutes, or until the fish bones can easily be pulled out. Remove the fish from the oven and season with salt and lemon juice. Keep warm.

9 While the fish is in the oven, cook the cauliflower florets in a pan of boiling salted water with half the butter.

10 Heat up the turkey juice in a pan with the wild mushrooms. Heat the cauliflower cream up in another pan.

11 In a separate pan, cook the spinach with the remaining butter and a little salt until just wilted.

12 To serve: pipe the mashed potato on one side of the warmed plates. Arrange the spinach, cauliflower florets and wild mushrooms around the other side. Place the fish on top of the mashed potatoes leaving a small amount of the potato showing. Spoon a little of the cauliflower cream over the cauliflower and a little of the turkey juice inside the garnish.

Broth of Quail, Wild Mushrooms, Baby Leeks and Artichokes

2 whole quail, boned (get your butcher to do this for you, but make sure you get the bones)
12 quails' eggs
salt and freshly ground white pepper
a little oil

FOR THE STUFFING:
100 g / 3¹/₂ oz skinless chicken breast fillet
40 g / 1³/₄ oz foie gras
2 tbsp whipping cream
1 sprig of tarragon, finely chopped
1 sprig of basil, finely chopped

FOR THE QUAIL STOCK:
8 shallots, chopped
1 garlic clove, chopped
10 g / ¹/₄ oz butter
2 quail carcasses
3 tbsp white wine
250 ml / 9 fl oz chicken stock
1 sprig of thyme

FOR THE VEGETABLE GARNISH:
8 small Jerusalem artichokes
12 baby leeks
2 sprigs of flat-leaved parsley
100 g / 3¹/₂ oz wild mushrooms
dash of cream
85 g / 3 oz butter
truffle oil (optional)
salt and freshly ground white pepper
lemon juice

1 First make the stock: sweat the shallots and garlic in a pan with the butter. Add the quail bones and pour in the wine and chicken stock. Add the thyme and bring to the boil. Simmer for 30 minutes. Pass through a fine sieve, skim off any fat that may have appeared and set aside.

2 Make the stuffing: mince the chicken breast and foie gras together. Put the mince into a bowl over some ice to keep it cool, add the seasoning and gradually incorporate the cream. Finely chop the herbs and add them. Leave in the fridge until needed.

3 Prepare the vegetable garnish: place the artichokes in a pan of boiling salted water and cook for about 10 minutes, or until they fall from a small knife (don't overcook as they go to mush). When cooked plunge into iced water. Drain.

4 Place the baby leeks in the boiling water and cook for about 5 minutes, depending on the thickness of the leeks. When cooked, plunge into iced water. Drain.

5 Pick all the leaves from the parsley (leaving very little stalk) and place in the boiling water for about 2 minutes. Plunge into iced water so that they keep their bright colour. Drain.

6 Place the quails' eggs in some boiling water containing a little vinegar and boil for 1¹/₂ minutes. Lift the eggs out and plunge them into iced water. When cold, shell and store in the fridge.

7 Preheat the oven to 190°C/375°F/gas 5.

8 To stuff the quail: place each quail on a board, skin side down, and open it out flat. Season the inside of the bird. Place a dessertspoon of the stuffing in the centre and place a quail's egg in the middle of the stuffing. Bring the skin back around the quail so that it resembles a whole bird. Using a needle and cotton, sew the bird up along the cut.

9 Season the stuffed birds and colour both sides quickly in a little oil in a hot ovenproof frying pan. Then cook in the oven for about 8 minutes, turning the birds on the other side halfway through. Remove from the oven and allow to rest in a warm place for about 5 minutes.

10 To complete the dish: bring the stock to the boil, then reduce to a simmer. Add the cream and whisk in the cold butter (don't allow to boil again). Add the artichokes and mushrooms and cook for about 2 minutes. Add the leeks and quails' eggs and simmer for a further minute. Season and add a squeeze of lemon juice, truffle oil if you are using it, and the parsley. Divide the garnish between 4 warmed bowls.

11 Remove the cotton from the quail and cut them in half so that each portion has a whole breast and a leg. Place in the centre of the bowl and pour over a little of the sauce.

Hot Banana Soufflé with Honey Ice-cream, Butterscotch Sauce and Caramelized Bananas

225 g / 8 oz bananas, roughly
chopped
1 tbsp lemon juice

FOR THE PASTRY CREAM:
4 tsp milk
1 vanilla pod
15 g / ½ oz flour
1 tsp cornflour
4 egg yolks
50 g / 2 oz sugar, plus more for the
ramekins

FOR THE MERINGUE:
whites of 6 eggs
35 g / 1½ oz sugar

Honey Ice-cream (page 166)

**FOR THE BUTTERSCOTCH
SAUCE:**
125 g / 4½ oz brown sugar
125 g / 4½ oz butter, plus more for
greasing the ramekins
250 g / 9 oz golden syrup
250 ml / 9 fl oz whipping cream

**FOR THE CARAMELIZED
BANANAS:**
1 tbsp hazelnut oil
100 g / 3½ oz icing sugar
2 bananas, sliced

1 Well ahead, make the Honey Ice-cream as described on page 166.

2 Make the Butterscotch Sauce: put the sugar, butter and syrup in a heavy-based pan and bring to the boil, then cook until golden in colour. Add the cream, bring back to the boil and continue cooking until it has a good dark-brown colour and thick consistency, about 10 minutes.

3 At the same time, put the banana in a pan with the lemon juice and 200 ml / 7 fl oz water. Bring to the boil and cook over a gentle heat, stirring, until all the water has evaporated.

4 Purée the bananas, then pass through a sieve.

5 Preheat the oven to 190°C/375°F/gas 5 and grease 4 ramekins with butter, then coat their insides with sugar.

6 Make the Pastry Cream: in another pan, bring the milk with the vanilla pod to the boil. In a mixing bowl, mix the flour, cornflour, egg yolks and sugar together. Pour the milk on to the egg mixture and stir. Pour back into the pan and cook out until thick. Add 2 tablespoons of the banana purée and cover with greaseproof paper to prevent a skin forming. (The remaining purée can be used as a dessert or as a garnish for ice-cream.)

7 Make the meringue: whisk the egg whites until they form stiff peaks. Add the sugar and continue whisking until the mixture forms a shiny meringue.

8 Take 4 spoonfuls of the pastry cream and warm up in a mixing bowl or in a microwave. Add 4 spoonfuls of the meringue and mix in well. Add a further 8 spoonfuls of the meringue and fold in gently.

9 Spoon into the prepared ramekins and bake in the oven for about 10 minutes, until coloured on top and well risen.

10 While the soufflés are cooking, reheat the butterscotch sauce gently and make the Caramelized Bananas: get a frying pan hot, add the oil and icing sugar and heat until foaming. Add the bananas and toss quickly.

11 Serve the soufflés as soon as they are cooked, with a side plate of the ice-cream and caramelized bananas dressed with butterscotch sauce.

Spiced Apple Flan with Cider Butter

4 Granny Smith apples, peeled, cored
and quartered
2 eggs
175 g / 6 oz caster sugar
90 g / 3¼ oz flour, sieved
25 g / 1 oz butter

CIDER BUTTER (PAGE 170)

FOR THE MULLED WINE:
1 cinnamon stick
1 vanilla pod
250 g / 9 oz caster sugar
4 heads of star anise
500 ml / 18 fl oz red wine
250 ml / 9 fl oz water

1 Well ahead, make the Cider Butter as described on page 170.
2 About 1 hour before you want to serve, make the Mulled Wine: mix all the ingredients together in a pan and bring to the boil.
3 Drop the apple quarters for the flans into the boiling mulled wine, remove the pan from the heat and allow them to cool in the wine.
4 When cool, make the Flans: preheat the oven to 190°C/375°F/gas 5. Whisk the eggs and 60 g / 2¼ oz of the sugar together until doubled in volume, then fold in the sieved flour.
5 Put one-quarter of the remaining sugar and one-quarter of the butter into each of 4 small ovenproof blini or pancake pans and heat to make a caramel. Add 4 apple quarters to each pan, spoon over some of the flan mix and bake in the oven for about 10 minutes.
6 Turn the flans out on plates, with the fruit upwards, pour over the cider butter and serve with Honey or Caramel Ice-cream (page 166 or 169) if you wish.

Welsh Rarebit Soufflé

butter, for greasing
25 g / 1 oz Parmesan cheese, finely
grated
whites of 6 eggs
1 tbsp lemon juice

FOR THE RAREBIT MIXTURE:
350 g / 12 oz Cheddar cheese
5 tbsp dark beer or stout
1 heaped tsp flour
1 tsp cornflour
25 g / 1 oz breadcrumbs
½ tsp English mustard powder
1 egg, plus 1 extra yolk
dash of Worcestershire sauce
salt and freshly ground white pepper

1 First make the rarebit mixture: in a pan, melt the cheese in the beer. Add the flour, cornflour, breadcrumbs and mustard, stir in and cook until thick and smooth. Beat until cool.
2 Add the egg and extra yolk with the Worcestershire sauce. Season to taste, then leave to rest until coolish.
3 Preheat the oven to 190°C/375°F/gas 5 and grease 4 ramekin dishes with butter, then dust the insides with the Parmesan.
4 Whisk the egg whites to firm peaks, then gently stir in the lemon juice.
5 Reheat the rarebit mixture over a low heat until soft. Beat a large spoonful of the whipped egg whites into the rarebit mix to make a paste, then gently fold in the rest with a large metal spoon.
6 Spoon into the prepared ramekins and bake immediately in a hot oven for about 10 minutes, until nicely coloured and well risen.

Glazed Rice Pudding with Caramel Ice-cream and Butterscotch Sauce

150 g / 5 oz rice (Carolina pudding rice), soaked
1 litre / 1³/₄ pints milk
1 vanilla pod
5 tbsp hazelnut oil (optional)
4 eggs
125 g / 5 oz caster sugar
brown sugar, to glaze

**CARAMEL ICE-CREAM
(PAGE 169)**

**BUTTERSCOTCH SAUCE
(PAGE 217)**

1 Well ahead, make the Caramel Ice-cream and the Butterscotch Sauce as described on pages 169 and 217 respectively.
2 Pour a spoonful of the butterscotch sauce into the bottoms of each of 4 ramekins and leave to harden.
3 Put the drained rice in a heavy pan with the milk, vanilla pod and the oil if you are using it, and cook until the rice is tender, about 15 minutes.
4 In a bowl, cream together eggs and sugar. Bring the rice to a roaring boil and stir in the egg and sugar mixture.
5 Pour into the ramekins and leave to cool.
6 When cool, preheat a hot grill, sprinkle the tops of the puddings with brown sugar and caramelize under the grill.
7 Serve the puddings with a side plate of ice-cream, dressed with the remaining butterscotch sauce.

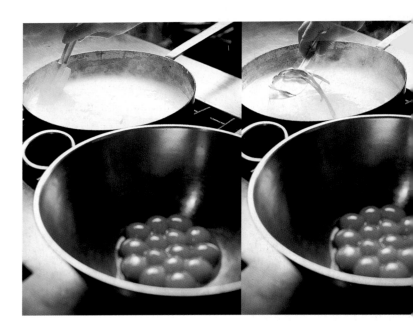

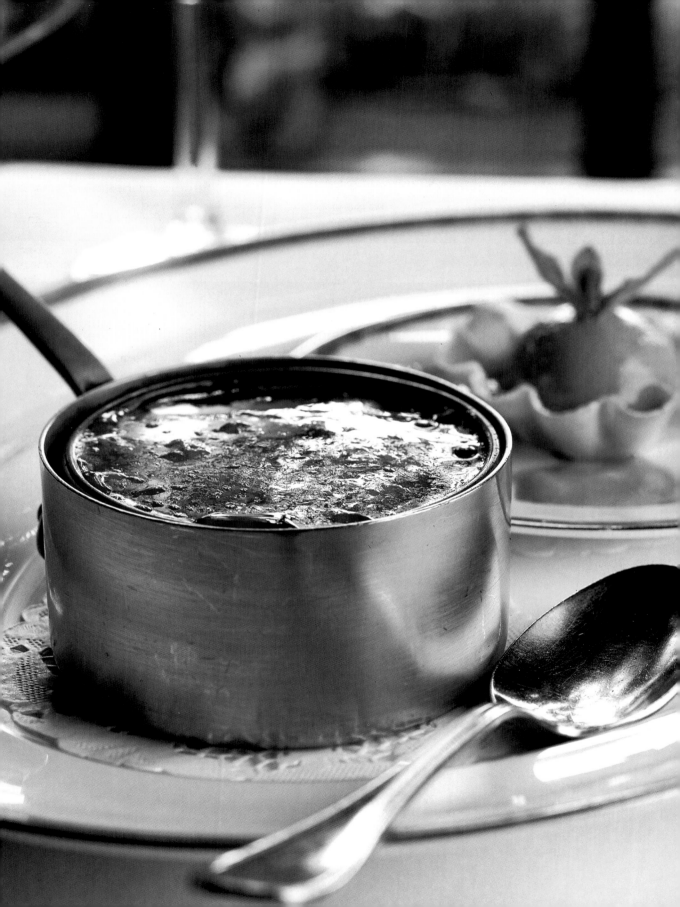

Index